designing across cultures

ronnie lipton

HOW
DESIGN
BOOKS

Designing Across Cultures. Copyright © 2002 by Ronnie Lipton. Manu-
factured in Singapore. All rights reserved. No other part of this book may
be reproduced in any form or by any electronic or mechanical means
including information storage and retrieval systems without permission
in writing from the publisher, except by a reviewer, who may quote brief
passages in a review. Published by HOW Design Books, an imprint of
F&W Publications, Inc., 4700 East Galbraith Road, Cincinnati, Ohio
45236. (800) 221-5831. First edition.

06 05 04 03 02 5 4 3 2 1

Library of Congress Cataloging-in-Publication Data
Lipton, Ronnie.
 Designing across cultures / Ronnie Lipton.
 p. cm.
 Includes index.
 ISBN 1-58180-194-7 (alk. paper)
 1. Commercial art—United States. 2. Graphic arts—United States. 3.
Multiculturalism in art. I. Title.

NC998.5.A1 L56 2002
741.6'0973—dc21 2001051522

Editor: Clare Warmke
Editorial Assistance: Amy Schell
Designer: Wendy Dunning
Production Coordinator: Sara Dumford
Page Layout Artist: Kathy Bergstrom

The credits on pages 186–188 constitute an extension of this
copyright page.

dedication

my gratitude and love to my husband, Jeff Young, and to my other teachers: my parents, Shirley and Nathaniel; Mr. Vincent Palumbo, Josephine Dzioba, Gus Miller, Ivor de Silva, Edwin Peskowitz, Reed Hankwitz.

acknowledgments

my gratitude too to no less than 150 people who generously contributed their time, insights and enthusiasm to this project. I'd like to especially mention those who gave all I asked—often a lot—and then went many steps beyond. They include:

Clare Warmke, my editor; Julia Huang, Bill Halladay and David Chao at InterTrend Communications; Richard Weltz of Spectrum Multilanguage Communications; Victoria Varela Hudson, David Orona and Jesus Ramirez of Cartel Creativo, Inc.; Michel Gibbs and Stephen Thompson of Chelsea-Harlem Interactive, Inc.; Luz de Armas; Jeff Lin, Arati Nath and Peter De Sousa of Admerasia; Gabriela Hernandez of Gabriela Hernandez Design; Vicky Wong and Kendal Yim at Dae Advertising; Norman Ishimoto of Kiyomura-Ishimoto Associates; Daniel Chen of D. Chen Design; Janine Thomas of *HealthQuest* magazine; Lisa Skriloff of Multicultural Marketing Resources, Inc.; Rupa Ranganathan of Strategic Research Institute, and so many more (whom you'll find in the resource list in the back of the book).

Thanks to friends who've helped and supported: Lenira Amaral, Tony Ardavin, Ann Brandstadter, Craig Braquet, Joe Chiappetta, Jessica Fagerhaugh, Kim Farcot, Les Greenberg, Jay Heflin, Noriko Hoge, Isabel Hon, Lorelei Kornell, Jim LaBelle, Alessandra Marinetti, Marcy Mandello, Margaret McGovern, Patrick Mirza, Emilio Ricci, Fred Showker, Conrad Taylor, Marisa Torrieri, and Robert Marshall Wells.

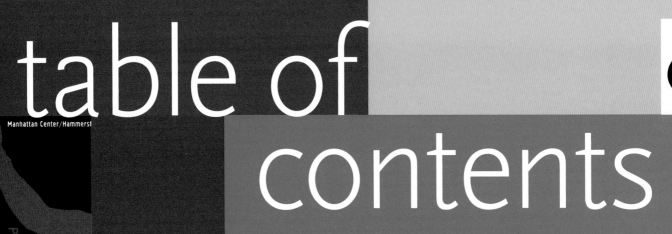

Manhattan Center/Hammerst

table of
contents

ый
йско-
канский
естиваль

introduction

THE WRITING'S ON THE WALL AND IT COMES IN MANY LANGUAGES. IT'S THE MESSAGE OF ETHNIC GROUPS IN THE U.S. THAT FOR DECADES LARGELY WENT UNNOTICED BY ADVERTISERS. THE MESSAGE READS: "NOTICE ME, UNDERSTAND ME, TOUCH ME, HANG AROUND." AND THE WRITING'S GETTING BIGGER, ALONG WITH THE GROUPS THEMSELVES. MOST U.S. COMPANIES KNOW THAT THEY CAN NO LONGER AFFORD TO PLAY ONLY TO CAUCASIANS BORN IN THE USA.

AFRICAN-AMERICAN, ASIAN-AMERICAN AND U.S. HISPANIC POPULATIONS ARE GROWING AT LEAST THREE TO FIVE TIMES THE RATE OF THE SO-CALLED GENERAL MARKET (TYPICALLY CONSIDERED WHITE, WITH ANGLO-SAXON ROOTS, AND BORN IN THE UNITED STATES).

it's a "new" world

the growing number of print and broadcast media outlets that target ethnic groups fuels the demand for ethnic-targeted design. That in turn has spawned a surge in the number of ethnic-targeted advertising and marketing agencies. What's more, the huge popularity of African-American and Hispanic performing artists has exerted a powerful influence on fashion, language and graphic images, even for the general market. The Internet also influences interest in ethnic culture.

You probably picked up this book because you've already sensed these trends. And you know that one-size-fits-all design rarely works, especially for diverse audiences. Of course there are commonalities that all humans understand, such as a baby's cry, said Peter De Sousa of

Admerasia, Inc. This book focuses on the differences. That's because your new ethnic audiences, like any audience, view the world—and your designs—through their own cultural filter. The filter's formed by language, religion and other shared experiences and it goes beyond what can be externally observed.

Many major corporations have invested in the need to understand these "new" filters. They're forming ethnic-marketing departments and working with ethnic-specialty agencies. Sometimes, as you'll see in this book, that's not enough to avoid blunders. Some companies and their designers are still learning—the expensive way—that it takes a sensitive touch to design for ethnic groups. Effective design begins here: You can't assume what's culturally relevant to an ethnic group (or subset of that group) that you don't belong to. (It's not even safe to assume it for a group you *do* belong to.)

I heard this over and over during more than 130 interviews with agencies and designers who specialize in ethnic audiences. If you dilute what's ethnic about a design until the client gets it, you risk watering down—or losing entirely—the intended impact on the audience. Or worse: A design that doesn't ring true may turn off the audience, wasting all that effort and expense. Your client's competitors will thank you.

minority majority

In the 10 years between the 1990 and 2000 Census counts, the U.S. Hispanic population has grown by 57.9%, Asian-American, by 48.3% and African-American (and black), by 15.6%. Compare that to only 5.9% growth in the general white population, and it's easy to see the trends.

In less than 10 years, half of U.S. residents under 21 years of age will be a member of an ethnic group. Already, ethnic groups make up the majority in California, according to the results of the 2000 Census. In fact, the very term "general market" is heading for obsolescence.

get visual: images speak every language

So how do you communicate with your ethnic audiences? You begin as you would for any other: Base your design on insights into the audience. Then imbue these designs with subtle visual cultural cues. Visual design is important in reaching ethnic audiences, especially those for whom English is a second language. Here's why: In the first seconds that a person views a message—before even reading a word, no matter what the language—it's the images that hold the power to connect. It's the images that make a viewer decide even whether to read a word.

If the audience is made up of recent immigrants, combine cultural cues with a reflection of the immigrant experience. That's because the biggest differences in target audiences isn't between subgroups (country of origin) but between levels of acculturation and recency of immigration, said Daniel Nance of D'Arcy, Masius, Benton & Bowles, Mexico City. People who've been in the U.S. for four or five generations are very different from the first or second generation.

Creative directors have designed effectively for some groups of recent immigrants by reflecting the frustration of feeling misunderstood, feeling out of control or outside of normal life, and having to rely too much on others for help. Also, this group is likely to be more receptive to cultural cues than they were before they arrived in the U.S. In many countries outside of the U.S., western images often are fashionable because they're exotic. Coming here where everything's western, and perhaps missing home, immigrants might respond more to images that evoke their native lands.

Besides, when immigrants arrive, images of home become locked in time, especially if they don't travel home often. But even then, visiting isn't the same as residing so changes won't be as apparent.

For an ethnic group with a long history in the U.S., such as African Americans, you'll be wise to reflect reality by depicting the audience as part of mainstream U.S. life, not as living in a black world.

Design that's inclusive, and targeted, is important for any ethnic group whose members have been made to feel like outsiders.

Navigational symbols are placed in the margins of this book help you pinpoint the information you need quickly. Say you're designing a print campaign for an Asian market and want to know what facial features you should look for in your models. Simply turn to the Asian-American chapter and flip through until you see the "casting" symbol. (See page 148 for proof!)

The symbols you'll find in this book:

CASTING

TYPOGRAPHY

HOLIDAYS

ICONS

CLOTHING

COLORS

... AND THE PINHEAD THAT REPRESENTS STEREOTYPES!

understand rather than offend

begin by knowing enough about your audience to keep from offending it. Like the Hippocratic Oath sworn by doctors: "First do no harm." But if all you do is avoid offending, you'll miss the opportunity to connect. For that, you have to look deeper. For example, the first thing you often hear about ethnic cultures is that the people tend to live in extended families. Stopping there will result in a design that looks like too many others, no matter what the product.

"I'm tired of seeing smiling grandparents in ads, for all segments, including Asian, Hispanic, African American," said creative director Wilky Lau of Muse Cordero Chen & Partners. Especially when Westerners aren't familiar with a new audience, he said, they tend to be cautious, sometimes overly cautious. "I don't think every family has to be smiling. Westerners don't always show smiling families."

But though a cliché, at least a smiling-families design shows some attempt to be sensitive to the audience, unlike this one: A San Francisco-based company used an image of the city's Golden Gate Bridge shrouded in fog on its English-language website.

The image works fine for a San Francisco audience, but Designer Kerstin Goetz of Jungle Communications said recognizing it might be a problem even for someone in New York City. For an international audience and a site in twenty-one languages, the image makes no sense so the designer wanted to change the visual. By saying no, the client unwittingly made the image into an appropriate metaphor—a foggy bridge into other cultures.

Some designers modify their visuals for specific audiences. A U.S. client brand guide for EDS had to be revised for some parts of the world because some images didn't translate. Although this book focuses on ethnic groups in the U.S., the EDS examples illustrate differences in visual meanings that immigrants to the U.S. may bring with them. For instance, to make the point that the company is like a catalyst in a chemical reaction (like yeast to bread), the U.S. version showed a photo of bread. The image worked well for Europe, but had to change for China, where bread is not part of the diet. Latin Americans understood the image, but they "weren't crazy about it" so Planet Leap substituted a photo of a car being filled with gas, said Rupali Steinmeyer.

A campaign for a New York telephone company changed for each of its three audiences, African-American, Asian-American and U.S. Hispanic. For Hispanic communities, Aurora Flores of Aurora Communications arranged for sponsorship of parades, with floats and music on the floats. For African-American, she sponsored cultural events and worked with events like Historically Black College and University touring fairs, supporting post-secondary institutions whose educational mission has historically been the advancement of education for African Americans.

For Asians, they took a different approach. With an Asian creative associate, Flores went to community leaders and told them the company was planning to open a store in the community. To acknowledge their leadership

biker blunder?

It turns out you have to be careful where you send biker images: An image of a muscled arm with a Harley-Davidson tattoo worked in the U.S., but other cultures reacted differently:

• In Asia, the image was associated with gangsters.

• In Europe, it evoked a negative response because of biker gang problems.

• In Latin America, it wasn't a negative image, but it also wasn't considered a big brand there. To avoid the "blah" factor, the company switched to an image from another client, Levi's jeans.

in the community and ancient Asian traditions, they enlisted the leaders' help in staffing the store. An Asian priest did a cleansing/space clearing ritual for the store. Asian musicians and dancers in a lion costume performed a dance that ended with the lion "chewing up" a head of lettuce and spewing out the shreds. Don't get it? In Chinese, the word "lettuce" is similar to the word for money. The action symbolized showering the bystanders with money.

If you ever become frustrated by trying to reach all, say, Hispanics with one campaign, imagine having to reach Hispanics, African Americans and women in one shot. A Department of Energy campaign to recruit those groups to apply for fellowships included a poster, brochure, newsletter and card. It helped that the groups were younger: high school graduates through college. The campaign used photos of a representative of each group but it "didn't scream 'minorities,'" said Irma Maldonado, HMA Associates Inc. She didn't want to suggest to potential recruits that they're only wanted for their minority status, not for their skill.

Still other designers take the "Pan" approach, using models who represent an overall ethnic group. "Pan-Asian" or "Pan-Hispanic" means that the model is an Asian or Hispanic person with a universally Asian or Hispanic look. This is safe because, for example, the facial features don't identify the face as being from any one particular Asian country.

The problem with "Pan-": "You would be successful in not offending everyone but I don't think you'll get everyone's heart thumping," Steinmeyer said. But it does cost money to target. "A client spends $10 million on the general market, then they feel hurt when we say it'll cost $50,000 to do the Hispanic." Ethnic marketing often is an afterthought, she said. So while some companies are still dipping their toes in, the opportunities may exist for those who are willing to take the risks.

start sensibly

To avoid errors and to be most effective in your designs, you'll be wise to include at least some of these steps:

- Observe your audience.

- Check available research on the audience.

- Ask well-chosen focus groups to check your designs.

- Ask other members of the ethnicity and demographics of your audience to check your designs.

- Consider working with a consultant who specializes in the ethnicity.

- Especially if language translation's needed, give it to an expert.

Stay on Target

There are various levels of targeting ethnic groups. As a rule, the targeting gets more effective—and more expensive—with each level.

1. Just adding subtitles to a general-market ad (no one recommends that).

2. Changing the language in typesetting or voice-overs (called "localization," it's a little better).

3. Adding Pan-Asian or Pan-Hispanic models.

4. Also (or only, if there aren't people in the design) changing other visual cues to appeal to specific groups.

5. Designing a different ad for each ethnic subgroup you want to reach, including a different model, altered message, relevant attitudes. It's not just recommended because ad agencies like huge budgets, but because advertising is about building relevance. And although there are commonalities to be drawn among ethnic groups (and all people, for that matter), in many cases, the most relevant designs are those that can capture what's unique about the consumer.

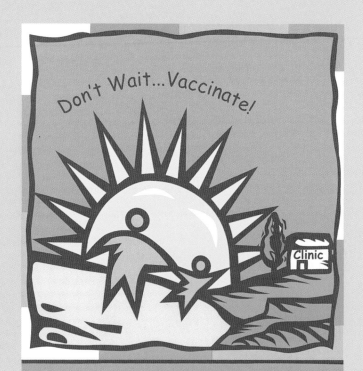

Don't Wait...Vaccinate!

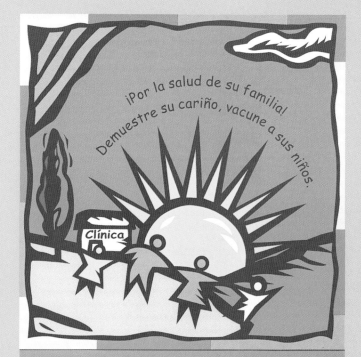

¡Por la salud de su familia!
Demuestre su cariño, vacune a sus niños.

2001

JULY

A vaccination health record helps you and your health care provider keep your child on schedule.

Sunday	Monday	Tuesday	Wednesday	Thursday	Friday	Saturday
1	2	3	4	5	6	7
			Independence Day			
8	9	10	11	12	13	14
15	16	17	18	19	20	21
22	23	24	25	26	27	28
29	30	31				

12

2001

AGOSTO

Ayude a proteger la salud de nuestra comunidad, asegúrese de que las vacunas de su niño estén al día.

Domingo	Lunes	Martes	Miércoles	Jueves	Viernes	Sábado
			1	2	3	4
5	6	7	8	9	10	11
12	13	14	15	16	17	18
19	20	21	22	23	24	25
26	27	28	29	30	31	

But because few designers always—or maybe ever—have the budgets to do a specific ad for each unique audience, this book focuses on levels 3 to 5, plus one more, that you'll find in chapter five: Multicultural Design.

This book will give you plenty of guidelines and examples for appropriate ethnic design, based on actual work. It will show you many stereotypes to avoid. And it will tell you when the best thing you can do for your client and your designs is to question your client's directions. Use the book as part of your research. You already know that every situation is unique, though, because messages, clients and audiences vary. A chapter is devoted to each of the major ethnic groups in the U.S. who interest corporations and other organizations as potential customers: Asians Americans, U.S. Hispanics,

African Americans, and (mainly Eastern) Europeans. Within each chapter, you'll discover the differences among subgroups of that ethnic group. For example, major Asian-American audiences comprise China, Korea, Vietnam, Japan, Philippines and India (with most advertising attention and budgets being paid to the first three).

In most cases, it's the larger ethnic groups that draw advertisers' attention, but not always. Asian Americans, a fast-growing but still tiny population, attracts advertisers for at least two reasons: their bigger-than-average household incomes and the fact that they are concentrated geographically so they are easily reached with regional campaigns.

13

The images in *Don't Wait ... Vaccinate!/ Demuestre su cariño, vacune a sus niños* work equally well for African-American and Latino audiences because they are neither overtly ethnic nor recognizably mainstream, and because they speak to universal themes.

Aside from specific references in each calendar to ethnic holidays and the use of Spanish for the Latino audience (right), the strong family images and abstract design cross cultural lines for a variety of groups.

The use of color, and parents and children together evoke the warmth and close-knit atmosphere of ethnic families. Abstract, multicolored renditions of people are subtle reminders of diversity, without singling out a particular ethnic group.

AGENCY | IMA Associates, Inc.
CLIENT U.S. Centers for Disease Control and Prevention/National Immunization Program

cultural filters

a n example of how cultural background puts a spin on everything we see is in this story that was going around Canada. In many office buildings, smoking is not allowed, so smokers congregate outside the building to get their nicotine fix between breaks. As a Russian visitor entered one building, the assembled smokers all were women. "Ah," remarked the man sympathetically to his host, "prostitution also is a problem in my country."

hispanic
americans

hispanics: ban the piñata

"Wake up and smell the café con leche," advises the website of Zubi Advertising, a Coral Gables, Florida-based multicultural agency. The Hispanic market in the U.S. is huge and continuing to grow fast. By the beginning of this millenium, Hispanics had become the majority in California. And they're headed toward that same status in the U.S. by 2010.

Hispanics not only are changing the U.S. population mix, they also have broadened our senses. You don't have to look further than trends in music, food and other customs appreciated by the general market. In fact, marketers have gotten carried away with Latino-"flavored" products for Latinos and the general market. In April 2001, for example, McCloskey came out with "Decora la Casa," a line of interior wall paints with Spanish names—Azul Cielo (blue sky), Blanco (white), Crema (cream), Nuez (nut), Luz del Sol (sunlight) and Pistachio—and mostly Spanish labels.

To reach this enormous, growing—and lucrative—market, Fortune 500 advertisers and designers have been leading a flood of Spanish, English and "Spanglish" messages to Hispanic-targeted media vehicles. Whether they reach the hearts as well as the ears of the audience depends, as in all advertising, on their ability to link the message with an understanding of the audience.

For Hispanic audiences, that's easier to say than do, because even Hispanic creative directors and designers disagree about what the Hispanic market responds to. What everyone I talked to did agree on is the need to avoid stereotypes and clichés such as piñatas, sombreros and cacti.

But, you'll find, they don't always agree on what the stereotypes *are*. Daniel Nance, of D'Arcy, Masius, Benton & Bowles (Latin America), based in Mexico City, hosted a Cuban visitor who wanted to know where all the sombreros were. He found them only in the airport gift shops.

Maybe the visitor should have looked on the front page of London's *Financial Times* (2/1/01), where he would have found a photo of Mexican President Vicente Fox *wearing* a sombrero. Inappropriately enough, the photo appeared next to a mention of an inside story … about the president's crime crusade. Although the graphic identified his country, but hardly his position, to non-Hispanics, Hispanics are unlikely to welcome the association.

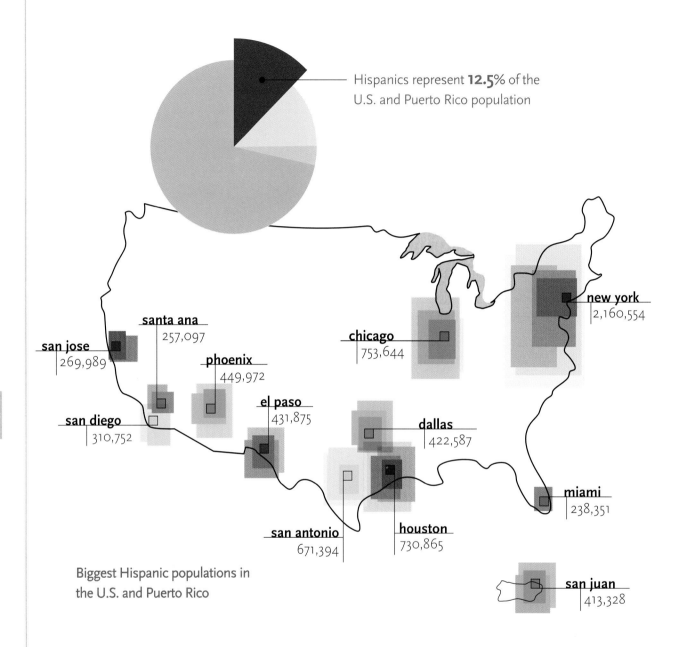

Hispanics represent **12.5**% of the U.S. and Puerto Rico population

santa ana
257,097

san jose
269,989

phoenix
449,972

chicago
753,644

new york
2,160,554

san diego
310,752

el paso
431,875

dallas
422,587

miami
238,351

san antonio
671,394

houston
730,865

san juan
413,328

Biggest Hispanic populations in
the U.S. and Puerto Rico

16

*Source: Hispanic, Black and Asian regional spotlights are
based on Census 2000 data released on the Internet: 4/2/01.*

how to steer clear of stereotypes

don't even get Mexicans started on the old Taco Bell chihuahua. Among those I talked to, a few were amused, some annoyed, a lot insulted. Even many non-Mexican Hispanics reacted negatively. Cuban-American Carlos Castellanos, however, thinks that visually the dog is a smart move. "Talking animals tend to get away with more than a person could. Some Latinos can cuddle up to that, if you bring creativity into it."

But although Hispanics aren't a target audience for Taco Bell, many others regret the perpetuation of the Mexican stereotype in the general market. "They're pimping the culture," said Alfonso Carrubias of Muse Cordero Chen & Partners. A San Jose branch actually displayed a Mexican flag, he complained. "It's hard to find a Latino on TV and when you do it's a little dog." What's worse, he said, once they dressed him up in the costume of Che Guevara, the Cuban revolutionary. "To me, a Latino, that was insulting."

Some advertisers even get the *stereotypes* wrong. One general-market advertiser planned a spot for its enchiladas that showed a woman doing the Mexican hat dance. She danced barefoot in the dirt (the dance is never done barefoot), she was dressed in a Castilian flamenco costume instead of a Mexican one (the dance originated in Jalisco), and chickens and pigs were running around in the background! Again, Mexicans aren't the audience for the product but why turn them off? said Andrés

Sullivan of Mendoza Dillon. The spot never ran, because, to the clients' credit, they sent the spot to Mendoza for approval. People are becoming more aware of the implications of a mistake, he said.

But it may take a while longer to recognize mistakes. One persistent error in advertising to Hispanics is simplification to the point of insulting the audience's intelligence. "It's the twenty-first century and the meaning of being Latino shouldn't be dumbed down to those old-school images," said Melanie Feliciano of Latino.com, a now-defunct web destination.

A lot of Anglo clients underestimate the intelligence of the Hispanic audience, agreed Gabriela Hernandez of Gabriela Hernandez Design. As a result, a lot of work targeted to these groups looks simplistic or bland. *Or it*

17

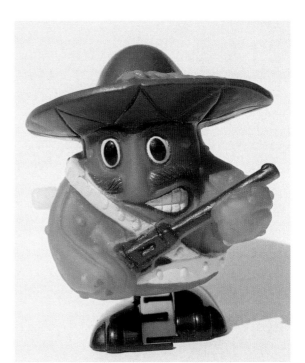

It doesn't get any more stereotypical than this plastic windup toy: cactus, sombrero, bullet strip, rifle, moustache, even the expression on the "face." Even alone, most of these elements don't belong in designs.

PHOTOGRAPHER Jeffrey Young Imaging, Bethesda, Maryland
FIGURE from the author's collection

looks too flashy. "It's a party, but it's always the same party, whether it's advertising fried chicken or a long-distance service." The younger audience must be talked to in more sophisticated way, but it's tough to sell that to a client who wants to play it safe. Too many ads are geared to the person who just showed up in the U.S and only needs to cash checks or make long distance calls. A lot of Hispanics were born in the U.S., or have been here long enough to be more acculturated.

And Rochelle Newman-Carrasco of Enlace Communications reports that every corporate PowerPoint presentation she's seen about the Hispanic market includes cactus and lizards, possibly confetti and sombreros. "It's not a big deal, but it's interesting to see the U.S. corporate version of what Hispanics are about."

In advertising design, though, it *is* a big deal. Visual icons like sombreros not only don't convey relevancy to your audience, they're likely to have the opposite effect. In most cases, dropping in a visual cliché only conveys that the designer didn't take the time to look beyond the surface. The dual need, added Christian Dobles of Rapp-Collins, is to show respect, not just for the audience, but for the client who doesn't understand it.

To be effective in talking to the audience, you've got to live with or at least visit them, said Dobles, who suggests: "Talk to ten creative directors in agencies and ask where they went for their last vacation. Do you ever go to Mission Street, Alivero, Culver City in Los Angeles? What about San Antonio, or Miami's Hialeah? I moved to El Barrio in Union City, New Jersey, and went every Sunday to the market with my kids. I would play the stupid father. 'I have to buy this for my wife …'"

What's more, Hispanics are so diverse that such symbols don't even touch the surface for some subgroups. Although the majority, at least 65%, are Mexicans, concentrated in California and Texas, there are significant numbers of Puerto Ricans (about 10%) mostly in New York and Chicago, and Cubans (about 5%), mainly in South Florida.

The market also includes people from other parts of Central and South America, such as the Dominican Republic, Guatemala, Colombia, Argentina and other countries. However, because their numbers are fewer, they're often targeted with the same messages as Mexicans, Puerto Ricans, and Cubans.

When there's a need to focus the message to one group, based sometimes on geographic location, these are the main groups U.S. advertisers look at. And as you'll see, you can't even consider your work done by looking at each country of origin because within each are strong demographic divisions, due to factors like time and condition of immigration, and economic and educational status.

Cuban Americans » Look at Cubans, the most affluent and well-educated of the Hispanic group overall. And take these insights into your designs. The audience comes in three main subgroups, says Victoria Varela Hudson of Cartel Creativo, Inc.:

1. Well-entrenched, traditionalists who fled Castro
2. Their also-affluent children, the YUCAs (young urban Cuban Americans) who were born in the U.S.
3. The "boat people," the economic refugees

Those distinctions are reflected not only in some of the products that would target each one, but also in the way you'd target them.

For example, the first two groups are sophisticated, skeptical consumers. They differ in that the first group tends to embrace pre-Castro Cuban traditions and boycotts those established since that dictator's regime, but the second group makes no such distinctions. Both are highly educated and bilingual, but unlike the first, the second group tends to be English-dominant.

As economic refugees, the third group, although literate, consists of new consumers and in need of education about products, brands and credit. They, like economic refugees from other countries, tend to appreciate and trust advertising messages, as a way of navigating product choices in quantities they've never seen before. And many economic refugees from Mexico and other Latin-American countries are illiterate, not just monolingual, so on packaging, visual representations of products and their uses will help more than Spanish text.

More about Cubans: Their food isn't spicy. The diet includes black beans and white rice (moros y christianos: Moors and Christians) that dates back to Spain. Pork and beef are heavy in their diet, but there's not much chicken and no tortillas. Although their English may be perfect, the first group watches primarily Spanish TV.

Women in the first group are very concerned with appearances. They won't go out without jewelry, high heels and makeup. They also feel it's their job to raise their family in a cultured environment. A photo of the dinner table should include a lace tablecloth.

When you cast for photo shoots, keep in mind that traditionalists tend to prefer European-looking Hispanics; YUCAs like all colors. The first two groups don't relate to Mexicans, Nicaraguans or any other economic refugee.

But the traditionalist and the boat people have icons and habits in common: They both would respond emotionally to El Malecon, a main walkway in Cuba. All three groups love soccer but these two are more likely to root for the Cuban team; YUCAs root for women's and U.S. soccer teams. And both traditionalists and boat people play dominoes. There are parks in Hialeah where they play every day. YUCAs don't play this game.

With a high level of brand loyalty, the boat people appreciate ads. You don't have to be the first brand to communicate with them, just the most relevant. They're mostly blue-collar, love to spend money and hate to save. They're a gold mine for mass merchants. Some also believe strongly in witchcraft and voodoo (segue was accidental but if the spell fits …), but YUCAs and most traditionalists don't care about them.

PUERTO RICANS » Puerto Ricans, as part of a U.S. commonwealth, are divided politically in three equal parts:

1. The ones who resent U.S. control, wish for independence and refuse to speak English
2. Those who love everything U.S. and wish for statehood
3. Those in the middle

As you'd expect, the first group doesn't relate well to U.S. icons. The last two groups are constantly traveling between the island and the States, so products and ads seen in New York have, as they say, legs.

Puerto Rico has the soundest economy in the Caribbean, and their people love to shop for designer and trendy brand names. They're sophisticated consumers, and everyone has a credit card. Even secretaries will eat potato chips for a month to lay away an expensive pair of shoes, says Hudson. Beauty is very important to Puerto Ricans: From hairstyles, to pedicures, it's important for a Puerto Rican woman to look her best, so she'll respond to messages that recognize that.

In casting for Puerto Rican audiences, there's a tendency to use the mid-range of skin colors you'll see in Puerto Rico: people with the Afro-Antilean look and café con leche skin, but, like other Hispanics, Puerto Ricans also come in lighter and darker skin colors. It's a myth that they look the same.

It's also a myth that all Hispanics are Catholic. Although most of them are, you'll also find Protestants among them, and in lesser numbers, other religions as well.

You can't even make assumptions about what to call Hispanics, and although they share a language, Hispanics don't even agree on what to call themselves—Latino, Hispanic, or by their country or continent of origin or citizenship, such as Mexican, Guatemalan, American.

It's a naïve designer who doesn't take all of this diversity into account.

You can show that your message includes all Hispanics by showing a lot of Hispanics. The get-out-the-Hispanic-vote poster shows 18 people of various demographics and 18 names that represent the diversity of the cultures in the U.S. The use of 18 different typefaces and three colors on the black-and-white photo reinforces the diversity message.

CREATIVE DIRECTORS
Jesus Ramirez, David Orona,
Cartel Creativo Inc.

PHOTOGRAPHER
Phillip Esparza/Photocom, Inc.

PRINT PRODUCTION
Rudy Longoria, Del Stephens

TYPE Breen Enterprises

COLOR SEPARATIONS
Ackley Martinez Company

PRINTER CLP Printing

CLIENT Southwest Voter Registration
Education Project

HERMANOS Latinas, Hispanics, Guanacos, Tejanos, CHICANOS, Mexicanos, CUBANOS, PuertoRicans, Dominicanos, CARIBEÑOS, CALIFORNIANOS, NORTEÑOS, SudAmericanos, SALVADOREÑOS, Ticos, Americanos. AMERICANS.

REGISTRENSE Y VOTEN.

Southwest Voter Registration Education Project

driving the diversity theme

Some creative directors have taken the diversity idea a giant step beyond casting. They've used it as a theme. A JCPenney TV spot by Cartel Creativo, Inc., in San Antonio, features Hispanic kids on bikes in a U.S. suburban middle-class neighborhood. "How do you say 'cool'?" is the question asked of each child from a different country. Each would say it in a cool way for the child's country of origin and in its accent. The tag line: "It doesn't matter how you say it, the important thing is being who you are."

A Southwest Voter Registration Project spot by Cartel also hit the theme of diversity, as well as unity. One after another, Hispanic celebrities (a source of pride to many Hispanics) showed up on screen to say, almost chant, different Spanish and English words that describe Hispanic people: "gente, Puertoricanos, Californianos, Nuyoricans, Ticos …": "ugly ones, pretty ones, skinny ones, fat ones, tall ones, short ones, Latinas, mothers, daughters"; finally "Americans, Citizens, Americans." In the final frame, the celebs say in unison: "Come together and vote." The accompanying print ad (see pg. 21) combines eighteen different names for Hispanics, each in a different typeface, with a group photo of eighteen non-celebrities of various demographics. The tag line's in still another typeface.

A diversity/recruitment print ad for Motorola by Uni-World Group's Ricardo Trejo used more than surface casting to break stereotypes. The ad features photos of five people of different colors and races, including Asian. Their Hispanic names and the names of their (also Hispanic) countries of origin appear next to them. The simple combination of photo and type gets across the company's awareness that it can't paint the audience with one brush.

That theme was essential for the U.S. Census Bureau's effort to drive participation in its Y2K count. So for a TV campaign, Federico Traeger of The Bravo Group cast people of "every color in the Hispanic pallette, from indigenous to Spanish white."

Enlace Communications also took the rainbow approach for a Macy's spot by showing four women, one after another, each captioned with her first name and her country: Jacqueline de Colombia, Rocio de México, Lucila de Argentina, Elena de Cuba. The voiceover does the pan-Hispanic thing: "Our accents don't matter, nor do our roots, nor what we do, we are different, but the same …" Then it makes the point that they all shop in the same place.

The spot ends with a quick graphic of the continent to reinforce the idea that Latin Americans are Americans, too. "It's all the same land mass. You can drive from Brazil to the U.S.," said Newman-Carrasco. U.S. Anglos "tend to usurp the word 'American.'" At first, there was concern that the image might convey stores throughout the continent but no such confusion came up in tests.

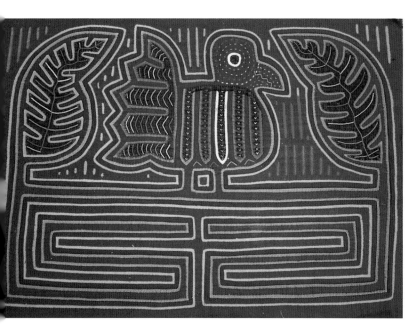

South American textiles are gorgeous but often too country-specific to work as a Pan-Hispanic visual icon. This mola, multilayered handwork, was bought in Cartagena, probably came from Panama. A Latin American would know the difference.

PHOTOGRAPHER
Jeffrey Young Imaging

22

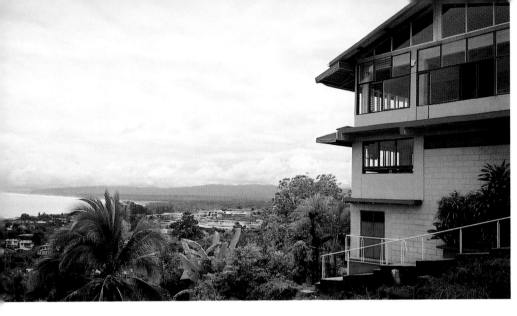

Brightly colored houses in Latin America are proof of Hispanics' love of color, say those who spec accordingly. Here's a house in Costa Rica.

PHOTOGRAPHER Ronnie Lipton

embrace the similarities, watch those differences

many creatives try to express commonalities among Hispanics in messages to them. For one thing, and it's a big one, Hispanics all share Spanish as a first language, although accents and idioms differ from country to country. For example, Puerto Ricans and Cubans tend to cut off consonants and endings. Mexicans pronounce everything, says Angela Carrales, Grupo Cuatro Publicidad. Advertisers attempt to bridge that gap by using accent-less "broadcast Spanish," a counterpart to what you'd hear on network news programs. In print, that means idiom-less Spanish.

Music, too, can have a Latin flavor without strong identification to any particular country's style of dance. But a Cuban salsa beat doesn't necessarily translate to a mariachi-loving Mexican audience. It's not necessarily even safe to expect all Mexicans to love that style.

But it *is* safe to assume Hispanics love music. In fact, "music, dance and poetry are part of our everyday living," said Aurora Flores of Aurora Communications. The general market also loves the arts, but it has a separate time and place for it: They'll go to a concert. But she said she doesn't understand all the general-market public relations parties she goes to that have no music. "To me that's not a party. They're sitting around picking at food. They could've stayed in the office."

Speaking of food, that's an even tougher crossover. Beans and rice dishes may be a staple throughout Hispanic countries, but each has its own take on them. A native can tell the difference, even in a photo. And spicy Mexican dishes don't translate to, say, Miami Cuban tastes for blander food, except to the All-Americanized YUCAs.

myths versus cultural truths:
it depends whom you ask

So you know to avoid stereotyping Hispanics (or anyone else for that matter). You know that Hispanics, like everyone else, don't want assumptions made about who they are and how they should look. Are there any "truths"? Sure, but no truth applies to every sub-group, demographic or client and the more you try to cling to generalizations, the more you're headed for stereotyping disaster. And even cultural truths, when portrayed too much, begin to overshadow the product.

But there *are* general truths. Here's what you'll hear about Hispanics in general and see reflected in designs for certain Hispanic audiences:

» They love their families.
» The father is the king of the household.
» The mother will go to great lengths to feel that she's taking good care of her family.
» The kids are the gods of the household for whom parents gladly sacrifice.
» They love extended family, including grandparents, who probably live with them, shop with them, and have a role in raising the children.
» They're close to the church and the community.
» They tend to love bright, or at least more saturated, colors.
» They love parties, festivals and music.
» They don't read as much as the general market.
» They prefer Spanish, even if they're bilingual.
» They prefer visuals to type treatments.
» They like to see people in their ads.
» Broadcast is a more effective medium than print; TV is #1, followed by radio, but both print and the Internet are growing.
» Novellas that come from Venezuela and Mexico are popular in many cultures.
» They love sports: soccer is universal, baseball's also a passion in Puerto Rico and Cuba.

It doesn't take a literal "translation" to convey the all-important Hispanic value of family. This magazine ad simply used a man and child's linked hands to show the connection (to each other and to the product).

TITLE Lazos Familiares (Family Ties)
EXECUTIVE CREATIVE DIRECTOR Luis Miguel Messianu
CREATIVE DIRECTOR Jose Luis Villa
ASSOC. CREATIVE DIRECTOR (ART) Monica Marulanda
ASSOC. CREATIVE DIRECTOR (COPY) Christian Relsen
AGENCY PRODUCER Loraine Albury
AGENCY del Rivero Messianu DDB
CLIENT McDonald's

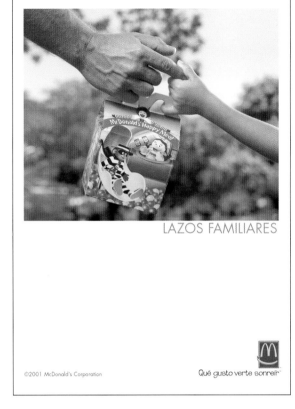

LAZOS FAMILIARES

©2001 McDonald's Corporation

Qué gusto verte sonreír

Daniel Nance makes the case that less acculturated Hispanics tend to take things more literally than their general-market counterparts with this example. A bank spot showed birds sitting on telephone lines to say "you no longer need to wait in line, you can call in." Hispanic consumers found it irrelevant and needed solid information to get the point.

But the audiences also tend to love double-meanings and puns; just make sure you test them. And beware that English double meanings and puns may get lost in the translation, losing your audience, especially when the visual was designed to work with the English pun. For example, said Newman-Carrasco, a department store ad used a photo of a genius-looking kid with a headline about not having to be gifted to give a great gift. By the time it made its way into Spanish, the double meaning was lost, and the headline no longer supported the art.

Conversely, Gabriela Hernandez adds, it can be hard to convince Anglo clients that the audience will understand a Spanish-originating pun or double meaning if the client doesn't understand it because it doesn't translate to English. So, she says, there are not a lot of original concepts.

Here's a double meaning that worked for the audience and that, with only brief explanation, passes any client test. Luis Miguel Messianu of del Rivero Messianu DDB tells this story: A dad comes home from a day of work, holding a McDonald's bag. His wife brings him the baby, whom he tries to get to "say 'poppa!' Say 'poppa!'" She doesn't, until he starts eating his fries. "Poppa," she says. The word means both "dad" and "french fry" in Spanish.

Other truths on the list also work as far as they go, but none go far enough to follow blindly, and some—including lifestyle and educational norms—are changing quickly as immigrant populations acculturate. So, for example, because clients have learned that Hispanics love family, and extended family, they tend to want to see the whole family in every spot. You don't have to be that literal. For example, you can talk about the extended family. Or you can show close-ups of children not stereotypically surrounded by masses of relatives. A lot of people think clutter is good for the audience, said Christian Dobles. "I like simpler images."

how to tell it's not the general market

here are some other effective ways to talk to Hispanic audiences:

» Show the Hispanic consumer as part of a group of peers. Ads for the general market, on the other hand, focus on telling the viewer he's unique.

» Tell what makes your product special without putting down the competition.

» Don't oversimplify. It was okay for advertisers to do unsophisticated ads when only one or two brands were in the market. Because that's no longer the case, you've got to dig deep to compete for the consumer's attention. When everyone has the same insight, find the twist on the insight. For example, with all the cereal ads embracing the family by showing the mom serving her kids, one marketer wondered why nobody's showing kids serving cereal to their parents.

Here's a telling story from Christian Dobles: In advertising the product Zima to the general market, a Charlie-Chaplinesque character walked into a bar and said everything with a Z. Although the character was obnoxious, Dobles said, the ads were somewhat funny and irreverent. For the Hispanic market, though, he advised a different approach because:

» it's hard to weave "Zs" into Spanish speech so the character would've sounded drunk;

» the audience would think he's a loser because no self-respecting guy would go into a bar poorly dressed; he'd go in dressed up to meet women;

» the audience would think he's a loser because he went alone to a bar, which means to the audience that he doesn't have any friends.

The new strategy presented a sophisticated drink to bring man and woman together. The couple was dressed up in high fashion, tailored jeans with nice shirts and blazers.

Ed Flores of Bromley Communications, who works on Procter & Gamble's Dawn dishwashing liquid, added, "it's unique to Hispanic audiences that the woman wants to feel 'tranquila'" (have peace of mind that she's taking good care of her family). So the copy-less spot showed a woman enjoying washing dishes to music. (Author's note: It's true that would never work in the general market, at least not in my house, and at least not these days. For the general market, that's an old scene from the kitchens of June Cleaver and Carol Brady. And beware, the days of the effectiveness of that image for even Hispanic audiences are numbered, as audiences become acculturated.)

You can see that concern for the family—what Jesus Ramirez of Cartel Creativo referred to as "the martyr syndrome"—in the California Milk Processor Board campaigns, says Gabriela Hernandez. The familiar "got milk?" general-market line and visuals support the individualistic concept. For Hispanics, on the other hand, it's: "Have you fed your kids milk?" For them, the focus shifts sharply from concern for oneself to concern for the family.

The martyr syndrome also means that Hispanic women won't be attracted to a convenience message for food or cleaning products, said Thomas Tseng of Access Worldwide. Don't speak to them of time to pamper themselves with a scented bubble bath by candlelight. Speak to them instead of benefits to their family. The convenience concept might work only if angled toward more time to do other things for the family.

While the general market venerates work, saving money and time, Hispanics value being with their family and friends. And although some of the old ideas are falling by the wayside, some immigrants come to the U.S. with the old ideas, Hernandez said.

nonverbal communication

immigrants also may come with shaky or nonexistent English skills. For a Spanish-speaking audience or one that's learning English as a second language, visual icons traditionally have helped flag products even before producers started putting messages in Spanish. For example, when Ed Flores was growing up in the U.S., his Mexican-born mother would send him to the store for the flour with "la paloma" (the white dog) on the package. It was all in English and she had trouble pronouncing the brand name. Hispanic-immigrant mothers traditionally have done the same with Betty Crocker's icon: "Bring me the one with the spoon on it," they say.

The icon didn't have to be a Hispanic image but they sometimes made it one, like the non-Hispanic face on the Pringles can that became "Pepe Pringles" to its audience. And the recognizable feature isn't limited to images. "The one with the green label" works almost as well. And Coca-Cola's winter-holiday polar bears, another general-market-born icon, are popular in the Hispanic market.

Sometimes when Hispanics "translate" a visual image and a name, they see too much meaning. Felipe Korzenny of Cheskin tells of a brand of rum that's successful in the general market and that the client wanted to test for Hispanics. The cartoon icon that's used on the bottle is an Anglo pirate who, given the history of Central and South America, looks like an oppressor to many Hispanics. In fact, the name is the same as a pirate who terrorized parts of South America. Although Hispanics tend to like rum, negative test results led to a decision not to market the brand to Hispanics, he said.

But a general-market element can beat out a Hispanic one for the Hispanic audience, as was the case for the Oscar Mayer jingle that won overwhelmingly over a Mexican cradle song in tests.

And some images just don't translate: Newman-Carrasco inherited a 1950s-type Hispanic campaign for (now-defunct) Home Savings of America that only changed the language from the general market. The English headline was "banking the way it used to be, except for the computers and stuff." The Norman Rockwell imagery wasn't going to work for Hispanic immigrants, she said. Many Latinos immigrated in the 1970s, so they couldn't relate to the U.S. 1950s experience. For others, who had arrived by then, the image wasn't irrelevant so much as negative: the 1950s weren't a good time for non-Anglos.

But, she says, someone who doesn't understand the market, or who knows just the buzzwords might say: "It's got people and it's got dancing, what's wrong with it?" Newman-Carrasco's Spanish headline translated to "At Home Savings, we make you feel at home." "The image was just passable for Hispanics because the guy looks Hispanic and the retro element from a distance makes one think of the zoot suit period that's in with Hispanics." But a Hispanic will recognize why it's Anglo 1950s retro, not Hispanic retro: The shoes, clothes and the look of the woman are wrong.

Remind your audience of home with a familiar character. From his hat to his shoes, "Candido, El Billetero" the Lottery-ticket vendor, looks like those in Latin American and Caribbean countries. One piece is a billboard; the other's a dangler, often placed on the door or cash register of bodeguitas, small Latino grocery stores that sell Lottery tickets.

CREATIVE DIRECTOR Fausto Sanchez
ART DIRECTOR Enrique Duprat
AGENCY Sanchez & Levitan, Inc.
CLIENT Florida Lottery

Characters, in particular, answer a key issue in advertising: getting people to talk about a product, even to name it. Pepto-Bismol had a puppet called "The Professor" that became popular on TV spots and in community events and store appearances. The icon had a long life span—at least five years—and was successful, said Diego Cantú of Leo Burnett's Lapiz division and who had worked on the account at Bromley Communications. (At Lapiz, Cantú retired the icon because by then, he says, the icon was so popular that it distracted attention from the product.)

And to increase Hispanic awareness and playership of a Florida Lottery game, Sanchez & Levitan created a ticket vendor character named "Candido, El Billetero" (above) that's reminiscent of ones in Latin America and the Caribbean countries. They dress in nostalgic clothes ("guayabera," an overhanging shirt style, straw hat with a winning ticket in it, dress shoes) and chant in humorous rhymes called décimas to sell tickets.

(By the way, native dress has its place, and the above example is a fine one. But folk costumes don't belong in most advertising. Dobles told of an account manager who wanted the models to wear decorative native Guatemalan costumes. But that's only how people might dress for a festival to celebrate their heritage. They wouldn't go to school or work with those clothes on.)

To reinforce brands especially for the non-Spanish-speaker, use ads to emphasize the icons on the package or show the name flying off, said Daniel Nance. Although there's a trend away from featuring the product in the general market, product is king in ads for Hispanics, especially the less educated ones and those who may be dealing with language barriers.

how about those bright colors

ike many other elements in ethnic graphic design, there are two schools of thought regarding whether to use bright colors. Those in favor point to Mexico and Latin America where houses sport colors—pinks, greens, and blues—unlike what you'll see in the States (see pg. 23). They refer to other indicators like folk costumes, signage, proximity to the equator, tropical foliage and flowers year-round. Fans of bright colors also point to the fact that Hispanics are great celebrators, so they love warm "fiesta" colors: reds, oranges, yellows.

The love of vibrant color among Hispanics is more of a cultural truth than a stereotype, Nance said. You can see the difference between the game and talk show sets on Univision and Telemundo—yellow, pink, orange, green—and those of the more conservative general-market sets. For further proof, look at the explosion of colors in the work of Diego Rivera and Frida Kahlo, famous Mexican painters.

Look, too, at the weavings of Guatemala and textiles from other countries (see pg. 22). But be careful. Christian Dobles reported that a website design that used textiles drew complaints from focus groups in four cities because it looked too Mexican. "None of the formulas work," he said. "People say Latinos like to be barraged with color, but the iconography has to work for the message."

No matter what colors you use, as a designer you've got to ask: "Is the imagery impactful enough to draw attention?" says Jose Matos, formerly of Siboney USA. Color can help. For example, orangey-reds that bring to mind a sunset on an island can tie some audiences to their roots. But, he cautioned, you can't choose one color and "say that I as a Nuyorican and she as a Dominican will feel the same thing … we won't." Still, he concedes, if you were to put general-market and Hispanic ads side by side, you'd probably see "our ads have more color … more salsa."

Preferred colors are stronger and bolder, said Gabriela Hernandez. You tend to get more saturated hues, even in corporate identity. She designed one for a Hispanic public relations agency in combos of warm, rich earth colors.

When you think of colors that would appeal to Hispanics, think of New Mexico and adobe and soil colors, strong blues, reds, brick reds, burnt orange, gold, earth tones and browns, even bold magentas and blues in combination. Gabriela Hernandez favors an unpolished, hand-drawn, earthy quality, with rougher lines and curves. She prefers a kraft paper to a slick look.

Even for the United Way, which did a study of Hispanic people in Los Angeles County, she used a hand-drawn cover with bright colors that looks like the work of a street painter. (The project is shown on page 32 and 33.) It was targeted to Anglo and Hispanic business people in Los Angeles County. For an audience that includes Anglos, she said she often has to exaggerate the Hispanic look to match the audience's expectations.

And when Marisa Estevan of Muse Cordero Chen thinks of the colors of Mexico, fuchsia, greens and coppers come to mind. Other color connections: Pre-Columbian Aztec colors, made of mineral and vegetable dyes, consisted of "deep reds, clay brown, vivid straw and lemon yellows, turquoise blues, deep emeralds, grays and blacks," according to The Color Compendium by Augustine Hope and Margaret Walch.

30

You don't see burnt orange much on corporate stationery. Here, it and other saturated colors give a warm look to the identity of a Hispanic public relations firm. The color's printed solid on the back of the letterhead and business card. Three interlocking rings, either darker than the background or reversed out of it, represent the three principals, and unity in general.

ART DIRECTOR
Gabriela Hernandez
AGENCY Gabriela Hernandez Design
CLIENT Valencia, Perez, Echeveste Public Relations, Pasadena, Calif.

But creatives also caution that bright colors don't always work. As the Hispanic consumer gains in sophistication and choices, it'll become more and more important to be appropriate to each situation. Take pink and yellow, for example. Those colors had a place when there wasn't much competition for the Hispanic audience, but now that consumers have more sophistication, it's overdone, says Hudson of Cartel, cautioning designers to avoid the "Mexican-restaurant syndrome." Ed Flores agrees, "We're getting away from pinks, magentas, purples … color can be another way of stereotyping."

And Newman-Carrasco of Enlace said she's heard a lot of Hispanics say, "Why is it always red or bright?" They think it's a knee-jerk reaction. In fact, many Hispanics dress in black, and decorate their houses in earth colors. Brightness, though, is appropriate for festive occasions or to evoke nostalgia.

Yury Vargas of The Bravo Group agrees. In his native Colombia, color preferences vary with the region. In Bogota, for example, people dress in black or dark

VALENCIA,
PÉREZ &
ÉCHEVESTE

PUBLIC RELATIONS

RUTELY CONDE
Account Executive

rutely@vpepr.com

87 N. Raymond Ave. Suite 400 ☎ 626.793.9335
Pasadena, CA 91103 📠 626.440.5263

VALENCIA,
PÉREZ &
ÉCHEVESTE

PUBLIC RELATIONS

87 North Raymond Avenue, Suite 400
Pasadena California 91103

VALENCIA,
PÉREZ &
ÉCHEVESTE

PUBLIC RELATIONS

87 North Raymond Avenue, Suite 400 Pasadena California 91103 ☎ 626.793.9335 www.vpepr.com
 📠 626.440.5263

Warm colors, brush lettering and a hand-painted, free-form illustration give a folk-art look to the brochure cover. The brush outlines alone are repeated in brick-red tone on tone for the inside back cover of the all-in-Spanish piece. An inside spread (shown opposite page) continues the informal, handmade look on a roughly drawn map of the Los Angeles area and stylized, almost cartoonish bar charts.

ART DIRECTOR Gabriela Hernandez
ILLUSTRATOR Gayle Kabaker
AGENCY Gabriela Hernandez Design
CLIENT United Way of Greater Los Angeles

Creadores del Sueño Americano

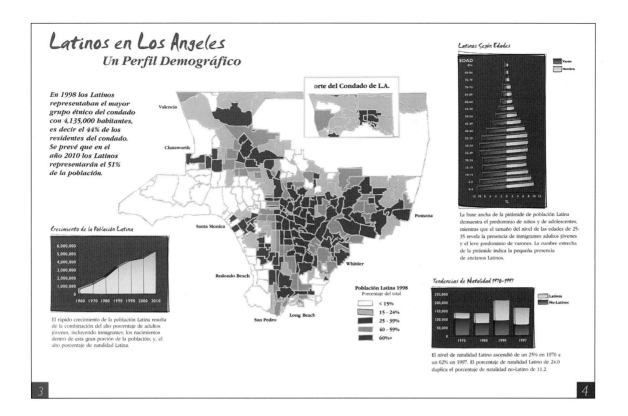

gray (which is why he's so at home in New York City, he said) rather than bright colors that are more popular in other areas.

But, he said, bright colors pack an emotional tie for many Latinos, especially those raised near the sea, especially the Caribbean. And in Peru and Venezuela, you see a strong presence of blues, yellows and reds, in higher hues than you'd usually use, mixed without fear or restraint. Two or more of those colors may be too rich for the general market.

Aldo Quevedo of Dieste & Partners is another creative director who doesn't head straight for a bright palette, but looks for other visual elements to provide impact. For example, he did an ad for HBO that showed tabasco sauce about to pour on a pulled-open eye (next page). It almost hurts to type that line, let alone look at the visual. Do so only if you're very brave.

Ricardo Trejo of UniWorld Group goes to the point of calling the "Hispanics like bright colors" theory a myth: He did one version of a particular campaign for African-Americans and another for Hispanics. To satisfy those who subscribed to the theory, color was used for the Hispanic version, while black and white was used for African-Americans. When the Hispanic focus group saw both, he said they preferred the one without color.

A coloration caution: When designing for a Mexican audience, avoid yellow flowers, except to convey mourning or the Day of the Dead holiday. If you forget, you'll be comforted to know that death and its symbols don't hold the stigma for Hispanics that they do for Asian and even general-market cultures. In fact, Hispanics have an enlightened approach to death. Also avoid the use of red flowers, except for poinsettias (see *Holidays and Their Visual Icons*, pg. 61), which are sometimes interpreted as a curse.

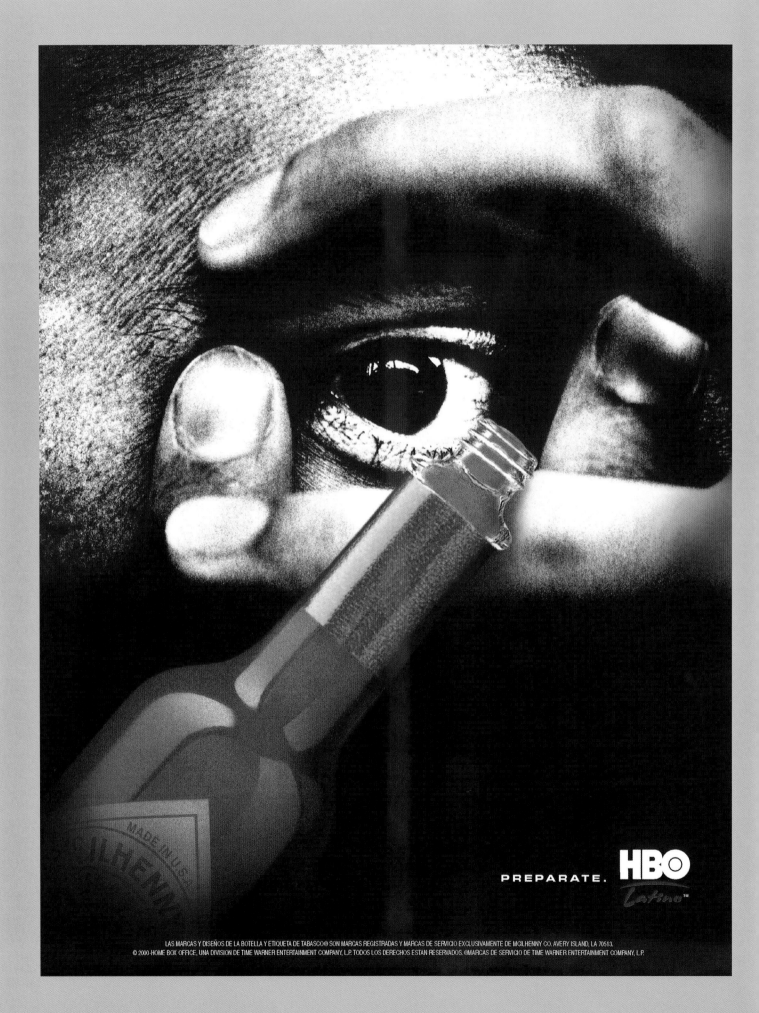

PREPARATE. HBO *Latino*™

meaningful icons

Religion

Religious images in general need special handling, depending on the application. They tend to hit many Hispanics in the heart so their use in graphic designs will do the same. Whether the hit's positive or disastrous depends on the message and the subgroup. As a rule, the older the viewer or newer the immigrant, the more sparing you should be with the icons. In fact, for them, it is a good idea to leave out religious icons, unless you're designing something about religion.

La Virgen de Guadalupe is such a powerful symbol to Mexicans that traditionally she was considered off-limits in secular designs, but you'll see the image used more and more. For example, Federico Traeger of Bravo Group showed the Statue of Liberty, a strong symbol of immigration, merging with her in an illustration for the cover of *Publicidad & Comerciales* magazine. In doing so, immigration, which the Statue symbolizes, became country-specific.

Other Hispanic countries have their own version of the Virgen, with a different look, name and story attached. For example, many Cubans worship La Virgen de la Caridad del Cobre (Our Lady of Charity). So not only does the image have to be appropriate to use at all, you also have to think about which Hispanics your choice excludes. It's not a big deal though, because each country tends to respect the other's symbol. (And although she's strongly associated with Mexico, Guadalupe's also known as the Patron Saint of the Americas.)

The Virgen's image has become a hip symbol of pride to younger Hispanics, agrees David Orona of Cartel, who reported seeing the image spray-painted on overpasses in Texas. And as a religious symbol, the statue is displayed in front of homes throughout San Antonio barrios. Other hip Virgen sightings: *Latina* magazine ran photos of a girl wearing a Virgen de Guadalupe T-shirt and a reader who'd used rhinestones to depict a saint on the back of a general-market designer's denim jacket. The latter's an example of a trend: taking a general-market style and "hispanicizing" it.

For an older, more traditional audience, the Virgen can be used in a religious context like a community event. To show its connection with the community, one company joined with the Roman Catholic Archdiocese of Los Angeles to commission a replica of the original statue in Mexico. They arranged a three-month road tour for the statue. The image was prominent on the fliers as well as an elaborate set designed for the replica's display at the L.A. Sports Arena. (See next page.)

Are you ready for this? The saucy, eye-opening image depends on more than bright color for impact.

Agency Dieste & Partners
Publicidad, Dallas

Client Bernadette Aulestia/HBO

Product HBO Latino

Executive Creative Director
Aldo Quevedo

Creative Director Carlos Tourné

Copywriter Alex Duplan

Art Director
Jaime Andrade/C. Tourné

Account Supervisor
Jose Pablo Rodríguez

Agency Producer Karin Hargrave

Photographer Tom Hussey

Be careful using religious images, especially La Virgen. Here the image is appropriate because it promotes a tour by a famous statue from Mexico. It shows on the flier and the set design for venue. (By the way, she's Guadalupe. Peregrina means Traveling Virgin.)

Art Director Gabriela Hernandez
Agency Gabriela Hernandez Design, Glendale, Calif.
Client Pueblo Corporation

The image of the Virgen also appears on religious symbols like votive candles, which you could put in a shrine for a photo shoot.

Remember: Timing and context is everything with this symbol because it can be controversial. About six years ago, an art director used it for an ad that showed a woman praying to the Virgen for help with her over-whelming household chores. It backfired. After the client got complaints from the public, including a local priest, the ad was pulled (and the agency lost the account).

Other Catholic icons: An apartment in Manhattan's Upper East Side was the backdrop for a *Latina* magazine story about inner beauty. There were shrines and altars in every corner of the apartment. Irasema Rivera shot them as they were because "when you start placing stuff, it doesn't ring true and the audience knows it."

The key to what rings true can hide in the most surprising, yet fundamental, places. Felipe Korzenny points out the differences between the Hispanic Catholic attitude to morning and that of the general market, and how that difference might influence a coffee's ad concept. While the ad general market might show a bleary-eyed person who can't move or think without coffee, "Hispanics wake up thanking God for not having taken their soul overnight," so their ad might reflect that relief.

Again, in considering religious icons like these, remember that all Hispanics aren't Catholics. More universal than the Virgen or any religious icon, and probably as powerful an icon, is Mom. That's especially true in Mexico where the world comes to a stop on Mother's Day, much more so than in U.S. In Hispanic cultures in general, reverence and respect for the mother is paramount.

Politics

The Statue of Liberty, the U.S. icon, figured in an aspirational spot for Tecate Beer. A Hispanic-looking guy holding a flag runs up the stairs of the Statue of Liberty. He bursts out on the balcony, unfurls and waves the flag, cheering. The flag reads "Llego para quedarse" which means "Here to stay." The image reduces to a TV screen in a bar, and the face of a young man watching intently, with Mexican-sounding music in the background. He toasts his friend and you see lime squeezed into the can. The camera pans back to show the Manhattan skyline behind the Statue with the Tecate flag still waving from the balcony.

The spot was designed to establish two things, says Jesus Ramirez, Cartel. "We won't lose our Mexican identities in the U.S. and we're here to make our mark and be noticed." It's controversial, he says. "It's a little undignified to cross a river to enter a country as many illegal aliens have done, unlike coming to Ellis Island. Mexicans and other Hispanics often have felt invisible in this country. The presence of the Statue of Liberty legitimizes Hispanic contributions. The guys in the bar get inspired by the image on TV and say in Spanish, "It's our turn."

Lotería

Literally, the name Lotería refers to a bingo card game played mainly in Mexico, but also in Central America, said Aldo Quevedo. In advertising, the cards have been used more like tarot cards in ad messages. For example, Dieste's website (www.dieste.com) relates the cards' symbols to the information categories on the site. For example, click on the heart (el corazon) to get facts about the agency, on the drum (el tambor) to see work samples, on the world (el mundo) to learn about the Hispanic market, and on the parrot (el cotorro) for press releases.

Other uses: An invitation to the *Latina* magazine's fourth anniversary party in San Antonio also used the concept of Lotería. Because it's a Mexican icon, it would not have worked in New York, Rivera says. For the typical images on the cards, an illustrator substituted elements: earth, fire, water, air, one for each year of publication.

The cards, superstition and humor figured in a TV spot for AT&T's Caller ID. An English-speaking Latino with a dog watches TV. The spot is filled with cultural cues. The guy is dressed in a retro-looking style of shirt,

popular with Chicanos during the time the spot aired. On TV, he sees a Spanish-speaking fortune teller (who looks like Walter Mercado, a Hispanic fortune teller who has a show on Univision). When the phone rings, he can't decide if he should answer. The dilemma? He wants to speak to Elena, but, he agonizes, what if it's Ariana?

The indecisive man turns to the Lotería cards, which he uses like tarot cards. He pulls the spider (La Araña) card, which suggests he shouldn't answer it. The card proves accurate. After circling the dog who chases his tail, and watching a spinning top (used for gambling in some parts of Latin America), the guy picks up the phone and lives to regret it.

Lotería cards, like other icons, work better for some things than others. A Hispanic company that makes cheese for Hispanics on the West Coast used Lotería cards in its advertising. One piece showed the devil character saying he wouldn't be the way he is if he'd eaten the cheese. But Gabriela Hernandez didn't think it worked too well because non-Mexicans didn't understand it. And although the cheese is used to make quesadillas, a Mexican food, Mexicans aren't the only ones who make quesadillas.

More Visual Icons

You'll have to dig deep to run out of iconography in these icon-rich Hispanic cultures. Have some more:

ROLLER LADY » A 'roller lady' is an illustration of a woman in hair rollers that was used as an icon in now-defunct Latino.com banner ads and billboards. The roller lady (affectionately known around the company's offices as "La Curlata") is a hip-looking young woman. In Puerto Rico and Cuba, there's no stigma attached to wearing rollers in public as there is in the States, said Beatriz de la Torre, who worked for Latino.com. Although the women wouldn't wear rollers in public here, the image is familiar and relevant.

MURALS » Murals are a big part of Hispanic culture. They're painted on buildings in U.S. cities and have been used in advertising. The Mexican Cultural Institute in Washington, D.C., features a multi-story mural along a stairway.

PEOPLE » Say what you will about low readership among Hispanics, Ed Miller of Verizon says that Hispanics' tendency to open direct mail is actually higher than that of the general market. And he's found that using Hispanic faces and families on the envelope encourages opening. Depictions of family and community togetherness are so respected, however, that they've been overused.

AZTEC SYMBOLS » The Aztec calendar can be sophisticated and appealing, say some art directors, although it's specific only to Mexico and not necessarily even relevant to all Mexicans. It's actually pre-Mexican, said Ricardo Trejo, who said he won't use the symbols at all. Christian Dobles agrees and goes further. "I don't think [the Aztec

PUEBLO™
Corporate Identity Guide

MAYA ADVERTISING & COMMUNICATIONS

These two logos suggest Mayan imagery, while another Aztec image—of a warrior—is designed to appeal to the Hispanic audience in Southern California.

DRM LOGO
EXECUTIVE CREATIVE DIRECTOR
Luis Miguel Messianu
AGENCY/CLIENT del Rivero Messianu DDB

MAYA LOGO
CLIENT/AGENCY Maya Advertising & Communications, Inc.
CREATIVE DIRECTOR
Luis Vasquez-Ajmac

PUEBLO LOGO
ART DIRECTOR
Gabriela Hernandez
AGENCY Gabriela Hernandez Design
CLIENT Pueblo Corporation

calendar] is a celebration of ethnicity." He referred to a retail chain that used a Mexican pyramid, which he called a symbol of genocide, not heritage pride. "It's a part of my heritage that I abhor and detest. The pyramid is where people were massacred when they came to Mexico. So when I see Aztec calendar images, I don't see it as representing Hispanics."

But others have used the images confidently and successfully. Mayan stuff, Aztec calendars and gods are hip icons to young Chicanos, said Traeger. Although they're from Mexico, Traeger finds it an appropriate symbol for all Hispanics. He used it in a poster for Philip Morris on youth smoking prevention.

The logo of del Rivero Messianu DDB shows a jaguar and a tongue in the Aztec style to suggest that "the power of our roots is the power of the words." A few companies that see the imagery as powerful have used it for their names, not just their logo graphics. Mayan pyramids and bright colors are appropriately the logo for Maya Advertising.

And the Pueblo Corporation logo is an Aztec warrior in feathers. It's an appropriate traditional Mexican icon for a company that sells discounts cards in Hispanic communities in Southern California, said its designer, Gabriela Hernandez.

MAYAN CEREMONIAL MASKS » David Orona did a campaign on HIV awareness among Chicanos in the Dallas-Fort Worth area. He asked an artist to create three masks painted yellow, red and blue: one to represent fear, one for ignorance and one for denial. Underneath the masks, he carved type out of wood, painted it and scanned it into the computer. He used the masks in this case because he thought real people in the ads would look threatening.

TILES » Tiles are a universal product among Latin Americans, and each country has its unique patterns. For a Pepsi promotion, Orona used a tile pattern that simultaneously appealed to Puerto Ricans, Cubans and South Americans, as well as Americaños.

Sun or solar imagery » The sun is widely used in iconography. *Latina* magazine's Empowerment Seminar materials featured an icon of a powerful-looking woman holding up the sun.

Nature symbols » Flowers, blue sky, green fields, trees and palm trees are popular.

Terracotta pottery » A *Latina* magazine section on holiday recipes showed off the foods on beautiful clay dishes. "These are modern versions of what our mom and grandma used … the attitude is to embrace tradition, yet make it modern," Rivera said.

The plaza » Two-thirds of the Hispanic population consists of relatively unacculturated, recent arrivals who need to call internationally frequently, said Ed Miller of Verizon. Many have immigrated to improve living standards, so he sends them aspirational materials. A campaign called "La Plaza" is modeled on the idea that most towns in Latin America have a plaza where villagers go to see and support their neighbors. In keeping with the idea, the campaign offers English-as-a-second-language videos, savings bonds, translation calculators and a video course on how to become a citizen.

The design of an accompanying magazine, *La Voz de la Plaza* (the Voice of the Plaza), mimicks the look and feel of *People en Espagnol*. More evidence of Hispanic willingness and ability to read: Verizon research found that three-quarters of customers keep the magazine as a reference; 60% act upon the info in it by calling 800 numbers. It's true that, in general, readership is not good in this population, but he thinks that may have been due to the low quality of available reading material.

Sports symbols » With Hispanics, you can hit every segment with sports, and soccer is universal, almost a religion, Miller said. People from Caribbean countries also like baseball and boxing; Mexicans like boxing, too. But although you can pick up sports themes, use them

Wimpy women need not apply! The Latina Empowerment seminar logo features an illustration of a woman who's so powerful, she can hold up the sun.

Publication *Latina* magazine
Art director Irasema Rivera
Illustrator Alexander Verbitsky, www. verbitsky.com

Sun imagery also dominates this design for Nuestra Gente, a U.S. Latino awareness conference.

Creative Director
Luis Vasquez-Ajmac

Agency/Client Maya Advertising & Communications, Inc.

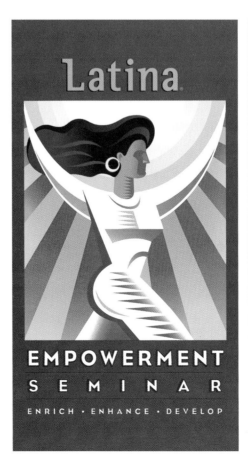

Corazón de Madre

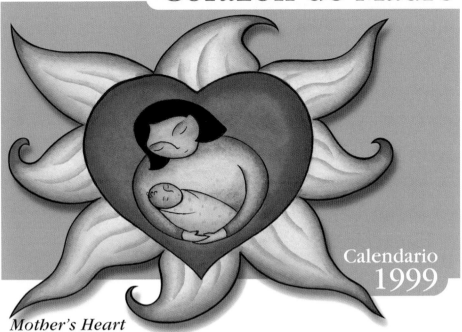

Mother's Heart

Calendario **1999**

Warm colors, a mother and child, a sun and a heart! The cover of "Mother's Heart" (Corazón de Madre), a pocket calendar with health messages for Hispanic families, pulls together a number of visual icons.

ILLUSTRATOR Andrea Arroyo
AGENCY HMA Associates, Inc.
CLIENT U.S. Centers for Disease Control and Prevention/National Immunization Program

differently than you would for the general market. Marisa Estevan gives this example: Four years ago, Nike's general-market campaign was about winning and being the best. Those are concepts that don't work for Hispanics, who respond more to sharing and having fun. So another spot showed two kids playing Foozball, transformed into players in a Mexican soccer game.

HEART IMAGERY » The heart is a strong icon to this family-oriented culture. Combine the heart with the mother and the sun, and the emotional pull is almost irresistible to this audience. HMA Associates used the triad on a bilingual pocket calendar that gives children's health advice to parents. "Mother's Heart" features cover art of a mom holding her infant, both enclosed by a heart in front of a friendly looking sun. Each month contains a different visual interpretation of the heart by a different Hispanic artist, along with a decho (a Spanish saying).

FOOD » Although bean and rice dishes are a staple throughout many Latin countries, feed a steady diet to your audience and they too become a stereotype and a cliché. Hispanics eat more than beans and rice. And even within that dish, most countries have their own variations, which people from each country can recognize on sight. So if you're regionalizing, make sure you don't use, say, a Mexican culinary element in an ad for Cubans.

Pepto-Bismol turned to thoughts of food when it retired its Professor puppet. The concept changed to "with 20 million things on your mind, the last thing you should have to think about is indigestion." The visual showed all the food—chicken tortillas, paella, mole, enchiladas—a woman had eaten floating above her in her thoughts. After she takes the product, all the food begins to dissolve so she can go back to thinking how she'll tell her parents she eloped.

41

Look between those logo characters and
you'll find a figure familiar to Mexican
audiences: the tarot-card reader.

Photographer Sybil MacDonald
Agency Enlace Communications, Inc.
Client Jack in the Box

Shawls » Irma Maldonado of HMA Associates Inc. used a Mexican-looking shawl prominently in an ad promoting breast and pelvic exams for Latinas.

Flags » Be careful with this one. Immigrants who are refugees won't necessarily react positively to images of their native flags, depending on the reasons they left.

Mariachis » Like piñatas, if you've chosen them just because they say "Hispanic," that's a recipe for stereotyping, said Newman-Carrasco. Mexicans have a lot of respect for these artists so if you use them, show the wardrobe and person in a meaningful way, such as in a story about their art.

Bullfights » They're so far removed from the U.S. Latino culture, no one really thinks of them, said Hector Cantú, who writes the Baldo comic strip. If they do, they may see them as old-fashioned and as lacking the "cool" factor. But to recent immigrants from Mexico and Spain where there still are bullrings, the images are more relevant, evoking bravery and honor. Cantú suggested that a bank or financial institution might make good use of the imagery as an analogy for facing danger of what's ahead.

Mystic symbols » Faith healers, psychics, tarot cards, witchcraft, the Caribbean's Santería (African pagan

Catholic) constitute powerful symbols to some, and acceptable ad symbols to most if they're used lightly, said Newman-Carrasco. For example, a spot for Jack in the Box (a restaurant chain) takes place at an outdoor market reminiscent of those in Mexico. Jack stops at a tarot card reader who has cards that all say Chicken Supreme. He thinks she's a clever fortuneteller, but it turns out she just saw a Chicken Supreme poster in the market.

The Botanica is a related symbol. It's a place where you buy herbs and get help for the evil eye. The icon is both humorous and real.

Mounted animals » An HBO spot shows a guy watching TV. He's alone, but he's not the only one who's watching. Mounted animal heads on the wall turn to watch too. The living room's designed with a retro style, including a painting that the guy "probably got from Grandma … awful framing." What's the deal with the animals? It's common among some Latino families who

A Mexican-looking shawl evokes feelings of home to the audience for an ad that encourages breast and cervical cancer screening.

Agency HMA Associates, Inc.
Client Edward R. Roybal Institute for Applied Gerontology, California State University

LA PRUEBA PAPANICOLAOU Y LA MAMOGRAFÍA

¡ Hágalo por su Salud, Hágalo por su Familia !

Cada Paso Cuenta

Hágase su mamografía y exámenes Papanicolaou y pélvico cada año especialmente si tiene 50 años o más.

Para exámenes de bajo costo visite su centro de salud.
Llame al 1-800-986-9505 o al número indicado abajo para más información.

Llame al:

National Association of Community Health Centers, Inc.

Sponsors: National Association of Community Health Centers, Inc.
The Edward R. Roybal Institute for Applied Gerontology, California State University at Los Angeles
Centers for Disease Control and Prevention

CDC
CENTERS FOR DISEASE CONTROL AND PREVENTION

43

don't hunt to buy mounted animals at resorts in Mexico, said Aldo Quevedo. You wouldn't see that in Argentina, which is very European, he added.

RETRO STYLE » The retro look mentioned above also can be seen in the "popcorn" ad for the same client (above right). "It looks like a typical house gone crazy," Quevedo said. The saturated colors were designed to pop out of the magazine.

CUTOUT PAPER (PAPEL PICADO) » Decorations of various religious icons and angels on strings were made for the Christmas tree in a JCPenney spot. Paper cutouts are kind of universal among Hispanics, Jesus Ramirez said. You'll even see cutout-paper signs hanging in liquor stores.

ZAPATA » He's the rebel who wore bullets across his chest, but be careful not to use him as a stereotype for Mexicans.

LOW-RIDER CULTURE » Low-riders are cool, Hector Cantú said. They represent youth culture and there's a lot of pride in them. "I've never seen them used in a negative way," he said. What about David Letterman's statement in a comedy monologue: "Go do this, you so-and-so low-riding punks." Cantú said he thought about it, then decided that's not bad. Letterman's use means that low-riders are "entering the mainstream." In fact, the idea that the older generation looks down on them ensures cool-

ness. He also cited a Conan O'Brian skit in which a non-Latino kid is playing with a radio-controlled low-rider. Talk about mainstream when Radio Shack is coming out with such items. "Low-riders are what hot rods used to be." (Be aware: Food references are another story entirely. A writer used the word "spicy" to describe the Baldo comic strip. Those references "border on offensive" because they're a cliché, Cantú said.)

SKULLS AND SKELETONS » These are used for the Day of the Dead. Although death and its symbols are not a taboo to Hispanics, Anglo clients often veto the idea of using those symbols in ads because it's too "out there" for them, Ramirez said.

David Orona got away with the symbolism for a safe-sex-awareness project. He was inspired by the art of José Guadalupe Posada, a famous printmaker, who designed motifs like skeletons on horseback. Although most Anglos would be horrified by such symbols in connection with an HIV-prevention ad, temporary tattoos with skeletons on them were popular with the target audience: Hispanic gay men aged seventeen to thirty-five.

44

comic strip icon

You can get cultural consulting for the cost of a newspaper—on the comics page. While following the life of a Latino-American family, a comic strip called "Baldo" dishes out a wealth of pan-Latino cues. The family includes a high school boy (the title character), his little sister Gracie, father and aunt, Tia Carmen.

What probably helps the strip reach across Latino-American cultures is the fact that the strip's writer, Hector Cantú, is Mexican American and lives in Texas, and its illustrator, Carlos Castellanos, is Cuban American and lives in Florida. The strip even reaches farther. "We get a lot of mail from non-Latino audiences," some expressing gratitude for reminders of time spent in Latin countries.

The creators bring to the strip the perspective of the second generation. "We both grew up watching 'Brady Bunch' and 'The Partridge Family,' and going to high school with maybe only twenty-five Spanish kids," said Castellanos. Still, "I never saw myself as being different." Now, he said, he appreciates the heritage. Like him and Cantú, "Baldo is an average American kid yet he has ties. He lives with his crazy Tia Carmen who reels the whole family into the heritage." Does Castellanos have a Tia Carmen? "Who *doesn't* have a Tia Carmen?"

In the first frame of a particularly memorable strip, Baldo's reading the directions for his school photo project: "Try to photograph people in their natural surroundings." He considers, then gets his shot of a kneeling Tia Carmen praying in front of her altar that holds candles, flowers, a Virgin statue and a cross.

Non-Catholic non-Hispanics who don't have a Tia Carmen on a kneeling stool in the back room who prays to the Jesus picture were scratching their heads and saying, "I don't get it," said Cantú. And he admits it wasn't a laugh-out-loud message, but meant to convey an emotional moment. It wasn't written for people who didn't get it but for people who did.

Another inside joke appeared during Halloween, when the illustrator used Day of the Dead folk-art images like dancing skeletons. These sorts of inside messages come up maybe once every six months, Cantú said. ("We get e-mail asking 'Who is Frida Kahlo?'—only the most influential North American artist! 'Who's Diego Rivera?'"—a well-known Mexican muralist, whose work, along with Kahlo's, Mexico considers national treasures.) But most of the time, "We go for the gag," and one that's more universally understood.

Cantú's favorite strips are those that address common and important issues, such as the kids of immigrants being put on the spot to translate for their parents. And it's a serious issue when a hospital's involved: "'Tell your mother that her sister has cancer and will die in a year.' Little children should not be translating. Hospitals should hire their own translators." Many are reacting to the need by doing so, he said.

Other powerful cultural cues brought to the funny papers by Baldo's creators include Chupacabra, a Spanish bogeyman. "A couple of years ago, news came out of Puerto Rico that some alien being, dubbed El Cucuy (the goat sucker) was killing farm animals by sucking out their blood." The creators did a week of strips on the topic. Dad complains that the house is a mess and tells the kids that if they don't do something about it, El Cucuy will get them—a common threat by Latino parents.

The threat doesn't work, so dad hands the bogeyman his pink slip because the kids "don't believe in you anymore." In another strip, a religious icon wields greater power over the boy. He walks by a 3-D painting of Jesus holding a glowing heart. When he sees the eyes looking at him, he "freaks out" and runs to his dad, kneels and confesses his latest sins. Dad says, "You've been walking by the 3-D painting, haven't you?"

The Dad has no identifiable job but, Castellanos said, he's probably an entrepreneur. "I think of immigrants as coming in with a strong work ethnic, taking whatever jobs they could find. I've got pictures of my father hanging from the Empire State Building."

In a mass-market medium like a newspaper, "we have to put stuff out that's palatable to the masses," said Castellanos. And part of what's palatable is spoofing

Hispanic kids may be onto the tricks of marketers, but that doesn't mean they're immune to them, any more than are kids of any culture.

Baldo © Baldo Partnership. Reprinted by permission of Universal Press Syndicate. All rights reserved.

the whole Latino marketing thing, said Cantú. "People are going overboard." For example, one series of strips takes a playful swipe at the trend toward Latino-oriented foods. While Baldo and his dad grocery shop on separate aisles, Baldo returns with a box of Spicy Hot Sugar Flakes cereal flavored with jalapeño bits. Nacho-flavored Pop-Tarts, another invention of the creators, appeared in another strip in the series.

Still another strip pokes fun at the entire Latino-American-marketing industry and its power. Baldo and his friend watch a TV commercial that uses low-riders (a hydraulic, ground-scraping, bouncing style of car that's popular in Latino neighborhoods on the West Coast) to sell fast food. "How pathetic!" says Baldo. "Do they really think they can appeal to our sense of cool with such phony manipulation?" Uh huh and it works. The last frame shows the friends enjoying their burgers at the advertised restaurant (see pg. 47).

The strip had two messages, Cantú said. That corporations are catering to certain groups by bringing in cultural icons and that even though Baldo is onto them, he's so easily swayed that he says one thing and does another. At least he's manipulated with his eyes open. That the audience is aware of the marketing tactics is an important lesson for anyone who would talk down to it.

The distinction is important to the creators. "Never do we want to have a laugh at the expense of our characters. Never sacrifice them to the cheap taco joke." Comedy deals with stereotypes, but the partners chose to "take what's essential about the comedy toolbox and throw it away." You'll find "no giant sombrero on Speedy Gonzales eating frijoles." The only stereotypes they use are positive stereotypes like a religious aunt, a very caring father, a militant little sister who's a "young Che Guevara." By the way, she's also career-oriented, creating a positive role model.

Castellanos suggests the strip's quick acceptance may be linked to the increased popularity of all things Latino. The strip started with 100 newspapers, the fourth biggest comic-strip launch in history. (African-American-oriented "Boondocks" is in the top three.) By October 2001, Baldo was in 170 papers, had its first compilation book published (The Lower You Ride, The Cooler You Are), and was in proposal for a TV show.

Cantú chose the name "Baldo" because it's Spanish but not so Spanish that it would be unpronounceable for non-Hispanics, said Castellanos. The name's short for Baldomero.

If your local paper doesn't carry the strip, you can find it at www.ucomics.com, which contains an archive of them. It's the first syndicated strip to depict Latinos in the U.S. (A strip called "Gordo," syndicated until the mid-1980s in the U.S., told the story of a Mexican tourist guide.)

typecasting

felipe Korzenny of Cheskin did some research on typeface preferences in the Hispanic market and found this: In general, the Hispanic audience prefers faces that are relatively simple, less cumbersome and more readable. Serif type is preferred over sans serif. Korzenny offers this research-based theory to explain those preferences: Hispanics have greater need for locus of control and their influences are strongly external. For example, they're uncomfortable if their chair has shorter legs than that of the person they're with. He thinks that preference for serif type is an extension of that trait. Serifs have a psychological base; they give you something to rest on.

A typeface case in point: When David Orona, Cartel Creativo, was at Ornelas & Assoc., he did a billboard for Mountain Dew. The message for the general market showed extreme winter sports. For Hispanics, he changed it to reflect the more relevant urban landscape, using hand-drawn type outlined in black, like graffiti murals in Spanish Harlem and in Los Angeles.

In many cases, Federico Traeger of the Bravo Group says he likes typefaces for Hispanic audiences that are "louder," bolder and edgier than for the general market. But that edgy look doesn't necessarily come from ready-made faces, added art director and type-lover Yury Vargas, also of Bravo. He said he doesn't use fonts that look—and sound— stereotypically Latino, like Latino and Fajito, because he believes there are more effective and subtle ways to attract the audience. "The Hispanic market is the general market with a twist," he said.

Instead, he said, you can take a classical face like Bodoni and transform it in a way that gives a different personality to the font. For a corporate logo, for example, you might add a Latin flavor just by italicizing one of the words in the otherwise corporate-looking logo.

Gabriela Hernandez adds the Latin flavor with clear, slightly curvy fonts. Hispanics like curvy lines more than straight ones, she said. You can see curves in gates and fences, not to mention in women. She prefers curves to the Aztec zigzag, which is used a lot, maybe overused. Hernandez also favors the hand-drawn look of headlines

A hand-drawn look on a brochure.

ART DIRECTOR Gabriela Hernandez
ILLUSTRATOR Gayle Kabaker
AGENCY Gabriela Hernandez Design
CLIENT United Way of Greater Los Angeles

lettered with a brush, as she used in an American Red Cross logo and a United Way booklet and brochure. In the United Way pieces, the type mirrors the illustration style. And Goetz used an Émigré font called Senator in a project that targeted Hispanic audiences.

Although it may have been a coincidence that the word "type" exists in "stereotype," take it as a warning. Take that typeface called Latino that has a lot of movement in it, triangles and zigzags like a serape blanket. From a design standpoint, Irasema Rivera said using a typeface like that is the laziest thing you can do.

Well, you also could be lazy with Mambo, Khaki or Carumba. They're all stereotypes with a festive look. Save festive looks for festive occasions. More important, Hispanics care about legibility, said Jose Matos. The typeface can be fancy as long as it's clear and can be read quickly, he said.

The Accent's on Gen Ñ

The little tilde (˜) is a powerful symbol. Not only does it turn *n* into a letter that's unique to Spanish, it also makes a statement, Newman-Carrasco said. Latinos own that letter; it's an identity thing, like upside-down question marks and exclamation points. You can "hispanicize" even English by adding the tilde or the upside-down marks.

Some clients have asked, "Can we get rid of all the accents?" Nope. That tilde isn't optional; it can change the meaning of a word. For example, Newman-Carrasco said, taking the tilde from "año" changes the meaning from "year" to "anus"! When you set all caps, though, it's customary to remove the other accents. That might be one of the reasons that Latinos—and designs targeted to them—haven't tended to use the all-caps style much.

But, she says, Hispanic graphics styles are changing, partly due to acculturating audiences and partly to creatives who want to push the envelope. So you may be seeing designers using all caps. (If readability is your goal, resist the urge. In any western language, the upper- and lowercase style is more readable.)

Layouts that Speak Two Languages

You can't leave the type topic without talking about bilingual layouts. *Latina* magazine, for example, typesets in both English and Spanish on every spread for its English-speaking audience. That's a "huge design challenge. Our pages can become text heavy. The Spanish can't be designed as an afterthought," Irasema Rivera said.

Spanish can contain up to 25% more words than English and take twice the space. That's mostly because Spanish tends to contain more flowery descriptions than English, says Angela Carrales of Grupo Cuarto Publicidad. When you're designing a direct-mail piece, you can't be sure that it will go only to a Spanish-speaking household, so it's advisable to make it bilingual.

A combination of the languages is popular for audiences who speak English but like it salted with Spanish. Conversely, there are also those who see a bit of English in their Spanish as acknowledging their embrace of a new culture.

Here's the standard reminder to leave translations in the hands of a pro. English to Spanish—and back again—is no exception, said Irma Maldonado. Pity the unnamed airline with an ad headline whose direct translation to Spanish came across as "Fly Naked." (Or salute it … no word on whether the error actually improved sales!)

You may make an even bigger mistake by trying to forcefeed English to those who want to hear and read Spanish. It's a myth that people who prefer Spanish will get over it when they become acculturated. Advertisers used to think they didn't need to advertise in Spanish because Hispanic immigrants all learn English eventually. But although many do,that doesn't mean they'll prefer it. Language preference isn't a function of bilinguality, income or education, Daniel Nance said. Or shopping habits, added Victoria Varela Hudson of Cartel. The preference for Spanish is so strong that a sign reading "We also speak English" hangs in a Miami department store.

Spoken Spanish has a power to connect or disconnect more quickly than written. The easiest way to regionalize a national campaign is to change the voice-over from broadcast Spanish to a voice with an accent, pronounciation and local idioms, said Andrés Sullivan of Mendoza Dillon.

casting a wide net: "real" models

"If I see an ad with Hispanic people, it's like the company is sending me a personalized invitation," said Christian Dobles. He sees an ad that's only translated as sending the message that they didn't value the audience enough to make a new ad. For a car ad, for example, he advised showing a Hispanic next to it or driving it, or a Hispanic mom loading groceries into it.

What color is a Latino? Every color of skin there is, yet clients and audiences may answer that question differently depending on their perspectives. Clients usually want very ethnic-looking models, said Ruth Olegnowicz of Siboney USA. "I'm completely Mexican, but I'm blond with blue eyes. I could never cast someone who looks like me in spots." *Latina* magazine's readers expect to see themselves, said Irasema Rivera, so the magazine casts different Latina looks, skewing toward brown skin.

"Americans are so good at separating things, even the food," said Aurora Flores of Aurora Communications. "You know those food plates that have little walls between the different types of food? America's obsessed with labeling and separating," she said. Referring to the Census terms 'non-Hispanic Black' and 'non-Hispanic White': "What *is* that? I'm fair-skinned, but I have cousins who are so black, they look blue. Yet we have more similarities than differences." (But that's true only within a common geographic area. There's always been a difference between people who live in the suburbs and in the city, she said. See *Urban Design and Advertising* in chapter two, page 106.)

Hispanics span every skin, eye and hair color, race and build, ranging "from Jesse Jackson to Jimmy Carter." It's hard to be inclusive when budgets force hiring models with a Pan-Hispanic look. It's more effective to favor the rainbow look when casting for still photography or TV spots. But if you have to, there is a middle-of-the-road Pan-Hispanic look: olive skin and darker hair.

It hasn't been easy finding that middle-of-the-road look in stock and photography books, said Jose Matos. He said for Hispanics (and Asians), it's hard to find stock images at all. Matos said he has been complaining to stock houses for years and enhancing stock photos of people who could be from Kentucky to make them look more obviously Hispanic. Yet for most Hispanic clients, light-skinned models aren't a problem. They often are only for Anglo clients, who are likely to say about light-skinned models: "They don't look too Hispanic."

"We need to show the world that we're not all the same," said Matos. "We have Gloria Estefan and Ricky Martin. Look who we found: an island boy who can mix with the white people!"

Body Image

Latina magazine models also tend to be rounded because Latinas have a more positive body image than general market, Rivera said. Like African-American women, Latinas are proud of their possibly voluptuous, bigger-than-supermodel bodies. "We do have Jennifer's ass" (well, at least what it used to be). In fact, if the magazine uses skinny models, or too many lighter-skinned ones, the editors get letters of complaint.

It's no accident that the logo for the Latina Empowerment Seminar—the woman holding up the sun—has a substantial bust and butt, said Rivera (see pg. 40).

Another model style that doesn't speak to Latinas is the haughty look in the general market. Latinos prefer real-looking people "who look like they could be my friend." There has to be warmth about them. Latinos want models that look both approachable and aspirational, but not necessarily perfect, said Rivera.

Clothing is sophisticated and similar to what Rivera's readers see in the general market because "we're not living in a Latino-isolated world." But, Rivera said, she favors Latino designers because her readers—in fact, all Latinos—take pride in the accomplishments of other Latinos. Even after a movie, she said, when you see in the credits that the best boy is named Alvarez, you say "yea!" You don't know which country, but it doesn't matter.

In general, models in advertising tend to dress less casually than their general-market counterparts would, said Traeger. You won't see T-shirts or shaggy hair. Again, it's that nonverbal aspirational message. And women tend to wear more makeup, bigger jewelry, sexier clothes and have more "done" hair.

There's even a difference in the way a Latina and a general-market woman puts on a pair of jeans. A Latina will wear them tighter to make a fashion statement and to look sexy, while a non-Latina is more likely to put them on for comfort, said Christian Dobles.

In fact, suggested Matos, almost anything you do with women and men has to have some sex appeal. That's confirmed by watching even female newscasters on Univision, who dress sexier than any you'll see in the general market.

turn the beat around

It may be hard to find a Pan-Hispanic visual icon, or the right Pan-Hispanic model, but you can always find a Pan-Hispanic beat, said Christian Dobles—and it's 6 x 8. Take rock and make it Latin American by bringing in a Mexican theme and it becomes universal. Once he took a spot's music to 6 x 8, the client started getting letters from Puerto Ricans, Mexicans and Peruvians all claiming it as theirs.

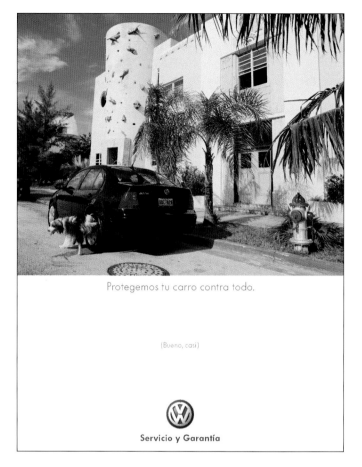

Protegemos tu carro contra todo.

(Bueno, casi)

Servicio y Garantía

But stop short of "edgy" for some audiences, said *Latina*'s Rivera, who pointed to a mistake the magazine made a few years ago. A fashion layout showed models with hair and makeup such as "you'd see in *Elle*: heroin chic," and too much for *Latina*'s audience. The magazine's job, she said, is to show the trends without exaggerating. The fashion has to look wearable, "unlike Paris runway shoes. None of us can wear them."

The real-people look—and sound—can be so effective that some art directors achieve it by casting real people instead of models. For example, the main objective of many immigrants from Mexico and Guatemala is to work to send money back to the family. For Western Union spots, Ed Flores went to those countries and found people who have family members in the States. He taped them talking about what their relatives' sacrifice means to them.

Celebrities

Hispanics tend to react more favorably to celebrities in ads than the general market does, says Angela Carrales. They find advertising more believable and word-of-mouth is very important to them. In fact, they rely on recognizable figures. (It means a lot to new immigrants to recognize anyone! That especially includes people they remember from home.) Popular TV celebrity spokespeople include Cristina Saralegui for AT&T (she has been called the Hispanic Oprah) and Don Francisco (whose show is broadcast in thirty-eight countries).

The Yankelovich Hispanic Monitor found that 66% of the Hispanic respondents prefer commercials that

have Hispanic spokespeople, slightly more than the 63% who prefer those with celebrities or athletes.

Crossover successes like Ricky Martin, Christina Aguilera, and Jennifer Lopez have been prime spokescatches for corporations wanting to target Hispanics, because Hispanics are proud of their acceptance by the general market. Martin has been a Pepsi spokesman.

Of course sports figures are popular, and celebrities certainly are an effective way to approach Hispanic markets, said Susan Leick of McDonalds. Boxer Oscar De La Hoya has worked well in the past. And Sammy Sosa, Hispanic baseball heavy-hitter, has joined fellow baseball star Mark McGwire in general-market ads. Mennen Speed Stick originally used Oscar De La Hoya, later Alex Rodriguez. Sports figures are considered aspirational to the audience, said Jose Matos.

f casting becomes too tricky, you want to avoid Hispanic cultural cues that clients may not get, or if a universal campaign better fits the clients' needs, you'll be glad to know there's an alternative. It's possible to design effective messages to Hispanics using Spanish language and universal images.

Headaches happen to people from everywhere, so Luis Miguel Messianu "cast" a honey bear, a teddy bear, a voodoo doll and a pin-the-tail-on-the donkey to show objects under stress (next page). Another print ad, for a automaker's service plan, has a real dog lifting his leg on a new car (an image any car owner can relate to).

Other Graphic Elements

More design touches can add up—along with relevant insights—to a Hispanic look (with all the usual disclaimers applying). For example:

To Luis Vasquez-Ajmac of Maya Advertising & Communications, "nothing seems to create emotional binds with the Hispanic audience like things made by hand." For the cover of a brochure of a healthcare company, he used a mural-style painting of family members in a park under a big apple tree. In the background are landmarks of Washington, D.C., the company's home base. Above it all, in the blue, blue sky, a Mayan-type sun shines. For Mayans, the sun represented life energy, Vasquez-Ajmac said.

55

Para esos dolores de cabeza

Ouch! A refreshing change from the typical image of a close-up of a person reacting to a headache, these amusing nonhuman symbols demonstrate the concept playfully and clearly.

AGENCY del Rivero Messianu Advertising DDB

EXECUTIVE CREATIVE DIRECTOR Luis Miguel Messianu

CREATIVE DIRECTOR Enrique Faillace

ART DIRECTORS Enrique Faillace, Felipe Verswyvel

COPYWRITERS Samuel Albis, Michelle Eggenberger

PHOTOGRAPHER Kiko Ricote

CLIENT Adult Tylenol - Extra Strength

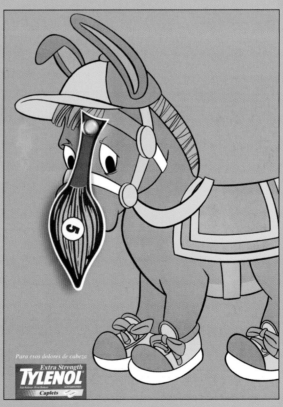

Lo tratamos como a alguien de la familia

We Treat You As One of the Family!

CHARTERED
HEALTH·PLAN

Hernandez used a journalistic type of photography to show what the Mexican-American community looks like. She likes photos because they look realistic, yet acknowledges that since Photoshop's features became well-known, the audience may trust them less than they did before. She's found that old-looking photos, those in black-and-white or sepia, tend to look more real. Here are still other elements that "speak" Hispanic:

LIGHTING » Meeting about whether some ads developed for California Mexicans could work for New York Puerto Ricans, Anglos in the group said no, said Ruth Olegnowicz of Siboney USA. They said they thought the lighting was "too Mexican." By that, they meant it was high contrasty and harsh. The coloring is warm, but what's dark is very dark, lights are very light.

SHAPES » In liquor category products, most often bought by men, Korzenny's research found that strong masculine, even almost phallic, shapes are more accepted than feminine ones (like perfume bottles). On these products, too, royalty symbols and coats of arms are well received, as are strong colors, like reds and greens.

The images of family, nature and health in a city setting (under the Mayan-style sun) come across in a mural-style painting for a healthcare company's brochure.

ILLUSTRATOR Karla Rodas (Karlisima)

AGENCY Maya Advertising & Communications, Inc.

SIZES » In any category, Hispanics prefer big containers, which suggest there's enough for everyone. This goes along with bigger families, lots of friends, love of parties.

UNIVERSAL VISUAL ART BEATS WORDS » Jorge Calvachi of Kraft said, "We found out we need to show the final product in recipes. Although that truism also applies to the general market, it's more important for Hispanic Americans (and African Americans). For a new recipe, the photo serves the need to educate these consumers about the outcome. In fact, Hispanic Americans prefer pictures that illustrate every step of the recipe."

As a corollary to that guideline, also use realistic photos of the product on the package. For example, pictures of dancing macaroni that could work for the general market might trigger a negative reaction among Hispanic Americans (as well as Asian Americans). Hispanic Americans in particular need packaging and ads to educate them. In their native countries, Hispanics had access to far fewer products and product categories, so it takes product photos to encourage trial.

A dramatic, high-contrast look characterizes
the art on this website.

AGENCY/CLIENT Cartel Creativo, Inc.
CREATIVE DIRECTOR Jesus Ramirez

"We know that Latinos are more visual than Anglos and that we don't want to read as much," said Aldo Quevedo. For those who can't read English or Spanish, a lot of packaging shows pictures of the contents. Doritos, for example, shows the cheese on the package. It's a "don't tell me, show me" culture.

Good, realistic visuals also are important because "Hispanics want to feel the package and pick it up, smell it," said Calvachi. It's part of their culture. They want to make a connection even if they don't want to buy the product, unlike the general market that wouldn't pick it up if not interested.

But that love of connection doesn't mean that Hispanics are swayed by expensive packaging. An elegant package may be appealing, but they won't buy it because there's a negative feeling about throwing out a nice package. They may keep a nice tin for future use if the tin's versatility is explicitly brought to their attention, but it's more likely that they'll wonder "what are you selling, a product or the package?" In fact, most immigrants to the U.S., who are "amazed at how wasteful we are," will have a similar reaction.

And, don't show the product alone when you can show a person holding it or otherwise interacting with the product.

holidays and their visual icons

CHRISTMAS, EASTER & OTHER CHRISTIAN HOLIDAYS » These are meaningful to Hispanics. And poinsettias, the Christmas flowers that originated in Mexico, have an important symbolic meaning to Mexicans. There's a folk tale about these flowers that grow wild in parts of Mexico and that have been used as medicine for digestive purposes by Olmecs (pre-Columbians) and Mayans. The story that David Orona's grandmother told him is similar to the story of the Little Drummer Boy for the general market. Mexicans traditionally take gifts to the Christ child on an altar at the church at Christmas. The gifts are donated to the poor.

As the tale goes, a little girl was too poor to buy a gift so she brought wildflowers she had picked. Everyone laughed at her…except, apparently, the recipient. The legend goes that Christ was so moved by her gift that He performed a miracle, turning the flowers into the red poinsettias.

As decorations, perhaps for the Christmas tree or elsewhere in the house, shapes are cut out of tin foil with scissors and painted, hammered and nailed. Paper flowers are also used. Folclorico art came about as a result of people's desire to create beauty from found objects: "When you don't have much, you use what you have."

Holiday themes are so important when you're away from home, said Ruth Olegnowicz. And customs differ among cultures even for shared holidays. After coming to the U.S. from Mexico, "I hadn't cried until I went to a church and was surprised to hear 'Las Manitas' ('Happy Birthday') sung in Spanish to the Virgen de la Guadalupe. You feel so close but so far away."

DÍA DE LOS MUERTOS (DAY OF THE DEAD) » Coincidentally occurring right around Halloween, the Aztec-created holiday is celebrated as the day when the dead return to earth. It has inspired a lot of folk art and visual icons, so many of which are included in the observances.

For most situations, the general market won't welcome a bunch of skeletons wagged before them. But the Hispanics view the imagery with humor and without dire associations.

According to Latino.com's former website, altars may contain:

- » marigolds; traditional flower of this holiday is used along with funeral flowers on altars and sometimes to make a path for the dead to find their own altar
- » favorite food and drink of deceased
- » toys and candy for deceased children
- » sugar skulls whose foreheads might be inscribed in icing with the name of the dead person
- » saints and other religious icons cherished by deceased during life
- » papel picado: intricate paper cutouts from brightly colored tissue paper
- » candles: used to decorate and light the way for returning spirits
- » a photo of deceased
- » pan de muerto: round bread loaf decorated with skulls

QUINCEANÉRA » A coming-of-age party for fifteen-year-old Mexican, Puerto-Rican and Cuban girls. There are some variations according to the country, but for all, it's like a mini-wedding. The girl and her attendants wear white or pink dresses, the event is celebrated in a church (or not, depending on the family's country of origin and the religion), and followed by a big party.

Easter, Christmas and other Christian holidays.

Jan. 5: Three Kings Day

March (2nd Sunday): Calle Ocho (named for 8th Street in Miami, the center of the festival); primarily celebrated by Cubans

May 5: Cinco de Mayo commemorates a Mexican victory

May 20: Cuban Independence Day; independence from Spain

June (2nd Sunday): New York Puerto Rican Day

June 24: Feast of San Juan Bautista (St. John the Baptist) for Puerto Ricans and Nuyoricans

October (end of the month, near Halloween): Día de los Muertos (Day of the Dead)

Quinceanéra: coming of age party for 15-year-old Mexican, Puerto-Rican and Cuban girls

THREE KINGS DAY » On the night of January 5, kids leave out shoes. The Three Kings pass through and leave a small gift in them. "They always left me a little gold coin," said Diego Cantú.

CINCO DE MAYO (MAY 5) » A symbol of Mexican bravery, it commemorates a victory by a Mexican army that was half the size of its French enemy. Resourceful General Zaragoza divided and conquered his foe by releasing a herd of angry cattle. U.S. corporations such as AT&T have built the celebration in the U.S. by sponsoring festivals and more. Although it's a celebration in the U.S., it's not so big in Mexico, said Ruth Olegnowicz.

CUBAN INDEPENDENCE DAY ON MAY 20 » This day commemorates independence from Spain. It's not a major celebration because as long as Castro's in power, many Cubans think independence is still far off. The true test of the depth of the celebration may be its centennial in 2002, suggests *Multicultural Manners* by Norine Dresser.

Cinco de Mayo means even less to Cubans because it's Mexican. And Calle Ocho, a pre-Lenten festival named for Miami's Eighth Street in an area known as Little Havana, means nothing to Mexicans. But, Olegnowicz said, "We Latins tend to group together, even if it's another subgroup's holiday. It's a brotherhood." For example, *Latina* did a Cinco de Mayo party, featuring a bus tour of various bars in New York, where the predominant Hispanic culture is Puerto Rican, not Cuban.

NEW YORK PUERTO RICAN DAY » The second Sunday in June; and for Puerto Ricans and Nuyoricans, the Feast of San Juan Bautista (St. John the Baptist) occurs on June 24. Commonwealth Day is July 25, a day of celebration or not, depending on one's attitude toward it.

glossary

ACCULTURATION Retaining native culture while embracing a new one.

AMERICAN Not just for someone born in the U.S.; properly includes people from Latin America, even if they don't refer to themselves that way.

ANGLO Derived from Anglo-Saxon, but generally used by Hispanics to refer to non-Hispanics in the U.S.

ASSIMILATION Leaving behind native culture in embracing the new culture.

CHICANO California-born Hispanics.

GENERAL-MARKET The traditional advertising audience, largely made up of U.S. whites.

HISPANIC Those who prefer this term say it refers to the common language; others—especially many in Texas and on the West Coast—object to it because it was coined by the U.S. Census, and also that the epithet "spic" was derived from it.

IN-LANGUAGE-PREFERRED Audiences who want their ad messages delivered in their native languages. (Census tracks this … everyone's working with the same figures.)

LATINA Latino woman (but you knew that).

LATINO Considered more politically correct by some, especially those who live on the West Coast and are less than thirty, because it's a name they gave themselves. "Hispanic" proponents argue that "Latino" is not specific enough because it also includes Italians and Greeks (from Italy and Greece, not from Hispanic countries).

LOCALIZATION Taking a general-market ad and just translating it.

MERICANO A blanket term for Hispanics in the U.S.

NUYORICAN Puerto Rican living in New York.

PAN-ASIAN, PAN-HISPANIC, ETC. Using models, or images, that can "pass" for an entire ethnic category to save the expense of different ones.

PUERTORICANO Puerto Rican living in the U.S.

SPANGLISH A mix of Spanish and English.

SPANISH Refers to the language or to people from Spain; few other Hispanics use the term to refer to themselves, even if their ancestors are from Spain.

TICO From Costa Rico; more often used by others to refer to them, than by them to refer to themselves.

african

americans

"what's black about it?" don't ask

If you think designing for African Americans is a church picnic compared with markets that speak a different language, you're right … or you're wrong, depending on whom you ask. Some creative and art directors say it's even harder, because the common language masks all manner of subtle and not-so-subtle distinctions. (If you spotted an image in this paragraph that some say has become a design cliché, you already know what I mean.)

This very lack of consensus reflects the first cultural truth to keep in mind when you design for African Americans: The market is even more diverse than the number of opinions about it, and that's what makes choosing appropriate visual images tough.

"You've got the Colin Powells and you've got the Puffys, the same as, among whites, you've got Eminem and you've got George Bush," said Juan Roberts of Don Coleman Advertising. "You can't shoot into the crowd and hit everyone. All black folks don't go to church or listen to Rhythm & Blues. Some of us listen to Wagner."

Vince Verdooren, Burrell Communications, added: "We always try to look for commonalities," being careful of how the audience is depicted. "Don't assume that all Caribbeans are dreadlocked Rastamen."

If you do make incorrect assumptions, not only will you fail to connect with audience members, you'll risk turning them off. When that happens, Verdooren said, the audience tends to be "very vocal about it, boycotting or calling in and complaining … No corporation wants Jesse Jackson complaining." The target wants to be recognized, not excluded or misinterpreted, just as older people of any ethnicity don't want to be portrayed as doddering fools. At other times, he said, the audience gets "paranoid … why are they targeting me?"

What's more, Munier Sharrieff also of Burrell observed, "I think the big misconception from clients is that there's a great divide" among the races, which puts a lot of emphasis on clichés like church picnics and family reunions (images that twenty years ago were ground-breaking, his colleague added.)

But most would agree that the African-American market is tougher than the general market for which you just have to be as graphically dramatic as possible, said David Wiseltier of The Chisholm-Mingo Group. African Americans have different sensitivities, and they've been stereotyped. For example, they've been portrayed as having no sense of family or respect for raising a family. So one way to appeal to African-American men and especially women—the family gatekeepers—is to show black men in responsible roles.

Ted Pettus, also of Chisholm-Mingo, tells of an ad he did last year that has a man dancing in the moonlight with the baby he woke up to feed. Lawrence Aarons, another colleague, points to an auto commercial with another positive role model: A father helps his son build a skateboard. (The skateboard wasn't an arbitrary choice. Dad shows how wheels set wider apart—a feature of the car—will give more stability.)

Blacks and African Americans represent **12.3%** of the U.S. population

new york
2,129,762

detroit
775,772

philadelphia
655,824

baltimore
418,951

los angeles
415,195

chicago
1,065,009

memphis
399,208

washington d.c.
343,312

dallas
307,957

new orleans
325,947

atlanta
255,689

houston
494,496

Biggest Black and African-American populations in the U.S.

The dad-and-son image also turns up in Happy Meal ads, which show a parent and child spending quality time together, and there's a grandfather and grandson enjoying each other's company in a Verizon ad.

But messages targeted to African Americans don't necessarily have to be more than darker-skinned versions of general-market ads. As in any design, what you do must depend on the case at hand.

In almost any case, though, avoid overdoing the black cues: When you design, remember that African Americans are exposed to the same visual messages as the general market; they watch the same networks, not just BET and UPN; and they read the same magazines, not just the ones that target them. In fact, even designers of some of the major African-American-targeted magazines say their goal is simply good magazine design.

Also, membership in the ethnicity you're designing for is no guarantee of effectiveness. As Ronald Franklin of Don Coleman Advertising likes to remind his own staff: "We are not typically the audience, by virtue of education, economic status and occupation." Instead of depending on assumptions drawn from one's own experience, he advises insights based on "affectionate observations" of the audiences' attitudes and values.

Even if the employees do come from the target audience, a lot of them need to be reminded that "this isn't about you personally talking to the audience … it's Ronald McDonald," or whatever the corporation, Verdooren said.

Nor are the *clients* the audience, a fact that's tough for many of them to get. Designs often fall victim to the "What's black about it?" factor. (Funny how clients never seem to ask what's *white* about a general market ad, commented one creative director.) That frequently asked question reflects what designers often have to go through to get ideas accepted.

As one agency art director said, "We present ideas and know it's right for the clients," but if the clients don't get the subtleties, they'll reject it. "They want to see something pushed," said another. So what gets approved may be what overdoes "what's black about it," which turns off the audience.

Ten to fifteen years ago, "what's black about it" meant kente or mudcloth designs. And when few advertisers were talking to African Americans, it wasn't necessary to look further. But for today's sophisticated audiences, those images are a red flag that the advertiser didn't work hard enough to understand them. In fact, in many internal creative meetings, it's a common inside joke to answer that question with, "We'll just throw some kente in it." (See *More Than Just Kente*, page 94.)

"Visuals need to resonate with the consumer. It's not one little element that's likely to make the difference. It all works together," Franklin said.

valued values,
cultural cue clues

here *are* some commonalities that designers have used successfully in ads where they're appropriate. Attitudes and icons that black communities have found relevant in the right situations include:

» close family ties (for mothers, the relevant cues are family and self-empowerment)

» responsible father

» independent women and girls

» woman as the boss at work

» success and status

» symbols of success and status, such as designer labels, expensive cars and jewelry ("driving cool cars, wearing Armani")

» pride

» dignity

» respect

» the avoidance of parodies

» church (including the church picnic and gospel choir, depending on whom you talk to)

» sports

» music

» education

» graduation

» supporting other community members

» joy, transcending hard times

» keepin' it real

» working out

» night clubs

» skepticism

» vocal activism against stereotypes

» African-American kids achieving things

Faces in the right places

Still, there are cultural elements and values that unite many African Americans and distinguish them from the general market. In advertising, "there has to come a point where someone says, 'I know you're African American and I need to make you feel comfortable,'" says Michel Gibbs, Chelsea Harlem Interactive, Inc. "There's an invisible veil advertisers have to pierce."

Gibbs agreed with other designers that, after the concept, the ability to pierce the veil depends a lot on casting. Visually, he said, "what speaks most to African-American communities is when we see our own faces." (More about casting in a bit.) To Lorraine McNeil Popper of UniWorld Group, most important is the concept of "keepin' it real, recognizing what's staged and what's not." She also agreed that "it's wonderful when we see ourselves."

Cultural cues for teens include both independence and connection. They want to connect with other teens and feel like part of something. At the same time, they're determined to make it as an individual.

For the *Honey* magazine cover photo of hip-hop artist Eve (Feb. 2001), photo editor Deborah Boardley said, "I just wanted her to look hot ... the new hip-hop icon." It's what girls want to look like when they go out to the club—fun, hot, independent. This is the last cover before a redesign shown on page 81.

MAGAZINE *Honey*
PUBLISHER Vanguarde Media
ART DIRECTOR Lamar Clark
PHOTO EDITOR Deborah Boardley
FASHION EDITOR Sydne Bolden
PHOTOGRAPHER Warwick Saint/CXA
MAKE-UP Leann Silva
HAIR Suzette Boozer
STYLIST Kithe Brewster/CXA

CRAZY, SEXY, SINGLE ISSUE

Honey

The Evolution of
eve

69
WAYS TO SIZZLE
- RED-HOT MAKEUP
- CLOTHES HE CAN'T RESIST
- HEAD-TURNING HAIR

ONE GIRL, THREE GUYS, SIX HOURS…
DETAILS OF A DATING MARATHON

THE ABORTION PILL:
ONE WOMAN'S STORY

REAL MEN
TELL US WHAT
THEY LOVE ABOUT
OUR LOOKS

$2.95US $3.95CAN

0 09281 02043 1

02>

10-CITY GET-YOUR-GROOVE-ON GUIDE

That means more than casting black people. African Americans see themselves when they're portrayed with a sensitivity of the audience and its history. If you look at the history of African Americans, Gibbs said, you see all kinds of negative imagery.

Awareness of that fact should make it easy for you to avoid an image such as the one Gibbs found in an ad for a colonial-theme resort. In the forefront is a black woman dressed up in colonial-period clothing and holding a plate of food. "The first thing I thought is she's a slave. My wife saw it and had the same reaction. In your designs," Gibbs advises, "there needs to be an acknowledgment that African Americans are human beings with families and accomplishments."

And more and more advertisers are getting that message. An evolution's going on in ethnic marketing, said Sara Lomax-Reese (publisher) of *HealthQuest: Total Wellness for Body, Mind & Spirit*, a supplemental magazine for African Americans. She gives the example of a Verizon billboard that shows an African-American man and his daughter. "While I was growing up in the seventies and eighties, you didn't see middle-class African Americans portrayed in relationships, with children or as part of the community … as human."

Lomax-Reese also sees refreshing humanness in a particular ad for a cereal. In the ad, a smiling mother in the foreground is eating her breakfast, while her smiling family stand in the background. "What strikes me about that is how ordinary she looks … average, not sexy." What's more, the image conveys "a recognition that historically we've been taking care of everyone else through history and the importance of carving out time to take care of ourselves. That's a good subliminal message."

In his designs, Gibbs also aims at positive messages that connect to the heart of his audiences. He's used relevant images that show school graduations, the close connection between a male and his grandmother, and successful African Americans.

That type of imagery works because it connects to a value that's important to this ethnic group. "If you were to distill what's different about the African-American audience, it's a certain amount of pride," said Clive Williamson of The Chisholm-Mingo Group Inc. So pride is reflected in his choice of images. He said he aims for visuals that "elevate a person."

Williamson referred to a piece designed for his agency as a tribute to one of its travel clients. The image is an African-American woman in a Caribbean setting. "You can see pride in the regal way she carries herself."

You also can also see pride in the visuals of a skin-care-products campaign. Each woman was photographed naked and prideful against white no-seam paper. The ads have a sculptural quality. The pride also comes through in the choice of realistic-looking, natural-hair models, which gave the audience—African-American women—a chance to see themselves. Each model, one for each of three ads in the campaign, reflected a different skin tone, ranging from medium to dark.

Fire, an original African-American magazine, was published in the 1920s. It was the first publication in America to show an Afro-aesthetic in print, said Janine Thomas. The art had a lot of triangles, and other geometric angles. Look closely: You see the seated lion, a symbol of strength and royalty. But what's over his rump? A shackle? And what's that on the left edge? It's the edge of a leftward-looking facial profile and the "shackle" on the right side becomes an ear with an earring.

From the collection of the family of Janine Thomas

dreams

Hennessy. Share accordingly.

Hennessy
Privilège
V.S.O.P
COGNAC

72

Pride—and success—translate into aspirational images like the one in a McDonald's spot called "Art Store." In it, the person who works at the art gallery sets her lunch on the table and walks away. The art on the walls and pedestals becomes animated and starts to smell her fries. In addition to casting an African American, the agency recognized the value of placing her in a cool job at an art gallery that specializes in African-American art, said Susan Leick of McDonald's.

Another aspirational image: For a BellSouth ad thanking the NAACP for an award, Isaac Dodoo (then at Dayn-Mark Advertising) used a stock photo of a black man running up bleachers to illustrate "climbing." "The copy reflects our aspirations. We don't always show a black person smiling," he said.

Kevin Hanson of Chisholm-Mingo did an ad for ROTC that, he said, speaks to the fact that African Americans tend to be less confident than the general market of their ability to get an education and to think that if they do, they can succeed. The ad ran in both *Black Enterprise* and *Source*, magazines that are targeted to two vastly dif-

ferent demographics, yet the graphic served them both. To drive home the slogan "Scratch the surface of a leader and you're likely to find ROTC," a photo of an executive is "scratched away" on one side to show the same man in a "hoodie," a hooded sweatshirt and a dogtag.

Would the executive in a tie turn off *Source* readers who'd likely relate more to the "before" than the "after"? No, said Hanson, a tie is an icon of business and a symbol that you take yourself seriously, and, he said, even kids understand that. "When you've been taught [as an African American] that you're stupid, it's prideful to see a successful person" in the trappings of success, including a tie.

Ted Pettus, also of Chisholm-Mingo Group, brings up a related and equally important value to pride and aspiration. His priority when he designs is "being respectful. Eventually my mother is going to see the ads." Ed Miller of Verizon adds that respect for older generations as a value that translates well into strong visual images.

73

More rich tones and elegant clothes with a glimpse of what appears to be a diamond necklace convey the look of success. This couple's expressions convey intimacy, connection and confidence.

AGENCY Kirshenbaum & Bond
CLIENT Hennessy, Schieffelin & Somerset Co., New York, NY

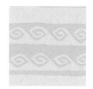

Show me

Wiseltier also points to a belief in the African-American community of "show me, don't tell me or promise what you're going to do for me," the result of a history of abuse and unkept promises by white people. That belief is reflected in two ways in effective messages to the community, and one of them is design-related. Visuals must prove claims, like a weightlifter hefting a dumbbell above his head, with hands wide apart for stability to show that a car with wide apart wheels also is more stable. The weightlifter image also speaks to another relevant image: working out. In general, African Americans are more into style than the general market is. That translates to striving to be fit, to dress well and to look good.

In fact, because many African Americans feel the need to look as good and as "on" as possible, a campaign for Tide detergent focuses on style, said Vincent Verdooren of Burrell. Buy the product, the ads suggest, to make sure your clothes look good so you look good, with a shift away from getting out the stain. So the ads are designed to look like fashion spreads, a far cry from the mom-with-dirty-kids concept so prevalent in general-market detergent ads.

(The other manifestation of that show-me, prove-it attitude is the vital need for advertisers to show their commitment by spending money in the community, including sponsorships. No matter how well-designed and well-conceived your visuals, many African Americans won't be swayed without that important step.)

Those attitudes also mean that celebrity endorsements can be dangerous, said Luz de Armas, formerly of Conill, which is now Saatchi Conill. Not only can celebrities overshadow the product, they can be considered unreal. Yet, she said, they work for beer and soda: "When we tried to do Tide with a famous person, focus groups scoffed, saying: 'Yeah right, like she does laundry!' I always thought it would be great to use the maids of famous people as spokespersons!" (While you're at it, why not choose a white maid who works for a black celebrity?)

Munier Sharrieff of Burrell also has learned the hard way that the African-American audience is extremely skeptical and literal. It's less likely than the general market to suspend belief while watching ads. For example, focus groups viewed a spot with Magic Johnson and Kareem

Abdul-Jabbar eating at McDonald's. The groups said that with all the money the stars make, there's no way they'd be eating there.

The audience is skeptical to the point of paranoia, Sharrieff said, and it's probably because of how the cultures coexist: Life is harder for African Americans than for Caucasians. Skepticism and distrust of the system also are why relatively fewer African Americans invest. "Many figure they had to work too hard to get it, so they're keeping it under the mattress. That to me should be the concentration on how you advertise, instead of blanket concepts that 'seem' black."

Lomax-Reese pointed out the roots of skepticism and distrust that are directed at healthcare systems and they are attitudes to be sensitive to in your designs and casting. It's hard to forget the kind of "blatant racism shown in Tuskegee, Alabama," (where, in the 1930s, a group of syphilitic men were told they were being treated but weren't, so doctors could observe the effects of the disease). Lomax-Reese also gave other examples such as "doctors [who] immediately amputated a limb instead of treating it." A systematic, different approach to treatment dating back to slavery created healthcare disparities that exist today, she said.

So, Lomax-Reese said, blacks feel disempowered by healthcare institutions. "There's no greater feeling of powerlessness than when you're sick." And when you're in a healthcare setting, "you're classless, out of context. You have no protection against cultural ineptness. There's a set of assumptions people come to you with and you're treated accordingly. I've felt it. That's why I'm doing the magazine: to get information and resources out to the people who need it."

Lomax-Reese runs AIDS updates in every issue. A lot of blacks think that the AIDS virus is an offshoot of germ warfare, a calculated plot to take out the black community. "But our message is 'who cares how we got it, we can do something about it.'"

Boiled down to a graphics message: Show black doctors and nurses in your healthcare designs (and make sure your company backs that message up with community support such as medical school scholarships).

Hit hot buttons but not too hard

Images include:

YOUTHFUL SUCCESS » in the form of obviously successful young black couples. Cues that ring true include messages that convey "I'm young and I have it." So portable status symbols still are important as props and products in ads: watches, cars, handbags, jewelry. Looking affluent is more important than in the general market: "A woman may have just ten dollars in her handbag, but it's a Fendi bag," said Pettus.

African Americans are trendsetters, said Lamar Clark of *Honey* magazine. What's hip can be found in the details. Even a woman dressed casually in sweat pants and sneakers will add some element of style, maybe a bandanna and some jewelry.

Still more proof that status counts: A McDonald's ad shows Kobe Bryant and his agent in the agent's fabulous offices. The agent's trying to negotiate for half, and you think he means half of Kobe's earnings but it turns out he means his sandwich. Sharrieff chose a spectacular office for the set because "the audience immediately equates lavish surroundings with power … It also makes Kobe look better if his agent can afford something like that."

And trendsetting extends beyond fashion. A car spot included midnight bowling, a "hot up-and-coming trend among African Americans," said Kevin Hanson of Chisholm Mingo. It's "kind of like a club without the risks."

ART » Art is a useful cue, Pettus said, especially if you're trying to reach people who are small in number but high in income and influence. "Not all of us are going into art galleries, but we appreciate art. Not all of us are going into jazz clubs, but we appreciate good jazz."

CHURCH » "The general market has the women who do lunch; we have the women who do church." If you use any images related to church, remember that African Americans dress up to go to church, especially in more Southern cities like Richmond, Atlanta and Washington.

"The church and the family are such core essentials to our culture," said Popper. Church and family images relate to joyfulness, she said. "Maya Angelou wrote, 'I rise, I rise, still I rise.' Seeing that reflected allows us to transcend problems."

Although church is a relevant image for black communities, however, some feel it should be used sparingly or not at all in ad designs. A rule in advertising is, "leave religion alone," said Hanson. (But he also said the biggest rule is that there are no rules. "I've seen ads with choirs that work. All depends on how you do it. Do what works.")

Yet enough advertisers have used gospel choirs that some art directors consider the image a cliché. McDonald's can use the image effectively because the advertiser is respected in the African-American community as a long-time sponsor of events that include a gospel competition.

But other art directors, like Janine Thomas of *HealthQuest* magazine, don't see choirs, church picnics, or a related cultural cue—the family reunion—as clichés. Although she said they're not all African Americans are about (and that's the objection of many who oppose the images), those elements are "something we're proud of."

Walter Allen of Anheuser-Busch agrees. He did a print and outdoor lifestyle campaign with the "What's Up" guys. He showed them in the same types of situations as anyone—relevant images, like the late-night club scene, picnic and family reunions, which are "huge in the African-American community," and beach scenes, which would work for any group.

Staying connected to family and friends is a universal for African-Americans, and research shows they do more phone calling than the general market does, said Verdooren. "We can tap into universals without having to show a rapper or a tap dancer," he said.

If you're going to have a rapper, let the image be relevant to the idea, Verdooren said. For example, about seven years ago, McDonald's did a burger just for adults. So they decided to show that kids wanted nothing to do with it. "I found rappers who were six years old, to do (something like) 'we've grown up, we're tough but we're still not big enough for …'" It was using rappers to make a point. "Spots that scream: 'Hey Blacks, look at us.' It's a turnoff. It's important to talk to them, not at them."

Thomas has her own triggers, citing images she's found offensive, including an ad for a premenstrual-syndrome medication. Although the headline "irritability" has the first five letters crossed out (leaving "ability"), and the black model is smiling, Thomas said she's never seen the ad in a general-market magazine with a white or Asian model. "It says to me we're the only ones who get this … oh, we need this medication? That's horrible to me."

Neither did Thomas appreciate a spot that showed a man watching a restaurant spot on TV. He was so overwhelmed by temptation, he overcame all obstacles to get to the food, while "Shaft-like" music played in the background. To her, that imagery played to a stereotype that black people can't control their appetites. And recruitment ads that show a black person as restaurant manager? "It's like saying that's all we can aspire to. Why not show a franchise owner? This [type of imagery] limits the race."

That's why a series of print ads for a financial services company includes close-ups of successful- and confident-looking faces. The people are outside of a work context. "It would be limiting ourselves [and the audience] to show [them] in a specific role," said Aubrey Hurse of Salomon Smith Barney, Inc.

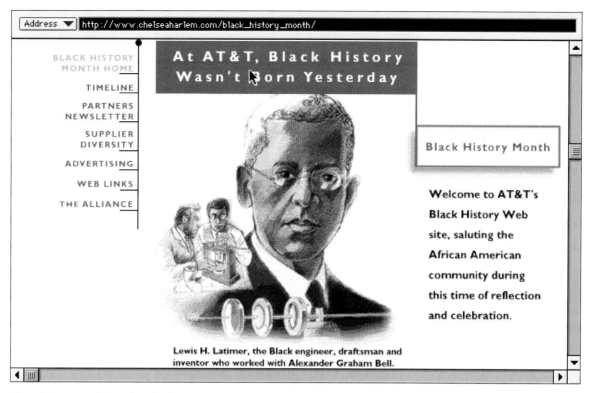

Address ▼ http://www.chelseaharlem.com/black_history_month/

BLACK HISTORY
MONTH HOME

TIMELINE

PARTNERS
NEWSLETTER

SUPPLIER
DIVERSITY

ADVERTISING

WEB LINKS

THE ALLIANCE

At AT&T, Black History Wasn't Born Yesterday

Black History Month

Welcome to AT&T's Black History Web site, saluting the African American community during this time of reflection and celebration.

Lewis H. Latimer, the Black engineer, draftsman and inventor who worked with Alexander Graham Bell.

Martin Luther King is far from the only role model who can represent Black History Month, as this website that features engineer/inventor Lewis H. Latimer shows.

AGENCY Chelsea Harlem Interactive, Inc.
CLIENT AT&T

Roberts adds to the list of cultural drivers that have become stereotypes. "All black agencies know what they are: basketball, oversized black women, angry black men, big shiny cars, sneakers." His list also contains church and gospel.

But most agree that dignity is another cultural cue you'll be smart to pay attention to in your visuals: African-American audiences, in general, won't appreciate seeing themselves portrayed by African-American models acting like fools (where a general-market audience could accept a general-market model doing so), Verdooren said.

For example, in the general-market version of still another spot that connects a car with stability, a guy wheels a kid around in a shopping cart, zooming down an aisle, going on one wheel, Wiseltier said. But that wouldn't work for African Americans who likely would have this reaction: "I'm not going to act the fool in a public place … I'd have 'the man' down on me in two seconds."

That reaction is based on reality. Wiseltier mentioned once watching a colleague spend a whole day on the phone to reserve a different rental car in each of the states he planned to travel. Although most white men wouldn't think twice about using the same rental car for the whole trip, his colleague had to worry about drawing unwanted attention from police as a black man in an out-of-state car.

how black is black?
casting tips

everyday images may be more welcome in casting. How do African Americans want to see themselves represented in designs? Try to answer that question with one stroke and you're doomed to stereotyping. As for anyone of any ethnicity, preferences are in the eye of the beholder, and for any group, one physical type doesn't fit all.

"We come in so many different flavors," said Dina Jackson of Burrell Communications. As we've seen in other ethnicities, many creatives, when they need more than one model per design or campaign, cast people with a variety of skin tones and feature types.

And as we've seen before, different products and purposes call for different treatments. For example, take a soft drink: You need visual cues that are arresting, provocative and unpredictable, said Steve Horn of Coca-Cola Enterprises. For a Coke spot, he said he wouldn't cast a typical-looking model that you'd find in *Essence* magazine. "The trick is to get as close to the core of your audience as you can without going overboard."

Popper looks for real-looking people, like those you see riding on the subway. Other situations call for the "flattering mirror" approach. When Pettus created ads for women's hair products, he said he used real-looking women who would attract another woman as a friend. "On a scale of 1 to 10, I'd choose an 8 or an 8½ … [a model with] an attainable look. She shouldn't look so farfetched that I know she doesn't do her own hair."

In Lance Pettiford's casting, he said, he skews toward the most "non-mainstream." Black women "come in all shapes and sizes and they're beautiful." He said he'll often pick the darkest. Janine Thomas feels the same. For the cover of a magazine she worked at, she fought to get Tamika Frasier, who has "her own hair, brown skin, dark eyes," but Thomas lost that battle. Even among some of those who cast black, she said, there can be a sense that "in-between or light-complected is considered more palatable. Whose standard of beauty do we follow?"

One way to get real-looking people in your designs is to *cast* real people, as Alfonso Covarrubias of Muse Cordero Chen did for an ad for the Office of National Drug Control Policy. Both the African-American and multicultural versions of "Soap Opera" used real teens— and their words—from the community center where the agency did the campaign's research.

Skin tone

Some creatives do skew toward darker skin and other specific looks, depending on their audience and purpose. Although "we come in all shades, the African-American message comes through stronger when you can show a darker person," said Williamson.

Thomas offered some history to that typical audience reaction. Skin-tone prejudice dates back to slavery when lighter-skinned slaves worked in the houses while the darker ones were sent to the fields. The prejudice even has turned up within the African-American community, she said. She cites the "brown-paper bag" test that early sororities inflicted upon pledges. Only those with skin lighter than the bag could apply. Some "light is better" prejudices still persist. But the emerging popularity of more dark-skinned models is working to eliminate those prejudices, and the pendulum may have shifted toward the darker range.

Sharrieff said that his client has received complaints from the audience about models—especially kids and women—who are too light-skinned or who have hair that's too straight. "There are a whole lot of mines you have to tiptoe over."

What's more, said Pettus, black skin reflects light beautifully. And natural skin—of any shade—also plays well with light. When the situation permits it, Williamson prefers subtle makeup on the models in his designs. "There's a certain glow and radiance that's dulled by makeup." Pettus also prefers a natural look "so if it's a close-up, you're seeing skin and not makeup."

For other creatives, like Walter Allen of Anheuser-Busch who created the "What's Up" campaign, "very rarely is skin tone an issue." Instead he has just two priorities: attractiveness and appropriateness for the spot.

Other traits: Hair, Clothing, Jewelry

For some, hair contains plenty of potential for sending messages. Williamson has "a personal battle to wage, a mission. I think black women go through such trouble with their hair. I love to see women who wear hair naturally—short or long," and he casts accordingly (again unless the situation calls for something else. For example,

capture the skin's true beauty

A technical tip from Sharrieff: Make sure you choose a photographer who has experience with dark skin. Someone without it can make the skin look washed out. And although he likes to show a spectrum of skin colors, he tries to stay away from "stark polar opposites in the same shot. It can be hard to do justice to both ends of the range."

SPRING FASHION SPECIAL | FREE BEAUTY GOODIES

HONEY

MARCH 2001

A NEW ANANDA

MAKEUP MADNESS!
GIVE GREAT FACE — TRADE SECRETS FROM TOP BEAUTY PROS

STYLE HEATS UP
127
NEW LOOKS YOU'LL LOVE

IS YOUR MAN CHEATING ON YOU? FOOLPROOF WAYS TO FIND OUT

$2.95US $3.95CAN

Hip and confident female stars wearing trendsetting and aspirational fashions shine from the cover of *Honey* magazine. The looks appeal to both genders (according to informal tests by the author). The Ananda cover represents the first issue of a redesign. The redesign lost the descender, which tended to limit the layout possibilities. The new logo mixes upper- and lowercase, all about the same height.

MAGAZINE *Honey*

PUBLISHER Vanguarde Media

ART DIRECTOR Lamar Clark

PHOTO EDITOR Deborah Boardley

FASHION EDITOR Sydne Bolden

PHOTOGRAPHER Garth Aikens

MAKE-UP Juanita Diaz/Deborah Martin Agency

HAIR Chioma

JEWELRY (headpiece, earrings, bracelet, rings) Craft Caravan, (choker) Ben Amun, (necklace) Claudia Rapisarda

STYLISTS Lisa Sellers, Rodney E. Hall

81

natural wouldn't work for a hair-relaxing product). And of course you have to keep an eye on what's in and out in hairstyle.

At the time of this writing, what's still in style for men is baldness, dreadlocks and the close-cropped executive look. For one particular family-oriented account, the mandate is to stay as far away from gang relations as possible, Sharrieff said. That means no baseball caps (bills turned to the left or to the right suggest gang affiliation) and no sagging jeans. But "dreads are fine."

African Americans spend more money on clothes than the general market does. So Williamson tends toward "a conspicuously affluent look" if it's appropriate to the message.

When it comes to jewelry, there's a tendency for more of it in the African-American market than in the general market. That goes back to a common

African-American need to prove success, and young men (who may have more to prove and more negative stereotypes to live down) are likely to wear more jewelry than women.

But women also know how to show their success with jewelry. *Honey* magazine put a stunning photo of actor Ananda dressed in only jewelry on the cover of its March 2001 issue. The jewelry, an obvious status symbol, calls to mind India and the Middle East and the way women there have adorned themselves. Indian styles also have been popularized by Madonna and Gwen Stefani.

Ananda's also dressed with confidence, the first thing photo editor Deborah Boardley looks for when she chooses shots for the book. She said it's important that girls see women of color in confident poses. They can look stoic or happy. Eye contact with the camera is important.

The cover of *Black Enterprise* magazine's Wealth Building Kit uses rich-looking colors—muted gold and black—and subtle currency images in the gold field to give an aspirational feeling. Recipients of the kit get a business-card-size reminder to invest, in the same colors and patterns as the kit itself.

ART DIRECTOR Terence Saulsby

MAGAZINE *Black Enterprise*

PUBLISHER Earl G. Graves Publishing Co., Inc.

© 2001 Reprinted with permission, *Black Enterprise* Magazine, New York, NY

Keep It Real

The important thing is to make the model look natural, like individuals who are part of the norm. That's a subtle thing worth keeping in mind so the design comes off as authentic. When Allen was casting the "What's Up" campaign, "people were saying 'can Paul have his hair that way?' 'He wears two earrings!' Yeah, that's him. I'm not trying to make him look like anyone except himself."

That concept may sound simple but it's not easy to achieve, Allen said. "Some go overboard. It can't look like you're trying too hard to be black." For that campaign, "we picked guys who … grew up together so they had a bond. And they're nuts to be around, great chemistry on camera. They're young, hip and good-looking." In short, they're real, and "keeping it real" is a major deal for a big segment of the African-American community.

The audience also drives selection of people shown in magazines: "we're looking to be representative of the range of readers," said Lomax-Reese, whose magazine displays human variety in hue, size and age, even gender. "Size is an important factor because it's a health magazine, so we represent where we are and where we want to go. The average woman is a size fourteen and African-American women can be obese. In our community, we also have people who are underweight. We want to show the balance." The magazine also includes images of men, which addresses the largely female audience's concern and care for the family.

In the case of *Black Enterprise*, a business magazine, the audience's desire to see people to whom they can relate goes beyond ethnicity, said Terence Saulsby of the magazine. The audience wants to see black people of a

certain level of success. Specifically, they respond to aspirational images, which means people who are one or two professional levels above them. They want to see small-business owners or corporate execs at the management level or just above.

Even more specifically, those attributes translate to people "who are doing well but aren't at the exalted level of a Ken Chenault at American Express, because the average reader may see that as unattainable," said Saulsby. (That doesn't mean the magazine doesn't profile Ken Chenault. The third time was just after he was tapped to be CEO in January 2001. "We had to do it because of who we are, and the readers said 'that's fine but it doesn't relate to me.'")

Beyond the choice of subjects, readers' tastes also carry a lot of clout in art direction. It's a bitter gulp of reality for all designers to learn that the audience doesn't appreciate our best designs, but that's often the case. For the readers of this magazine, like many others, content takes precedence over the quality of the design that conveys it.

In "what I think was the one of the worst covers we've done, we had a forty-something couple standing by a dock with a yacht in the background. I hated the shot. It was poorly composed and the couple wasn't too

attractive, but I deferred to upper management." And, Saulsby readily admits, the poor photograph was one of the best sellers at the newsstand because it reflected the magazine's positioning ("rich" sells).

Other art directors suggest sensibilities relating to behavior represented by African Americans in designs: "Don't show us 'cooning,'" a slang word some African Americans give to dancing, singing or clowning in a stereotypical way, said one.

One agency watches out for the "bug-eyed factor," eyes that are exaggerated—opened so wide that you can see their whites all around. It's a negative image dating back to the Step 'n Fetchit and Amos 'n Andy stereotypes. "These become things that will turn off our target."

Stereotypes even in contemporary media reinforce sensitivities in how African Americans want—and don't want—to be portrayed. Imagery, not graphic design or type or the way things are on the page, is what communicates specifically to an African-American audience.

photo design & reality

because it's photos that so often convey imagery, they're worth a look here. Take stock photography—but you can't take too much. Far fewer African-American image choices exist than general-market ones, although there still are plenty more of those than Hispanic or Asian images. So if your budget depends on using stock, you might risk seeing the same images coming and going in other designers' work.

Probably not for long, though. The situation is changing as quickly as stock houses can get the shots, because they know of the need. Most already have begun to address it with collections that have the word "ethnic" or "diversity" or both in their titles.

If your budget demands stock and until you have enough choices to suit your every need, here's how to choose more thoughtfully among what's available. "For African-American designers who are experienced, there's almost a science to using stock images that go beyond basic African-American shots that you see everywhere," said Lomax-Reese. "The way we use existing stock images versus commissioned photos reflects our understanding of the audience."

You almost don't need the headline to get the message of standing out from the crowd. The smiling entrepreneur exudes success and joy of independence. The near-redundant headline adds some useful color, alternating apricot and tomato with white.

ART DIRECTOR Terence Saulsby
PHOTOGRAPHER J. Van Evers
MAGAZINE *Black Enterprise*
PUBLISHER Earl G. Graves Publishing Co., Inc.

© 2001 Reprinted with permission, *Black Enterprise* Magazine, New York, NY

The key is in going beyond the obvious to really communicating the message. Thomas elaborated, pointing to an article about winter sports as an example that was created by another designer. A family in winter clothes smiles at the viewer. It looks posed and pat, she said, as if the designer fulfilled the minimum basics of the art requirement—a black family dressed for winter—and plunked it down. It's too literal, an "image for image's sake," rather than an attempt to look more deeply into the article and extract a meaningful image. In this case, she said, the photo needed—at the very least—to show action.

If you can conceive and direct the photography, of course it's easier to go beyond the obvious to connect with the audience and the message. Turn to *Black Enterprise* and you can see Saulsby's deep understanding of the audience right from the cover. A key insight that drives design at the magazine is that the readers have some aspiration to be entrepreneurs, even though they don't necessarily act upon it.

That insight means that a cover that conveys the "rich" concept is less about the image than the words. "Get rich," "stay rich," "retire rich" all hit the bulls-eye.

BLACK ENTERPRISE

SIZZLING SECTOR FUNDS

YOUR ULTIMATE GUIDE TO FINANCIAL EMPOWERMENT

FEBRUARY 2001

How To Boost Your Income

Sell Your Stock For Profit

Call Your Own Shots

Design your career
Take control of your life
Retire when you want

www.blackenterprise.com

$3.50 US $3.95 CAN
UK £2.50 R19.95

0 09281 02137 7

02>

BREAKING FROM THE PACK
IT professional Torrance Mohammed
follows his own career path

85

And, said Saulsby, who writes most of the cover lines, "there's only one way to say 'rich.'" 'Wealthy' or other synonyms don't cut it. To reach this magazine's audience, it takes the right words combined with a photo that telegraphs the "rich" message.

Concepts that speak to the entrepreneur-wannabe nature of the readers work, too. The commissioned cover photo of the February 2001 issue telegraphs the "Call Your Own Shots" headline. It's not the smiling man holding a laptop that sends the entrepreneurial message, but how he's set apart from the pack (in this case the backs of a small army of derby-hatted men). His attire also sets him apart from the dark-suit uniforms: The exec wears a stylish high-button, café-au-lait suit with a champagne satin tie.

But despite the focus on words and information, those photos do count. Readers of this after-work business book say they need the photos to get into the information, and to give them a visual break. As a result, Saulsby gives them art on every page of editorial.

Saulsby asks his photographic subjects to look as energetic and open as possible. He chooses shots that are eyes forward and expressions that convey emotional energy, such as smiles or looks of surprise. But frowns or scowls don't work. Readers—and management—won't accept them because they work against the positive, aspirational message of the magazine.

More proof of how knowledge of the audience and subjects drive visual concepts. For conceptual designs, "corny" works for neither his audience nor his subjects, as it might for a general market. "I've seen Bill Gates on a *Fortune* cover [in which] he's hanging upside down over a lake." Even if Saulsby wanted to do something like that, he said he's found that, in general, the higher the status of the African-American subjects he's worked with, the less they're willing to do anything beyond a typical pose. Again, the dignity issue is always an underlying element with this audience.

For example, Saulsby proposed a Mario Puzo's "Godfather"-inspired scene for a photo of three female executives. He visualized a boardroom furnished in a 1940s style and the executives in men's suits from the period. One of the execs expressed apprehension but relented … until she saw the set. The concept didn't work for her, she said, because she'd worked very hard to get where she is and femininity is part of her persona. But being an executive who, like any designer, is used to finding solutions, she said, "Can you give me an hour and call us a cab?"

african art as cues

To resolve the dilemma, the executives and Saulsby's associate art director went shopping while he used the time to fine-tune a backup concept. When the shoppers returned from Bloomingdale's (with nine feminine pantsuits, plus one for the lucky assistant), he photographed them against the more dignified, red-velvet background of a fine restaurant.

Another photo-directing tip you can take away, no matter your audience: Remember that the difference between photographing real people and models goes beyond the look. There are "direction" issues, said Saulsby. During that shopping hour, "the photographer was freaking out because he's used to dealing with models he can tell to 'put on these shoes and shut up.' But these people are corporate executives. They come with criteria of where they'll go and where they won't."

black Enterprise's readers also have a say in where the profiled subjects will go. Readers want to see subjects photographed in their environments, especially at work, to give them a visual image of the lives the readers aspire to. In these settings, African touches like artifacts show up "all the time. We just shot a couple who have a business in their home. Along the wall of their office, there's a row of beautiful African masks."

It's common to find such African touches in African-American homes, said Lomax-Reese. "There are elements I see in homes that are African-American: books, magazines, African tablecloths patterns, rugs, sculptures, masks … all kinds of images that show an effort to reflect the culture."

Saulsby also has used African art props in some layouts, "but only when it's appropriate," such as when the story's about a gallery owner or someone whose passion is the arts. "When it's appropriate" is an important distinction you'd be wise to bring to your designs. In this new century in particular, a gratuitous mask, like kente, dropped into a design may draw the audience's attention, but not the kind you're looking for.

Dropping in art for no reason is "an easy out. It's like saying that's all we're about instead of going in depth. We do other things besides have barbecues, dance and look at black artists' paintings," said Dina Jackson.

Yet all these images have been used effectively in African-American-targeted designs. Take dance. A 2000 Black History Month ad for Pontiac commemorates the African-American dance heritage with a dreadlocked dancer and a poem. The concept came about because "there's so much tragedy in black history so it's hard to find something that's exciting," Kevin Hanson said. So he decided to do a history of African-American dance, which includes the Nicolas Brothers, Swing, Alvin Ailey, the Dance Theatre of Harlem. In the ad, the dancer is stepping like a fraternity dance that's been popular with younger kids.

More about how to go in depth: What's appropriate often translates to what's meaningful. A BellSouth Corporation ad for Black History Month shows a painting of an African man playing a drum to send a message of communication across cultures. The concept of the drum as communication tool makes sense coming from a telecommunications company, and the copy supports that connection.

To build trust with the audience, the client has to say they understand and respect the differences, said Alfredia Scott at Dayn-Mark. "With that comes an understanding that you know something about the audience's background and community." Why the drum? "A lot of people say why do we want to reach back to Africa?" But there's a lot of interest in it; more African-American people are traveling to the motherland, she said.

What BellSouth wanted to do with the drum was to show that Africans have made a contribution. With the drum, Africans were "the first inventors of telecom. You all don't recognize it; here's a company that does."

Once again demonstrating that even best-laid plans may offend someone: Drums rarely work for Thomas, either as a designer or a consumer. She said she doesn't like to see black men in ads beating drums. She cited a TV spot for a liquor, in which the drumming appears gratuitous, not relevant. "It says that all black men do is beat the drums."

HealthQuest: Total Wellness for Body, Mind & Spirit, for which Lomax-Reese aims for an Afrocentric aesthetic, included hieroglyphics in the Q of the logo that mean the equivalent of the name. The typeface is Optima. Now the logo is "a bit cliché" so it was changed in the redesign,

she said. The horizontal lines around the logo also were omitted. Previous issues used more African touches, such as commissioned woodcuts for the department icons and a kente-like pattern in the logo.

For the redesign, art director Janine Thomas kept Optima, but elongated it, and used Geo elsewhere on the cover. She favors Geo because it has a style that's Afrocentric without "clonking you over the head with an ankh." She prefers subtle touches, which she said might draw charges that she's hiding the blackness in her designs. But she said, "sometimes you have to sneak them in. I don't want people to pick up my work because it's for the culture, but because it's beautiful."

Pettiford agreed: "I go for universally good design. I don't want someone to look at my design and say this was done by a black designer … you would never know that *Vibe* is designed by a white person, or that *Premiere* is headed by a black designer." He cites his multicultural influences as including album covers of the 1970s, especially the old Blue Note album, covers from black exploitation books, graffiti and the work of Saul Bass and Oliviero Toscani (see chapter five).

Watch the evolution of an Afrocentric magazine. Early versions of the logo pushed the hieroglyphics and woodcut feeling. A redesign pushed them out in favor of a cleaner look. As in the pre-design, the logo's still in Optima, except for the Q, but it's a retooled, elongated Optima.

The Q's in Penumbra, which gives the Q's diagonal stroke more style than the nondescript one on Optima. It's designed with more oomph for use as an acronym.

Magazine *HealthQuest: Total Wellness for Body, Mind & Spirit*

Publisher Levas, Inc.

Art Director Janine Thomas

To illustrate an article on race for *Savoy* magazine, Pettiford had the idea to make President Bill Clinton black. He said he got the idea from "Race and Lies," an issue of *Colors* magazine from Benetton in the early 1990s. In it, Toscani shows Spike Lee as a white man, Michael Jackson with blue eyes and Arnold Schwarzenegger as a black man with twists in his hair.

For the Clinton makeover, "we got an existing image from a stock agency, shot a black model with similar features and morphed the two."

And one company reflected the audience in a work of art. An ad for the National Cattlemen's Beef Association showed a sculpture of a black woman as Atlas holding up the world (next page). The ad appeared in *Ebony* for the first time in early 2001, after being in general-

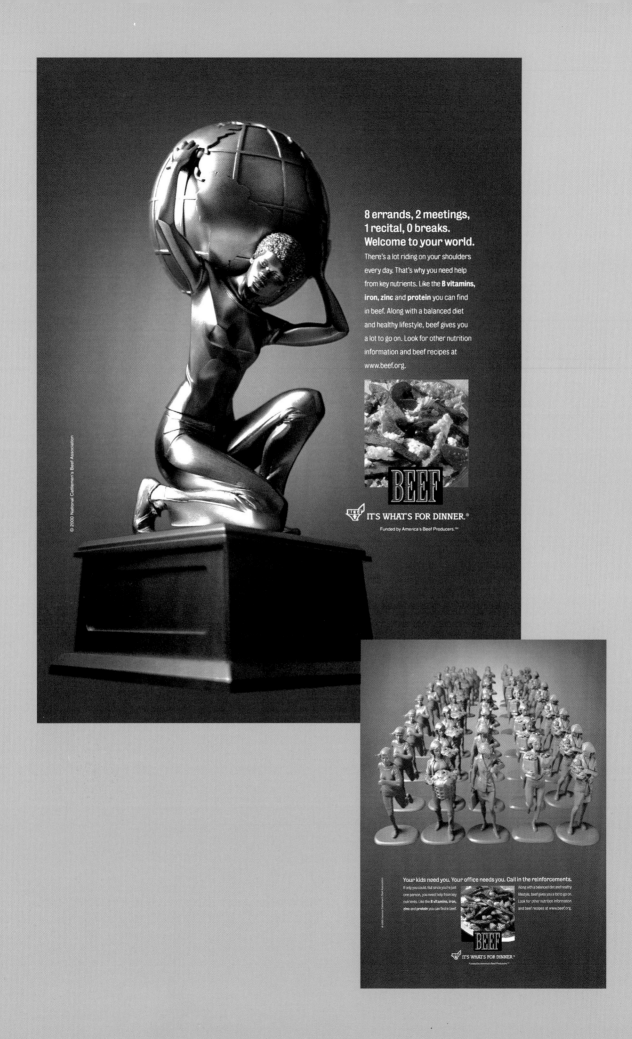

8 errands, 2 meetings,
1 recital, 0 breaks.
Welcome to your world.

There's a lot riding on your shoulders
every day. That's why you need help
from key nutrients. Like the **B vitamins,
iron, zinc** and **protein** you can find
in beef. Along with a balanced diet
and healthy lifestyle, beef gives you
a lot to go on. Look for other nutrition
information and beef recipes at
www.beef.org.

BEEF
IT'S WHAT'S FOR DINNER.®
Funded by America's Beef Producers.℠

© 2000 National Cattlemen's Beef Association

Your kids need you. Your office needs you. Call in the reinforcements.
If only you could. But since you're just
one person, you need help from key
nutrients. Like the **B vitamins, iron,
zinc** and **protein** you can find in beef.
Along with a balanced diet and healthy
lifestyle, beef gives you a lot to go on.
Look for other nutrition information
and beef recipes at www.beef.org.

BEEF
IT'S WHAT'S FOR DINNER.®
Funded by America's Beef Producers.℠

An everyday mom carries the weight of the world on her shoulders, part of a series that speak to overworked women. The ad ran in general-market magazines for a year before appearing in *Ebony*. This, and the green army models below it, are no digital manifestations but actual three-dimension objects crafted by a model-making company. This "army" on the bottom speaks to the fantasy of cloning oneself. The ad, designed as part of a general-market campaign, just happens to avoid the issue of skin color.

Art Director Amy Haddad,
Leo Burnett

Copywriter Anne Patanella,
Leo Burnett

3-D Modelmaker Clockwork Apple

Photographer Mark Viker

Client National Cattlemen's
Beef Association and Cattlemen's
Beef Board

market magazines on and off for a year. "We don't have funds for separate campaigns for African Americans," said Paige Miller of the association. The ad is part of a series that targets mothers aged 25 to 50, who may feel as if they carry the weight of the world on their shoulders.

"There are so many harried mom ads; I don't think moms want to be reminded of it," said Anne Patanella of Leo Burnett. So the creators took the idea and made it amusing. "We loved the idea of a range of ethnicity. The Atlas model is a black woman with natural hair. But note, although the image is amusing, it's also respectful.

All the moms in the series look "contemporary, representational … not like June Cleaver," said Patanella, (referring to the 1950s-style mom in the situation-comedy "Leave It to Beaver"). It also was important that the person and her clothes looked everyday, not like a celebrity, said Amy Haddad of Leo Burnett.

More in the series played on the notion with plastic-cast models of an army of little green "you's" (that's avoiding the whole skin color issue—although these models seem to have white features).

S ports and music still are important icons for targeting African Americans, said Chuck Morrison of UniWorld Group. The audience tends to pay attention to endorsements by celebrities in music and sports.

Morrison tells this bit of endorsement history from his tenure at The Coca-Cola Company: When he took Michael Jackson to Coke in 1982, Thriller had just come out. Coke could have had him for $1 million but they turned him down. By the time his popularity exploded, Coke had waited too long to reconsider and Pepsi snapped him up. Jackson, Morrison said, energized the brand and "I will go to my grave thinking that New Coke [was developed as] a result of Michael Jackson's Pepsi endorsement."

Later on, Morrison did outbid Pepsi for another celebrity with the same initials but "I don't think Coke made the most use of Michael Jordan that they could have. Nike did a better job with him." In 1986, Morrison got Curtis Blow, an "old school rapper," thus launching the Sprite and rap connection.

Sprite ads from Burrell feature close-ups of less well-known rappers doing their thing during the whole spot. Talking about one such spot that doesn't show the product at all and only the logo briefly at the end, Morrison said, laughing, "I think it's gone a little too far. At some point, you've got to sell the product." The client and the agency must have agreed: Another spot in the campaign that aired a few weeks later showed the rap artist drinking the labeled product after his performance.

Advertisers go to the huge expense of casting celebrity endorsers because especially younger audiences look up to them. But, as we said before, the audience is particular about what the stars can sell and how they can behave in ads. Tiger Woods, Kobe Bryant, Brandy, Sinbad, Cedric the Entertainer, Arsenio Hall and Sisqo are among the other celebs who've represented products.

You can tap into the power of music icons without using their music. For example, Jeep Grand Cherokee's positioning has been upscale, American and "purple mountains majesty. But most people don't take it off-road, and black people definitely don't," said Roberts of Don Coleman Advertising. With research, he said, "we found the vehicle has an iconic image and we looked at what is iconic in African-American culture. Barry White is iconic."

So White did the voice over for a campaign called "Enigmatic Joy." The campaign also worked in the general market because White's "an American culture icon, not just an African-American one." The agency looks for that universal appeal, he said, because "we don't live in a world that's all black."

More Music, With Stars and Without

But one celeb doesn't fit all. Like every other element in designs, the choice has to fit the audience and the product. Juan Roberts did a remix on a piece for a car spot that used the words of Sonia Sanchez and music and singing of Eric Benet. The demographic, he said, is forty-plus and upscale. "We went for something intellectual." That works for upscale, not for pizza: For Domino's Pizza, he "found the source of the funk" with Bootsy Collins.

In broadcasting, music has to have flavor, agreed Chris Robinson of General Motors. And it's most effective to use talent of the same heritage as the one you're marketing to. He advises hiring people who understand the culture instead of falling back on "scratch track and needle-drop stuff," the musical equivalent of clip art.

Creative directors even have found ways to incorporate music into print ads, without celebs (and without sound chips!). Because "much of African-American culture is music-driven," said Lawrence Aarons, since at least 1996, Chisholm-Mingo Group has connected a print campaign for Seagram's Crown Royal with well-known classic song titles.

The celebrity in some of the ads is the purple bag that encloses the product or the bottle itself. In a 1996 Christmas ad, a hollied tag reading "to Dad" hangs from the bagged bottle to reinforce the tag line "Papa's Got a Brand New Bag," based on the 1964 James Brown hit. In another ad, from 2000, "A Legendary Vibe" is illustrated by the bag's gold braided drawstring in the shape of a jazz horn player.

An empty Crown Royal bottle is featured in another ad, along with another tune, "Let's Do It Again," (1999), and with a single red rose for still another, Nat King Cole's (and posthumously, his and daughter Natalie Cole's) "Unforgettable," (2000).

The sports and music connection to the audience extends to advertising venues. "You have to reach people where they are," said Morrison. And "where they are" is important for designers, not just media buyers, because these events and locations translate effectively to design concepts. Hot spots and events include the Soul Train Music Awards Show, which Coke started sponsoring sixteen years ago because 50–60% of blacks in the U.S. watched the weekly dance show.

Another frequently marked date on African-American calendars is the Bayou Classic, an annual football game in New Orleans between Historically Black Colleges. "Three weeks ago, I walked into a client creative meeting and the executives didn't know what it was. Can you imagine me not knowing what the Rose Bowl is?" To communicate effectively to a culture other than the one you were born into, Morrison said, "you have to be bicultural."

93

more than just kente

"Effective advertising is about treating people the way they wish to be treated," said Walter Allen of Anheuser-Busch. "I think companies have to show respect for the marketplace without separating them from normal life. Kente cloth, that was just for black folks." Instead, Allen prefers to show African Americans as part of the norm.

Black Enterprise's Saulsby agreed, saying he sees two kinds of ads directed at African Americans: those that use an African-American model, and those that fall into what he calls the "kente" category. Federal Express falls into the first category, he said. It delivers packages the same to African-Americans as to the general market, so it makes sense to have a similar ad in *Forbes* and *Black Enterprise*, changing only the ethnicity of the models.

Personally, "I don't want to see the kente ads, in red, black and gold. It feels demeaning, as if the advertiser is talking down to me," he said. "We're part of mainstream life. Everything shouldn't have to look like an African mask or a gazelle to be relevant to African Americans."

Most designers are getting that message, so you're seeing less of the kente look. But as recently as 1998, even one advertiser that's consistent in targeting blacks used kente patterns on its Black History Month website. It also used Lithos, a typeface that's been overused in African designs, as has Mistral.

But such images are hard to understand without cultural context, said Michel Gibbs of Chelsea Harlem Interactive, who has designed the company's more recent commemorative sites. The newer ones reflect the design team's desire to "interact

Owia Pue means "the rising sun." Symbolizes progress, spiritual protection, divine creations and aspiration toward a brighter future.

Kyere Twie means "the leopard catcher." Symbolizes courage, valor, exceptional achievement and inspiring leadership.

Kente cloth is at the top of anyone's list of African-American design clichés. And it's a good thing. Keeping it out of your designs will keep the cloth patterns from disrespectful uses, such as toothbrushes. In Ghana, where the cloth originates, kente stands for royalty, philosophy and religion. Here are some of the many patterns and what they symbolize, according to the 2001 Kente Calendar.

FROM Kente Calendar 2001

PUBLISHER Sankofa Edu-cultural Publications

DESIGN CONCEPT Kwaku Ofori-Ansa

GRAPHIC DESIGN John Dean

COMPUTER GRAPHICS ASSISTANT Nan Adu Ofori-Ansah

PHOTO CREDITS Ghana Information Services, Ghana Tourist Board and Kwaku Ofori-Ansa

Sika Futro means "gold dust." Symbolizes wealth, royalty, elegance, spiritual purity and honorable achievement.

Wofro Dua Pa A Na Yepia Wo means "He who climbs a tree worth climbing gets the push he deserves." Symbolizes striving for success, aspiration, hope, noble deeds, mutual benefits and sharing.

Nkasewa means "eloquence." Symbolizes that, and wisdom and intelligence.

Boafo Ye Na means "Helping hands do not come so easily." Symbolizes the value of genuine help and sincere gratitude.

Aberewa Ben is the name of a courageous elderly woman during the C17th Asante Kingdom. Symbolizes courage, forthrightness, strength of character and exceptional abilities.

Emmaa Da means "It has no precedence." Symbolizes creative ingenuity, perfection, innovation, uniqueness and exceptional achievement.

Million Family March

October 16, 2000
Washington, D.C.

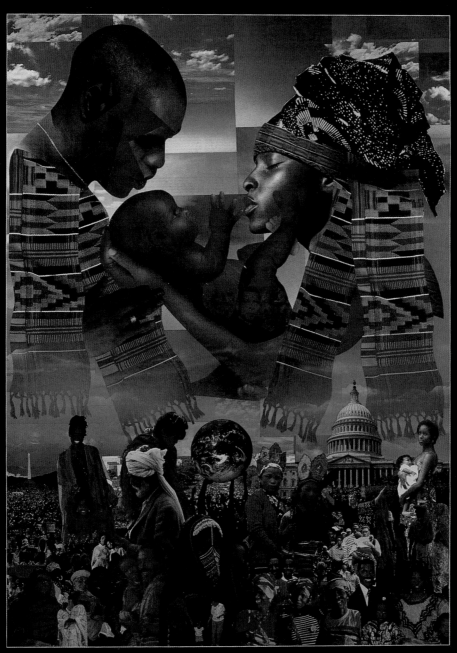

"WE ARE FAMILY"

MICHAEL BROWN

CULTURAL CIRCLES (202) 667-432

on a deeper level with the audience." The 2000 site said "you're more than just a kente cloth," said Gibbs, who used images of achievers and historical events.

What's more, designs that arbitrarily include kente don't just risk contributing to a cliché. They're also in danger of offending people who know its meaning.

Gibbs was once commissioned to design kente toothbrushes. For that project, he researched kente cloth and found that every pattern has a different meaning. "Some can be offensive, some uplifting, some are puzzling to a U.S.-born audience, such as 'If you have something to say to me, let me first give you a stool to sit down.'" (That particular cloth is a warning against "flimsy accusation and gossip.") So, he said, if someone from across the world looked at one of these things, "the pattern could have a very different effect than the one intended."

Gibbs's research (and mine) led to Kwaku Ofori-Ansa, associate professor of fine art at Howard University and a native of Ghana. Ofori-Ansa, whose Sankofa Publishing Co. publishes posters that detail the variety and meaning of kente patterns and Adinkra symbols (see pg. 100), adds that if you want to use kente in designs, be at least as careful in choosing the application as the patterns.

Kente has been used in "everything from sneakers and beach sandals to bikinis and baseball caps, even Band-Aids," Ofori-Ansa said. But "given the significance of kente in its cultural setting—the patterned cloths come from Ghana where they represent royalty, dignity, philosophy and religion—indiscriminate use of the patterns can devalue them."

On one hand, the use of kente patterns outside of cultural contexts "popularize them and could spark interest in the culture. They have become a symbol of Pan-African culture." On the other hand, Ofori-Ansa said, if kente becomes "too commonplace, the original intent of kente as a part of only special occasions" becomes devalued. It's a precious legacy that's being dragged through the mud by disrespectful uses, such as umbrellas left lying on the floor ... and toothbrushes.

But kente *can* work in graphic design, Ofori-Ansa said, pointing to a poster created for the Million Family March in 2000. And the design's respectful as well as effective because it honors African tradition and unity. In fact, on Ansa's office wall is a photo of the first Cabinet of Ghana, with each member dressed in a different kente pattern. The photo's also bordered in kente, a pattern chosen because it means unity.

Ofori-Ansa finds ads about Social Security, credit cards, savings and health insurance more acceptable vehicles for kente than, say, apparel, because "anything that relates to wealth and money is on the positive side."

Art director Isaac Dodoo of Images USA, another Ghanaian, also expressed reservations about designers who use kente without understanding its meaning, citing people he's seen dressed unintentionally in a funeral pattern. "It's not enough to splash it on a billboard and say I'm an African."

A poster for the Million Family March in Washington, D.C. uses kente appropriately... an African couple in kente hold a baby (in whose skin, you might be able to see the faces of African-American leaders such as Martin Luther King, Jr., Frederick Douglass and Malcolm X).

ILLUSTRATOR
Michael Anthony Brown

97

here for black history month, gone tomorrow?

nor is it enough for companies that want to reach African-American markets to say just "We appreciate that you spend with us, we honor Black History Month," said Steven Thompson of Chelsea Harlem. Although certainly that's an appropriate attitude, he reinforces the point that it has to be backed up with foundations, scholarships, diversity in hiring and sensitivity to consumers.

Honda, for example, commemorated the month with print ads that mentioned its sponsorship of the Campus All-Star Challenge, an annual academic competition that supports Historically Black Colleges. The "I wish" ads, designed by Wilky Lau of Muse Cordero Chen feature full-size close-ups of introspective-looking faces.

The richly printed photos, which show every facial pore of the models, reinforce the mood. Copy supports common aspirational and normal human desires. For example, in one ad, a little girl wishes for more dolls that look like her, not having to wait to give her father his present, and being old enough for "doctor school." In another, an older man wishes for more summers in Yosemite with his grandchildren and a way to show appreciation for his fraternity brothers. He regrets not having marched on Washington and worries about kids' self-esteem.

A TV spot for McDonald's also reinforces the idea of knowledge about black history: You see kids at school rushing to some kind of a showdown. It turns out they're heading toward a challenge of who knows the most about black history, Sharrieff said. (The concept turns peer pressure into a positive reversal on an experience that has been common to studious children: peer pressure to shirk their studies.)

A seven-page advertorial in *Ebony* for DuPont called "Leaps," highlighted African-American contributors to U.S. society (and how its products are helping them). Profiles included Mother Hale whose Hale House takes care of crack babies; firefighters and the country's first African-American Firefighters Museum in Los Angeles; Dance Theatre of Harlem; farmers; and Bernard Harris, the first African-American astronaut.

You're wasting your time and money if you design for African Americans only in February. Back up your Black History Month ads with messages throughout the year. The key is consistency, said Chuck Morrison of UniWorld Group. To demonstrate how many advertisers don't get the point, he offers this exercise: See how many of *Ebony* magazine's February advertisers also showed up in December. "Everybody's in February" for Black History Month. They're not fooling readers, who notice the companies that make a year-long commitment, and those that don't.

why february?

February may be the shortest month of the year, but it was chosen as Black History Month by the founder because it's the birth month of Frederick Douglass and Abraham Lincoln. In 1926, Dr. Carter G. Woodson, African-American author and Harvard professor, established Negro History Week. Later he extended the commemoration into a month, and in 1976, it became Black History Month.

special holidays? yes & no

Without a consistent commitment, advertisers appear only to "pay lip service" to African Americans. Showing up only in February tells the audience that the company just considers talking to African Americans as "an obligation they have to fulfill," Jackson said. Anyway, she added, February's the shortest month of the year. (Right, said Wiseltier of the Chisholm-Mingo Group, "I don't know why it isn't Black History Year.") And there you have more examples of the very sensitivities you face when designing for African Americans.

And don't focus all the attention on Martin Luther King, Jr., Jackson suggested. While not taking away from his many accomplishments, she said "he's like the poster child for black history" and wonders why there isn't more focus on other important figures.

It's true, said Saulsby. "Everyone from Anheuser-Busch to Charles Schwab has a tribute to Martin Luther King, Jr. It's a shame," he said. "A lot of creative people have great ideas but they can't do them, because they have to do the Martin Luther King, Jr. ad … and 'can you put kente in it?'"

Neither kente nor Dr. King showed up in the website Gibbs designed for AT&T in 2001 (see pg. 78). Lewis H. Latimer, an engineer, draftsman and inventor who worked with Alexander Graham Bell, peers out from the homepage.

designers and marketers also disagree on what, if anything, to do for other black holidays. Anheuser-Busch used to do promotions for black holidays, Walter Allen said. "But I believe that the Fourth of July is just as important to African Americans as traditionally black occasions." What's more, he said, you have to be careful not to be viewed as trying too hard. "Anheuser-Busch is not a black-owned company. Get too involved in black holidays and the audience might feel, 'What gives you the right?'"

Kwanzaa

Kwanzaa, designed to link African Americans with their African roots, is catching on. But most African Americans still celebrate Christmas. About the relatively new holiday, some African Americans expressed ambivalence, saying that the holiday is not worth celebrating because it's made up. But most things are made up, Jackson said in its defense.

Lomax-Reese, who includes a mention of Kwanzaa in her magazine, thinks the holiday's "very important." Although it's only about thirty-five years old, at the beginning of its popularity, "it's incredibly positive," she said. If there's ambivalence about it among African Americans, she said, it reflects "the fact that we as a culture don't take our traditions seriously."

McDonald's is among the advertisers that have honored Kwanzaa with an ad. For one design, Dodoo chose a stock photo of people dressed in African gowns.

Adinkra symbols are classified in five categories: animal images, human body, man-made objects, nonfigurative shapes, celestial bodies. Here are four:

Dwenini Mmen, the ram's horn, symbolizes inner strength, determination, humility and strength of mind, body and soul.

A different version of the ram's horn also symbolizes the use of power tempered with patience, humility, tolerance, wisdom and discipline.

Akokonan (hen's foot) symbolizes parental protection and discipline tempered with love.

Owo Fro Adobe (snake climbs a raffia palm) symbolizes ingenuity and ability to overcome all odds.

If you want to do more with your holiday designs, you'll be glad to know that Kwanzaa's a holiday that rivals Christmas in the variety of visual elements associated with it. For example, you've got Father Kwanzaa, a Santa-like figure; kente, adopted as a Kwanzaa symbol, along with its main colors of red, black and green; red, black and green candles and a special seven-branched candelabra; fruits and vegetables; straw mats; and ceremonial drinking cups.

Juneteenth

Juneteenth is another holiday that can translate to your designs. It commemorates the arrival of news of freedom brought in June to Texas slaves. Word arrived no less than two-and-a-half years (and nineteen days, thus the holiday's name) after the signing of the Emancipation Proclamation.

Since 1979, Juneteenth has been an official holiday in Texas. Other Southern states, plus California, Minnesota and Wisconsin, also celebrate it. And some advertisers, like Courvoisier cognac, have commemorated it in advertising.

no special colors for people of color

ike many other design elements, color for African Americans isn't likely to look much different, if at all, from color for the general market. In fact, a walk through *Essence* and *Black Enterprise* magazines show no obvious differences in palettes you'd see in a general-market magazine.

Use whatever works, Popper advises. Although she loves earth tones, color choice has to be a reflection of the assignment. It should depend on "the mood, motion and moment." For example, black history ads are nostalgic, so earth tones and sepia may be good choices for them. Thomas agrees: "Color for color's sake is not a good idea." Bright colors? "I don't aim for that."

If there are differences in the color palettes African Americans prefer, Thomas pointed to "more saturated colors … not muted but not pastels; rich but not necessarily bright … rich greens and golds." *HealthQuest: Total Wellness for Body, Mind & Spirit*, which Thomas joined in 2001, aims for a Caribbean palette, said Lomax-Reese. And in a typical issue of *Ebony*, you may notice colors that are "more sensual, warmer and richer" than those used for the general market," said Ute Jansen Alonzo of *Ebony*.

Plus, cosmetic ads in the magazine have shown more purples, as opposed to the blues, reds or whites more prevalent in the general market. In fact, purple's the color pick for Niaonline, a website for black women. Earth colors, Alonzo said, also are popular in cosmetic ads geared toward the general market.

A German friend of Lance Pettiford said he'd observed that African Americans use warm colors: oranges, reds, browns, blacks. "I think it's part of our culture … and they look good with our skin tones. I wear a lot of rust brown and burgundy and earth tones, because I think I look good in them … that's not to say I won't put on something bright, but it's not as typical."

Editorial layouts for the February 2001 Black History Month issue of *Ebony* include random combinations of red, green and black—"African colors," said Alonzo. It also adds yellow, which *Ebony* uses a lot, but which doesn't turn up much in other magazines targeted to the market.

When art director Lamar Clark joined *Honey*, a women's fashion magazine, after years of designing sports magazines, this "man's man," as he calls himself, had to do some research. He said he studied makeup ads, where he found "fruity colors" (apricot, melon, etc.) and the root of his palette. He took the colors down to 50% strength to soften them. "I'm a fan of pastels," he said, but so many women's magazines for all ethnicities use them that he brightened them to create a unique look.

African Americans are exposed to everything everyone else is exposed to, Clark said. "My designs aren't far from what you'd see in *Vanity Fair*, except maybe they're more hip and urban." He said he's inspired by cutting-edge design and contrasting color in ads from the likes of Gucci and Versace.

Black Enterprise readers asked for bright colors, and a lot of color on the page but, Saulsby thinks, that choice owes more to the subject matter than the ethnicity of the readers. Because it's a magazine read after work for business, not for pleasure, color makes it easier to get through the content.

Saulsby strikes a balance between giving readers the color they want and aiming for "a contemporary slick feel to show advertisers we've got all the marketing numbers they're looking for." It took a long time for BMW to show more than its "entry-level" model in B.E.'s pages, he said. "I'd like to think that the look of the magazine helped to persuade them." And a "Wealth Building Kit," sent out to readers by the magazine is dressed for success in black with a muted, classy gold (see pg. 82).

A type design evocative of the 1920s is made contemporary with the use of echo-look and mirrored type. The Geo type goes beyond information conveyance to patterning. A mudcloth design in the background is appropriate because of the African subject matter. Another card in the deck focuses on the 1920s African Art of the Harlem Renaissance. In fact, the repeated words "Harlem Renaissance" on their side form a patterned vertical text separator in the middle.

PROJECT Sankofa Afroaesthetic Design Reference
DESIGNER/CONCEPT Janine Thomas

For a Black History Month ad for Amtrak, Clive Williamson commissioned art using infusions of green, black, gold and red, associated with American Black liberation, as well as Rastafarians. The ad celebrates blacks' long-standing relationship with the railroad, including Pullman porters. Colors aren't necessarily bright. "I would tend to associate bright colors with Hispanics. If anything, African Americans tend toward monochromatics: strong blacks, reds."

One more color note: The original Sprite package was green until Steve Horn added silver and blue to give the brand a more hip-hop look. The bottom line? If you're designing for African Americans, let the purpose, not the ethnicity, determine your palette.

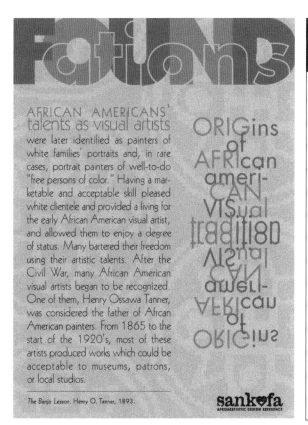

AFRICAN AMERICANS' talents as visual artists were later identified as painters of white families' portraits and, in rare cases, portrait painters of well-to-do "free persons of color." Having a marketable and acceptable skill pleased white clientele and provided a living for the early African American visual artist, and allowed them to enjoy a degree of status. Many bartered their freedom using their artistic talents. After the Civil War, many African American visual artists began to be recognized. One of them, Henry Ossawa Tanner, was considered the father of African American painters. From 1865 to the start of the 1920's, most of these artists produced works which could be acceptable to museums, patrons, or local studios.

ORIGins of AFRican american VISual tradition / Visual african american origins

The Banjo Lesson. Henry O. Tanner, 1893.

sankofa
AFROAESTHETIC DESIGN REFERENCE

THE NEW NEGRO MOVEMENT 19 20s

HARLEM RENAISSANCE HARLEM RENAISSANCE HARLEM RENAISSANCE

PRINTED ON FINE cream-colored paper and sporting a dramatic red and black cover designed by Aaron Douglas, the magazine Fire!! appeared in November 1926. It celebrated jazz, paganism, blues, free-form verse, and precisely everything "uncivilized" that proponents of the Talented Tenth preferred to ignore. Fire!! offered an alternative manifesto to The New Negro philosphy. Featuring fiction by Zora Neale Hurston, Wallace Thurman, and Richard Bruce Nugent; drama by Hurston; poetry by Langston Hughes and Countee Cullen; illustrations by Douglas and Nugent, Fire!! spoke devoted itself to younger Negro artists. In retrospect, Fire!! represents the vanguard of the Harlem Renaissance at its highest. The magazine had cost $1,000 to produce. Ironically, hundreds of unsold copies burned in a fire. Wallace Thurman (Fire!! creator and editor) spent the next four years paying off the printing bills, and he complained to Langston Hughes, "Fire!! is certainly burning me" (Watson, 92).

Fire!! First and only issue, 1925. Cover by Aaron Douglas.

sankofa
AFROAESTHETIC DESIGN REFERENCE

black type... all hype?

many designers give similar advice when it comes to typefaces. Trying to spec "black" can stereotype, Dodoo said. "It's the message, not the font, that's important." Well, Williamson allowed, maybe there's more type experimentation in magazines like *Vibe* and *Source* because of its younger audience. *Essence*'s type tends to be more mainstream. "In general, though, with blacks, we'll experiment a little more visually."

Popper's attitude toward type is "to try to make it conversation … hipper, cooler, funky, depending on the message."

Her colleague, John Church, added that he looks for type with more style to it. "We tend to take faces and alter them." For teens, and for urban looks, style may mean "layering," duplicating and overlaying a word many times to make an echo effect. And he'd probably use red and black rather than earth tones.

"When you're talking to younger audiences, funk it up to make it fresh." Church finds inspiration in the work of graffiti artists. To illustrate a Mountain Dew ad, he hired a tattoo and graffiti artist. "Right now there's a melding of the two styles." He also looks to the club scene, where he finds "tons of fliers … type and visual images."

For the teen-targeted ads for the Office of National Drug Control Policy, Covarrubias found inspiration in rave fliers. He also used the echo look, with outline type inspired by graffiti and bright solid colors. And Pettiford "got off on using Émigré fonts."

When you design for kids, design in the visual language in music and teen magazines, and local urban neighborhoods. Kerstin Goetz also used one of the Émigré typefaces, Keedy Sans, for the logo of YUTHE (Youth United Through Health Education, a San Francisco-based safe-sex-education program). The

white type's outlined in thick black, surrounded by a purple field and another black outline that connects the characters. The type sits on an angled turquoise oval.

Those are some the "do's" for when they're appropriate; here's a "don't": Gibbs talked about overuse of Lithos and Mistral in African-American designs. Thomas agreed that Lithos in particular has become a cliché for anything that calls up African roots. "A lot of people got stuck in the 1920s," said Thomas, who did her college thesis on African-American aesthetic influences.

"Those are typefaces that white people think are black," Pettiford said. "Lithos, yes, oh my God, I can't stand that face! That's the one they think represents us. It doesn't represent us! Make that clear!"

But, Thomas said, there are certain fonts that convey an African look. Geo and Kabel, for example, are well-proportioned, geometric, angular and stylized. They have tall ascenders and long descenders, and she likes the acute angles at the ends.

Although Futura also is geometric, it looks more neutral, less stylized than a face with an African flavor. And it's geometric to the point of confusion: descenders are made up of straight lines. "You only know it's a *j* based on the context." And the ends of the character are straight across, not blocked. Plus, a practical consideration: With Geo, you can fit more characters than you can with Futura.

Thomas's challenge, she said, has been to find a serif face that looks a bit African. Lubalin Graph is one she likes to use when it's appropriate. But it was plain old Times Roman that Thomas turned to for a logo that looks both traditional and hip. She got the rough-edged look of "Sankofa" by tracing the letters in ink on a porous paper towel (like the kind you'd find in a gas-station's restroom, she said), wetting the paper so the ink smeared, scanning the logo and cleaning it up a little.

"flossing it" and other street talk

So with all these cautions surrounding deliberate attempts to design "black," it's hard to find any universal truths. For example, Roberts said, "We haven't found that black people prefer different color cars than white people or that they prefer brighter colors. We buy platinum, silver, taupe like anyone else. Black is the number one color among all audiences around the world."

But Roberts said there are attributes that African Americans, at least younger ones, prefer in their cars: "Brothers like chrome … 'Flossing it' is a colloquialism used to describe primping up yourself and your car. And the stereo's very important: loud sound, flashy wheels." "Hoopty," he said, is a term for a popular mode of transportation in the neighborhood. "You take a large old American car from the 1960s or 1970s and dress it up."

(But curb the street talk. Claim the term "hoopty" or other lingo to put in an ad at your own risk. At first, McDonald's used street talk, "but lately we've been finding that it's been backfiring," said Susan Leick of McDonald's. "The audience has responded, 'You don't have to talk to me like that. I'm an American like anyone else.'" She referred to a radio campaign that was called "Shorty's Story" after what African Americans commonly call their kids. But in focus groups, "a good percentage of moms didn't like the fact that McDonald's used that term."

But you can use language that's relevant without being patronizing, said Caralene Robinson of The Coca-Cola Company. The key is to stay away from trendy phrases, she advises, because street language and terms often have a short shelf life. Often, "by the time a corporation gets hold of a piece of language, it's already out of date."

For example, added Popper, "'ill' used to mean 'bad,' now (at interview time) it's good." Creative people create their own slang." That way, she said, you don't have to worry about being too late with the language. What works also depends on who's using the language, said Robinson. "Someone in the segment may use an old term and the audience will say okay, it's old but so what? But if it's coming from a Big-Brother-type corporation, forget it."

That distinction's also true of design. "I don't design differently for the African-American markets," Hanson said. "If you've done something and it works and it happens to look black, it's fine. Depends what you're doing. Depends on the company. If it's a white corporation that's doing the ad, I wouldn't opt to make it look so black because [the audience sees] through it immediately," he said.

"As opposed to making something black, I try to make it brilliant. Come up with a good idea first." And that's the easy part, Hanson said. "If you just ask me to do a general-market ad, it's so easy because you don't have to deal with the extra levels. Make it good and make it black."

A long fry curls around a drinking straw. Headphones squeeze the word "loud," the name of a record label. The logo becomes wallpaper behind some of the food and message: "Celebrate Black Music Month."

AGENCY Images USA
CREATIVE DIRECTOR Isaac Dodoo
ART DIRECTOR Kim Sneed
CLIENT McDonald's

urban design & advertising

106

To Luz de Armas, urban advertising is the future of ethnic advertising. It targets not just African Americans, but also Latinos and everyone who lives or works in the city. It's typically a younger consumer, aged twelve to thirty, of any ethnicity with commonalities of clothes, subway, high-density living, said Steven Thompson. Consumers have overbooked lives and you have to address those lifestyles in your designs, added de Armas, who created a "Big City Pain" campaign for Aleve using on-the-street research.

To live in the city, de Armas said, you have to be an urban warrior, yet research showed "people don't want you to put down their city." But they do want you to acknowledge that they're special people, living a 24/7 life. The campaign connected with city dwellers who live with daily urban pain triggers like commuting. For Philadelphia, she did a series of billboards playing on familiar locations and signs:

- on the highway: Schuykill Expressway became "Schuykilling my aching back,"
- at the subway: "Express [train] ... yeah right"
- on the street: "No Parking ... anywhere ever."

A busy lifestyle is also the theme of a Honda print campaign with "a game-board/cartoony feel," Alfonso Covarrubias said. He used Photoshop to place a photo of a woman in the car driving an urban scene made from tiny scale models. The idea is that the car can get you through the game of life and that you win if you have free time at the end of the day. With the models, Covarrubias chose to represent after-hours activities that African Americans can relate to, such as a jazz club, gym, supermarket.

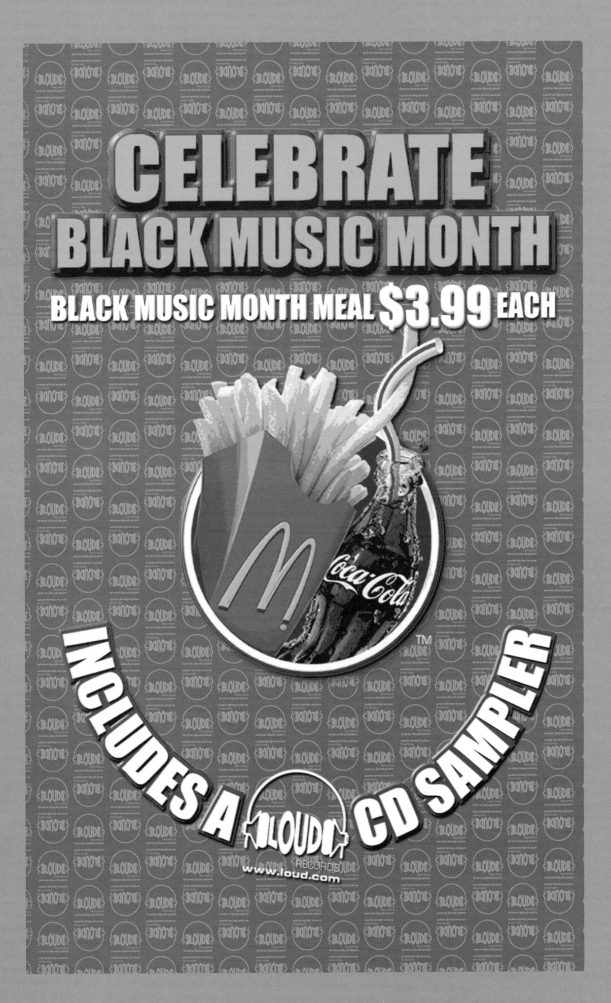

"Urban" is a state of mind to Juan Roberts of Don Coleman Advertising. "We focus on strategy based on an urban mind-set, not necessarily a urban location." That translates to a desire to "be in control, work the system, feel like an individual and get respect for being an individual and for being intelligent."

That's the definition of multiethnic, which the world has become. "A 50-year-old white executive may not know Eminem but he's playing right upstairs in his kid's bedroom. Ja Rule is the top rapper and 80% of his audience is white. Lil' Kim is advertising Calvin Klein, which never used an African-American spokesperson before. It's blowing people's minds." So beyond running the risk of insulting African Americans by overdoing what's black about a design, remember that the audience contains people of all races.

African Americans are trendsetters and early adopters, said Lorraine Popper. The culture is quick to adopt and create new technology and new ways of doing things. "Wearing baseball caps started in our community," she said, and the way kids tie their sneakers or don't tie them. Every week her son has a new way ... now [when we spoke], it's cross, cross, then skip one. More insider information captured: When a kid holds a bottle, he uses the second and third fingers (at least that was true at the time of this interview), instead of the whole hand.

And the baseball cap, also at interview time, was no longer bill backwards, but forward with a "do rag" (a head scarf tied in the back) under it ... makes a difference. But don't take these tips as gospel because they've probably already changed, maybe many times over. Take the tip to hang out around the target audience and notice the nuances. Those nuances can make the difference between a design that feels real and one that doesn't.

Watch how the younger people dress, Popper said. Watch brands like Phat Farm, Nitchi. FUBU ("for you by you") came out with a line of Fat Albert clothing, ("Hey, Hey, Hey!"), based on the old animated character voiced by Bill Cosby. Leather bomber jackets, a style made popular by rappers, hit the mainstream. "What has stopping power graphically" are status brands, like the "hottest, coolest motorcycle."

Another nuance can be observed in the way an African-American man looks at a woman, Popper said. It's "up and down and he's direct about it, while a general-market guy might sneak a peek. And a sister would not sit there and wait for the man to come to her ... she'd walk up to him. There's more flavor, more emotion in the interaction."

Keeping it real also explains the fact that LL Cool J wore a FUBU hat in a Gap spot. Although many general-market advertisers would never put another clothing brand in its spot, Gap knew the audience members would see it as authentic. "They know him like that," said Thompson.

People who are 17 to 24 are an elusive target, said Robert McNeil of Images USA, which works on Army recruiting. They're also on the cutting edge of urban culture, which moves so quickly. To make the connection, "we recommend wild postings" (ads and posters on abandoned buldings). He also uses technology, such as digicards sewn into a piece of clothing or given out at retail stores or with the purchase of on-sale records. The cards are sponsored business-card-size disks that play the music of up-and-coming artists in any CD player or computer.

The technology works because, although the audience still doesn't have as many home computers as the general market, it has access to them at school, the library, Kinko's. The technology also works because the audience is on the cutting edge of urban music. For Black Music Month in June 2000, he created a package for McDonald's Atlanta that includes the item in a "pop kit," which included a tray liner, counter card and more.

If your client has no budget for research, you can at least study *Source* and *Vibe* magazines, which stay on top of urban culture, McNeil said. Also, in a few cities, including Atlanta, Chicago and New York, you can turn to Creet Purnell, a publisher of local urban magazines.

Agreeing with the idea that it's common for suburbia to follow urban trends, Barron Steward of Burrell Communications points to more than music, fashion, sports and language. The sports utility vehicle, for example, was popular in the inner city before it reached the suburbs, and cell phone use took off in the yurban (young urban) communities. More proof of the influence of the younger, hipper crowd? "My mom dresses different because of me."

Trends don't necessarily travel in the other direction, proving that good design alone won't sell a product unsuited to the target. Ted Pettus tells of a client of his former agency that wanted to sell its minivans to African Americans, but they didn't bite. Not only weren't the cars sexy, but for a then largely urban audience, they weren't practical. For one thing, minivans are "open so you can see inside, and it's hard to protect anything stored there." For another, he said, "They're big, and it's hard to park even a small car in the city."

all in good taste

and make it sweet. Companies that make food products have found that blacks tend to like sweet flavors and aromas, said Luz de Armas, who worked on Minute Maid. They're the highest consumers of sweet beverages. And black women, known as scent seekers, have shown they like fragrances in household products. That explains an ad by a black nonceleb extolling virtues of lemony Pine Sol.

(But the image backfired with at least one African-American woman. Thomas said the ad suggests that the woman had to be a maid who washes a lot of floors if she gets that excited about a cleaning product.)

There's no substitute for research, Morrison said. "We know that African-American kids make a trip to the store each time they want a drink, even if it's six times a day. They'll buy one twenty-ounce drink at a time, not a six-pack. I don't know why, but that's what they do." Maybe it's not cool to lug a six-pack around; kids want to travel light. Besides, the sodas get warm. But the reason doesn't matter as much as acting on the information: "We put a cooler near the door."

What's more, Morrison agreed with de Armas that "African Americans have a high index (preference) for sugar drinks and flavors—orange, strawberry, grape—and a low index for diet drinks. So where do you think we're going to put our ad dollars?" And as a designer, it's obvious that brown probably won't be the color of the drink you'll put in the model's hands.

Another example, from Popper: The general-market packaging designs for Pillsbury pie crust show … pies, a no-brainer. But although African Americans also bake and eat pie, research showed that a different image would connect better. African Americans were using the product to make peach cobbler, she said.

And when you shop for set designs and props to help depict a family at their morning meal, take with you what Roberts learned in research: African Americans don't necessarily eat cereal in the kitchen, they tend to use larger bowls and spoons for cereal, and the food isn't just for breakfast. Eating cereal is a relaxing thing.

Food and cooking is important to the African community, said Autumn Boos of General Mills. It's a source of pride, so cooking for the family is an image that may connect with certain African-American audiences.

hot art & afr-icons

among graphic images that appeal to younger African-American audiences, Gibbs admires Lugz shoe ads. They use computer-generated illustrations that recall graffiti, an art form that speaks to a younger audience, he said. Other icons that speak to an African-American audience include a hair scarf and a platinum chain with diamonds (very hot) in an ad for Scorpio. And a Nike ad shows a close-up of a chain with diamonds in a K against a man's abdomen.

"That K is a subtle sign to tell the audience it's targeted to them," said Gibbs. "There's a specific group of college-educated men who associate with fraternity and K is a fraternity symbol." The fraternity association is strong after college in the African-American community. The idea is that a lot of life starts after you finish school. The symbol said "We're strong and proud to be African-American men" and a lot of ads do that.

The bottom line for the African-American audience? Images that show respect, dignity, aspirations, style, status and relevancy based on research, not "what's black about it." The same formula applies for any consumers, Morrison said. "Get in their heads and find out what makes them tick." He compares ethnic marketing to a man trying to woo a woman. If he gives her flowers and candy, takes her out to dinner and is consistent, she'll pay attention, right? The key is to do it consistently. "I can't make it any simpler than that. It's not voodoo!"

glossary 111

BLACKS When I say blacks, I'm referring to African Americans, even though they're not synonymous. Hispanic and Caribbean blacks don't call themselves African Americans, and recent African immigrants and expatriots living in the U.S. don't necessarily either.

URBAN Living in the city, or having the mind-set of one who does. Can apply to African Americans, Latinos or any other ethnicity. Many see it as a synonym for African American, though, because the group tends to set the urban trends. "Urban" radio stations, for example, are most often thought of as black.

YURBAN Young urbans.

asian
americans

asians: watch your step

as you venture into designing for Asian audiences, don't step on the threshold … literally. At least for traditional Koreans and Japanese, the act is a bad sign so keep it out of your designs. Koreans think it drives out luck and fortune; Japanese equate it with stepping on a parent's face. And that's just one of at least dozens of cultural missteps possible by a designer who's new to these markets.

"When you design for an Asian client, you have to become an Asian. Go to a supermarket, look at the billboards. Regardless of whether you agree or disagree with the cultural preferences, you must absorb them," says Supon Phornirunlit of Supon Design Group, Washington, D.C. And there's a lot to absorb. Asian cultures are steeped in superstitions and subtle symbolisms that vary by segment. When Asians immigrate, they rarely leave these attitudes at the border so you'd better understand them if you want to connect.

And you probably do. Ever-increasing numbers of advertisers are realizing it's worth the effort, even though Asian immigrants make up 3.6% of the U.S. population, according to the Census 2000. The effort may seem even less practical when you consider this: Asian immigrants who interest advertisers further subdivide into three to six major groups often needing separate messages.

But here's the draw: These groups tend to concentrate in a few areas of the U.S., so you can reach them easily and relatively inexpensively with regional traditional media like newspapers, TV and radio. For

example, the biggest population of Vietnamese people outside of Vietnam lives in Westminster, California, said Bill Halladay, formerly of InterTrend Communications, a Torrance, California-based marketing agency that specializes in Asian markets. And Asians have a higher household income than any other group: about $7,000 more a year than the general market. That fact reflects their also-highest levels of education.

More than two dozen agencies specialize in Asian immigrant markets including the "Big Three": Chinese, Korean, Vietnamese; and to a lesser degree: Japanese, Filipino, Thai and East Indian. The Big Three markets get so much attention because they're more likely to respond only to messages in their native languages (which for Chinese can mean Mandarin or Cantonese), because those segments are the most "in-language-preferred."

Vietnamese immigrants show the greatest preference for in-language ads among Asians. Being mostly refugees, they're the most homesick and responsive to ads, products, packaging and media that remind them of home, said Wanla Cheng of Asia Link Consulting Group. Koreans demonstrate the second highest preference for their own language, followed by Chinese.

In fact, even the U.S. government is getting into the translation act. For the first time, in 2000, the Census Bureau translated its forms into the Big Three Asian languages, plus a fourth: Tagalog, a traditional Filipino language.

But in general, Filipino immigrants—although second only to Chinese in numbers of Asian immigrants to the U.S., and it's a close second—tend to be more westernized and bilingual, with less of a preference for messages in their native languages. Japanese also fall into that category. There also tends to be less advertising to Asian Indians in languages other than English. Not only

Asians represent **3.6%** of
the U.S. population

seattle
73,910

new york city
787,047

san francisco
269,565

fremont (ca)
75,165

chicago
125,974

daly city (ca)
52,522

san jose
240,375

manhattan
144,538

los angeles
369,254

san diego
166,968

long beach (ca)
55,591

houston
103,694

honolulu
207,588

Biggest Asian-American populations in the U.S.

is the audience largely bilingual, but with the diversity of languages spoken in India, it's rarely practical to choose one. And Filipinos and Asian Indians are more dispersed through the country than the Big Three so they're less cost-effective to reach with specific messages.

That means advertisers are more likely to target these segments with general-market messages. The decision is both demographic and budgetary. When they have limited budget for targeting Asian audiences, advertisers must begin with the audiences that give—as the cliché goes—the biggest bang for the buck.

Yet the Japanese attract specifically targeted ads more often than conventional wisdom about numbers and low in-language preference might suggest. The size, wealth and habits of the expatriate population are factors. At any given time, at least a quarter-million Japanese expats live in the U.S. to go to school, to work at U.S. branches of Japanese companies or to join a family member who does, said Saul Gitlin of Kang & Lee Advertising.

Although the expats stay in the U.S. for two to five years, they keep close ties to home and its culture. That means these frequent fliers and callers to Japan are ripe targets for telecom companies and airlines. That also explains the coverage of Japanese visual cues you'll see in this chapter.

But as you work to infuse your designs with cultural sensitivity, remember this: Learn the old rules, as well as when you can break them. Their significance is fading because it's hard to know them all and because younger generations don't care as much about traditions as older ones do, said Noriko Ito of TechArt International. The answer to when you can break the rules and when you can't lies in the audience you're targeting.

Also remember that, within segments, sensitivity levels vary according to the immigrant's age and length of time in the U.S.

The design of this travel guide is effective because it telegraphs Asian culture without crossing the line into cliché. This cover of "Asia in New York City," published by The Asia Society, shows photos representing Asian cultures, with a pair of chopsticks picking up a mini Statue of Liberty.

PROJECT Asia in New York City
CLIENT The Asia Society
COVER DESIGNER Patti Ratchford
PHOTOGRAPHERS Corky Lee, Carrie Boretz

values to design around

advertisers who design concepts and graphics aimed at Asians tend to keep typical Asian values in mind. There's no question that group-specific advertising is more effective, said Saul Gitlin, but it costs a lot and budgets may demand finding a middle ground. Among Asians, the impact of Confucius and Buddha, adherence to the Lunar calendar (for many), the strong influence of China on other Asian countries and the immigrant experience connect them, he said. That means they also share values. Many of the designs you see in this chapter reinforce one or more of these values:

» education

» proper behavior

» luck and prosperity (Chinese, in particular, tend to be highly investment-oriented)

» family, respecting elders, honoring the dead, sacrificing for children

» enjoyment of holidays

» seasons, and love of nature

» respect for tradition

For Chinese and Japanese, some would add these qualities: modesty, self-effacement, pragmatism, compromise, reciprocity of action and face-saving.

Here's how a designer might incorporate some of the values … or choose to play them down. Traditionally, education and properness—how a child is brought up—are very important in the Chinese market, said Julia Huang of InterTrend Communications. For a retailer like JCPenney, in 1990 you'd show a conservatively dressed

and groomed Chinese child. Ten years later in 2000, it would have been silly not to show the child in spiked hair and FUBU. Still, unlike African- and Hispanic-American audiences, in which kids tend to do their own shopping, Asian-American parents still make the buying decisions.

The sense of family is so strong that few Asians buy two-door cars, said Ed Miller of Verizon. Practicality is another strong value, which Verizon addresses with more than low rates to China. He said the Chinese, in particular, don't approve of expensive paper used on promotions. To Chinese, "we must convey stability, credibility, strength, longevity and durability." With this culture, he advises, never forget that you're "dealing with a country that measures success in decades or centuries, not in quarterly cycles."

In 1997, AT&T asked Kang & Lee to create Asian versions of a spot for its wireless products. In the general-market spot, called "Beaches," a harried executive/mom prepares to rush out of the house. Her three young daughters want her to take them to the beach instead. She can't, she tells them, because she has a meeting with a client. "Mom, when can I be a client?" The plea gets to her; the next scene puts the family at the beach where mom's conducting her meeting by telecom.

Although the ad was successful in the general market, the client "did not have an expectation that it would work" for Asians, said Saul Gitlin of Kang & Lee. Asian focus groups confirmed it. The issues: The spot leaves unresolved where the father is: Was there a divorce? Had

the manly butterfly

To Koreans, believe it or not, the butterfly is a masculine symbol, said Patrick Chu of Loiminchay, Inc., so he used one—blue on a black background—for a scotch ad targeting Koreans. "You want me to tell you how hard it was to convince our client?"

The link between butterflies and masculinity is more esoteric than visceral, said Matthew Dewey of Korean Cultural Services in New York. When he asked the organization's director to comment, Byongsuh Lee "had to think about it." The result: Lee said the butterfly might be considered male in the way that flowers are almost universally recognized as female.

A butterfly goes from flower to flower collecting nectar. In the same way, a woman, being asked by the man to be more aggressive, may reply: "The flower doesn't come to the butterfly." When Dewey took the question to his Korean wife, he said she agreed, but mentioned that if she saw a butterfly by itself, it has a softer image, one a schoolgirl would choose to wear on her backpack.

he already left for work? And the woman has only daughters, not the sons that Asians prize. Where the U.S.-born, mainstream market saw heroism in the portrayal of the woman doing it all, the Asian-born more typically perceived the woman as having made poor choices, Gitlin said.

Gitlin described customized executions of AT&T's "All Within Your Reach" campaign for Chinese, Korean, Japanese and Vietnamese markets. They change based on understanding of the distinct audiences.

CHINESE: At night, a young man in the U.S. is at the computer, emailing his girlfriend in China. He's probably a graduate student, reflecting the fact that Chinese often come to the U.S. as students. The full moon is visible through the window. He writes "the moon is beautiful tonight." The girlfriend can't see it because it's daytime in China.

"Wait a minute, I'll send it to you," the man writes. Using a digital camera, he takes a picture of himself and of the moon. Then he digitally cuts and pastes them together so it looks like he's holding the moon. He sends her the image, with the inscription: "May our love last forever."

The situation would be romantic in most cultures, but it was especially significant to the Chinese, to whom the full moon—in classical Chinese—is the symbol of separated lovers. More significant still, the spot broke on the eve of the Moon Festival.

KOREAN: It's common for Korean immigrants to send children back to Korea to study the language. So a spot shows a boy at summer language school receiving an e-mail reminder from his family that "today's your mother's birthday." He e-mails himself wearing a party hat to the birthday party. But what really brings mom to tears is when he speaks to her in Korean.

JAPANESE: Many Japanese in the U.S. are expatriates; they tend to live in the U.S. for two to five years to work or study. Ties to Japan are strong. In the spot, a young man wakes up in an apartment or a hotel room. He sees on the calendar that it's the day of his class reunion in Japan. The scene cuts to Japan, where his teacher and fellow students have gathered. One says, "let's call him in

the U.S." They share digital images of each other, with the absentee celebrating as he becomes part of the gathering.

VIETNAMESE: An immigrant population that's largely made up of refugees, this group tends to feel most cut off from the home culture. Traditionally, they haven't traveled back and forth, as other Asian cultures have. So among Vietnamese, there's "a tremendous nostalgia" and desire to preserve the culture. The spot tapped into those feelings, linking the nostalgia with technology.

"How was school?" a mother asks her daughter and learns that the girl's teacher has assigned a report on Vietnam. While browsing the Web, her daughter sees a girl in a traditional costume playing a traditional stringed instrument. She shows her mother, who recognizes the instrument and finds one in the house. They call the father at work on his cell phone so he can experience his daughter learning to strum this instrument.

Other projects also have benefited from observing values. An insurance company's move to China required a rethought logo, said Rupali Steinmeyer. The original illustration of a set of parents with a son and a daughter doesn't work for a country that has a one-child policy, so Planet Leap redesigned the logo to include just one child. What's more, given the country's prevailing attitudes about gender, the company didn't want to be seen as taking a political stand so the child was drawn to look gender neutral.

Another logo—two hands holding up the roof of a house—also got a makeover because in China most people live in apartments, not in houses. Artwork also swapped a big car for a big-city-size small compact.

As you saw in the Introduction, effective designs for U.S. immigrant audiences also take cultural touchpoints and overlay them with the immigration experience. Because the younger generation acculturates more quickly than an older one, children often have to do things for parents and grandparents who may not know the language or the ropes. A spot for Bank of America reflected that reality by showing the benefits of its in-language telephone centers, said Gitlin of Kang & Lee. The mother-in-law depicted in the spot could do her own business and not have to rely on her daughter-in-law. That speaks to the heart of experience that's common to all immigrants … feeling helpless.

stick with "living" icons...

the fastest way to turn off your Asian audiences is to use funerary symbols in designs for the living. Many of the cultures' superstitions deal with luck, and dying is considered exceedingly bad luck, so Asians use plenty of symbols to separate the living from the dead. They also use symbols to show special respect for the dead. For example, shooting stars, a positive symbol in Western cultures, are bad luck to Chinese, according to *Cultural Insights*, compiled by Kang & Lee. Other symbols of death and bad luck include colors and numbers, even the position of chopsticks.

...The Thing About Chopsticks

After a Chinese funeral, it's customary to have a meal at which a place is set for the dearly departed. At that place, also according to custom, rests a bowl of rice containing upright chopsticks. And in traditional Chinese and Japanese homes, the same symbol might appear in a shrine to a dead loved one. The image doesn't belong in any advertising message except one like this: InterTrend uses the image in a house ad to say it takes a cultural expert to avoid such sticky situations (next page).

About the image, the ad's degree of impact depends on the viewer. Audiences come in three varieties, Halladay said: the ones who aren't bothered by such an image; the ones who think it should bother them but it doesn't; and those who find the image so alarming, they won't even look at it. (The third category included some InterTrend employees!) What determines an immigrant's degree of sensitivity, Halladay suggested, may be when that person left home. Cultural images become "pretty much locked in time" in a person's consciousness based on the traditions in place at that time.

In one ad (from a different agency) that targets a Japanese audience, the tips of the chopsticks (the parts that touch the food) make contact with the table. Artist Noriko Hoge said a Japanese would not do that; it would be considered bad manners. The tips should be up. Another big taboo is crossing chopsticks. Parents severely reprimand children who do so by mistake. When Hoge came to the U.S. from Japan in 1990, she said she saw American women use chopsticks as hairpins to look like the kanzashi sticks geishas used in their hair. But here, she was shocked to see, the westerners often crossed them.

If this picture offends you, we apologize. If it doesn't, perhaps we should explain. Because, although this picture looks innocent enough, to the Asian market, it symbolizes death. But then, not every one should be expected to know that.

That's where we come in. Over the last 7 years Intertrend has been guiding clients to the Asian market with some very impressive results. Clients like California Bank & Trust, Disneyland, GTE, JCPenney, Nestle, Northwest Airlines, Sempra Energy, The Southern California Gas Company and Western Union have all profited from our knowledge of this country's fastest growing and most affluent cultural market. And their success has made us one of the largest Asian advertising agencies in the country.

We can help you as well. Give us a call or E-mail us at jych@intertrend.com. We can share some more of our trade secrets. We can also show you how we've helped our clients succeed in the Asian market. And that's something that needs no apology.

InterTrend Communications
19191 South Vermont Ave., Suite 400
Torrance, CA 90502
310.324.6313 fax 310.324.6848

OOOOPS.

120

Flopped Flap Causes Flap

And watch how you fold models' kimonos! And you'd better watch it all the way through production. Even in a Japanese-American audience in modern times, sensitivities can reach deep. A community that will go unnamed here chose a photo of a kimono-clad young woman to promote a Japanese-American event. The woman properly wore her kimono with the left flap on top. No one noticed that the photo had been flopped—showing the right flap on top—until the image graced the full run of souvenir booklets, posters, banners and newspaper supplements. Then members of the planning committee "blew a gasket" and insisted on reprinting, said our source, a Japanese-American committee member who didn't see the need for concern.

What was the big deal? The worst that happens with a non-Japanese flopped photo is that type—and wedding rings—loses its meaning or a hair part changes sides. But in Japan, only dead people are dressed with the right flap of the kimono on top. The community considers the incident so embarrassing that the person who told the story asked to remain anonymous so as not to identify the group by association. (As the source added, the need to save face is strong among Japanese people.)

That's not the only kimono with flopped lapels. Another properly shot photo of Katherine Soshu Lyons, a teacher with the Urasenke School of Tea (Washington, D.C. branch), was flopped on the cover of the Food section of a major daily newspaper. It's not just the kimono that went wrong. The photo's flop causes Lyons to appear to use her left hand, not the right, to pour the water from the tea ladle. After training for almost six years in Japan, she never would do that.

"We received phone calls from other tea groups all over the country scolding us," said Austin Babcock, Lyons's husband and fellow teacher. Here's proof that discrimination doesn't discriminate. It comes even from some people in cultures that have been discriminated against. Babcock said the scolders unfairly assumed it was Lyons who made the mistake because she's not Asian.

But in fact, the couple and the photographer, Mark Finkenstaedt, took extra care with every detail of the photograph, even down to the position of the shadow, to be true to cultural tradition. In the yin and yang philosophy of balance, the right hand is the yang hand, which represents energy outgoing, so that's the hand that does the action. It holds the ladle, which is considered a yin object because it holds and receives energy, the water in this case.

Understanding a culture—or at least knowing when you don't—is important to avoid other errors: A photo of a small tea whisk on an inside page of Lyon's article resembles a flower … at least that's what the caption writer must have thought because, instead of identifying the object, the caption referred to the art of flower arranging.

deadly symbols

Symbols to avoid because they signify death:

- Chinese: shooting stars, upright chopsticks, odd numbers, 4, seven serving dishes, red ink for personal letters, white handkerchief, clock, watch

- Korean: chrysanthemums, red ink for names of the living and for personal letters

- Vietnamese: three people in a photo, white handkerchief

- Japanese: kimonos folded with the right flap on top, upright or crossed chopsticks, even numbers, 4, red ink for names of the living and for personal letters, white handkerchief

Colors to Avoid Like Death

For many Asians, white is the funeral color, especially for funeral flowers. For Chinese audiences, black and navy blue also come with cautions. Black (unless it's the logo color), especially used as a background, is taboo because it also may be worn to Chinese funerals, said Kendal Yim of Dae Advertising. (The custom, but not the taboo, holds true for western cultures.) Also avoid showing a photo of family members or other living people in a black frame, another funeral custom, for Chinese as well as Koreans.

For Chinese audiences, navy blue's no better than black, especially white with blue, Yim said, citing the custom of distributing white lanterns with navy blue lettering at funerals. Gitlin of Kang & Lee also cautions against white characters on a navy blue background.

Even a seemingly harmless phrase like "thank you" in the wrong form and colors can trip up the unwary. Vicky Wong of Dae Advertising mentioned an ad from a major telecom company in which a single black Chinese character that means "thank you" covered two-thirds of the white page. "Big no-no," she said, because that's a sign you hang in a funeral parlor to thank the guests for coming, and it's the only time you'd put the word in one character. For nonfuneral uses, it's two characters and never in black.

For Koreans, white and yellow are the colors of funerals, and chrysanthemums are the flowers of funerals; Japanese also wear white. In Japan, too, it has been traditional to hang a black-and-white striped banner on the wall for funerals (and a red-and-white striped one for weddings), but the colors vary from region to region. In Kyoto, for example, the funeral colors are yellow and white, Babcock said.

Outside of Kyoto, avoid using any colors including gold and silver for funerals. Noriko Ito once shopped for a card to send to her friend in Japan whose mother had died. She said she couldn't find the right card because almost all the American sympathy cards included inappropriate colors, like red, gold, silver, or colorful flowers that Japanese would never use for funerals.

But red has one place in Korean and Japanese funerals: to write the name of the deceased. So never use red ink to show the name of a living Korean or Japanese person. Similarly, avoid red for a personal letter to clients because it signals the death of the relationship, according to YAR Communication's website.

Other Avoidables

It's not just the subtle signs of death you'll want to bar from your creative concepts and designs. Also keep out the blatant ones. Shocking visuals don't work, said Wilky Lau of Muse Cordero Chen & Partners. For example, a couple of years ago, the agency tested anti-smoking ads for the California Dept. of Health. The ads showing caskets tested poorly. The audience members didn't care that the message was for their own good. They found the death images offensive, like a bad omen, he said.

It's also better to leave dead fish, and sometimes black fish, out of your designs. Dead fish are seen as a replacement for people, says Vicky Wong of Dae. "They die so you don't have to. It's a feng shui thing," she said (see *Feng Shui's Place in Graphic Design*, pg. 141) It's also a symbol meaning irreversible.

When your designs to Chinese include depictions of meals, make sure the photos don't include seven serving dishes, the number traditionally served at the funeral dinner. In designs targeted to Chinese, Vietnamese and Japanese, also avoid showing sorrow-related white handkerchiefs. Also leave out scissors, knives and letter openers—anything sharp—which symbolize cutting short good luck. For Chinese, umbrellas sound like "separation." Umbrellas also carry caveats for Koreans and Vietnamese. Don't show them open indoors. It's said to block luck.

The Power of Numbers

What's right with this "picture": 1235678? The number that's missing from that sequence also ought to make itself scarce in your designs to Chinese, Koreans and Japanese. They shun the number "4" more universally and passionately than westerners do "13." It's a sound-alike issue. In Chinese and Japanese, the number can be pronounced like the word for death.

So, for example, if you go to wedding gift sections of native department stores, you'll see the tableware packaged and displayed in sets of five pieces, not four, says Norman Ishimoto of Kiyomura-Ishimoto Associates.

Don't take this lightly. In the U.S., some Asians will spend as much as $1,000 to change the street address of their business or home. Phone numbers get similar editing. In China, anniversaries and birthdays that mark the 40th year for both sexes, and the 41st for women may go uncelebrated.

Also avoid "9" for Chinese and Japanese because it could be pronounced the same as the word for suffering. But the number "9" or any combination of numbers that equal "9" are good luck to Vietnamese. For that culture, bad luck comes with the number "10" or any combination of numbers that equal it. It's also considered bad news to show (or take) a photo of three people. It suggests the person in the middle will die.

Other taboos concern either even or odd numbers, depending on the culture. For Japanese, it's bad luck to show even numbers of things, like flowers, in designs. Even numbers can be divided easily, which signifies the end, so they're limited to funerals. For Koreans, it's the same. Not for Chinese: For example, objects like a bouquet of nonfuneral flowers should contain an even number, and envelopes in red (for weddings and holidays) or white (funerals) should contain new bills in even denominations and totals.

Sure, Chinese love red, the brighter the better, and other bright colors, which they use for celebrations. Chinese women even get married in red. Pair that popular color with prosperous-looking gold and Chinese tend to love it even more. Gold ink on cards and publications is especially admired.

Also for Chinese, green, the color of jade, is thought to bring health, longevity, prosperity and harmony. That's true as long as it's not on a hat, which indicates a variety of nasty stuff, depending on whom you talk to, such as the wearer's wife is unfaithful or his sister is a prostitute.

Advertisers to in-country Koreans use a lot of red, yellow and blue. The combination, adopted by Asiana, a South Korean Airline, and other advertisers, is based on the country's festive clothing, according to *Marketing Aesthetics* by Bernd Schmitt. But be careful using red alone in messages to Korean immigrants, because the

COUNTRY	POSITIVE	NEGATIVE
China	3, 8	4, 9
Japan	8	4, 9
Korea	3, 7	9
Vietnam	9	10

	3	4	7	8	9	10
China	pronounced like "life"	pronounced like "death"		pronounced like "get rich"	pronounced like "suffering"	
Japan		pronounced like "death"		power	pronounced like "suffering"	
Korea	good luck		good luck		pronounced like "suffering"	
Vietnam	avoid photos with 3 people				good luck	bad luck

color can evoke communism. For the same reason, Vietnamese immigrants take offense at a red star on a yellow field. But in-country, red and pink are thought to bring good luck.

The tricky part is that some Korean immigrants also consider red a positive color, and red and blue, with white, are the national flag colors. Red symbolizes yin (positive) and blue, yang (negative). The white's there probably because Koreans have long been known as people of the white cloth, said Kyung Eun An of InterTrend. That's probably because years ago, the country didn't have a well-developed system for dyeing cloth so only the royal family wore color.

The Japanese color tastes were cultivated from two contrasting traditions: Shibui, made up of muted vegetable-dyed hues, and Kabuki and Noh theater colors, which were dazzling to be visible under dim lights. The flag of Japan reflects this balance with a red ball, representing the sun, on a white field. Purple traditionally was a royal color. In all color choices, Japanese tend to look for balance.

A country's physical relationship to the equator influences the color choices of its people, said Andy Lun of the Toto Group in New York City. "The weather affects their thinking." To the north, above the equator, colors tend to be more subdued. Cultures below the equator tend to prefer bright hues. In the Philippines and Malaysia, for example, colors are loud and vibrant. That phenomenon, he said, is reflected in the States where you'll see different colors—and attitudes—in California and Florida than in, say, Chicago.

In color, as in every other design decision, don't make assumptions. "You can't just say blue is bad and red is good. You have to place [color choice] in context," said Lee Yang of Kang & Lee. It's true, said Lun, adding that bright colors are no more appropriate for promoting small business loans to the Chinese than they are to westerners.

壽　慶

4 月 8 日，星期六，JCPenney 98 年壽慶，邀您一起來歡慶！全店上百種新上市的商品，特價九折到半價，並請您剪下報紙上的折扣券，在當天早上八點到中午十二點使用，有些特價商品，可再給您 10% 的額外折扣。

而且，您更不可錯過 "買第二件只要 98¢" 的大優待。用 $24 買一件針織外套，就可用 98¢ 買一件背心，搭配成套。用 $24 買一個心愛的手提包，再買搭配的錢包，就只要 98¢。用原價買一件男西裝上裝，就可用 98¢ 買成套的西裝褲一件。用原價買太陽眼鏡或領帶，再買第二件就只要 98¢，來來來，全店好地找，到處都是 98¢！

JCPenney 98 週年慶生大特價，蘭喜好得難以置信，這個星期六，您一定要來搶購！＊折扣以本店原價為準。折扣券不適用於買第二件 98¢ 的優待。現品銷售，詳情請見 JCPenney 商店。

www.jcpenney.com

來逛・電詢・上網

發發發，賺免費機票，真發！

bongs, rocks and other symbols

'Behind the 8 ball?' Sounds good

The number "8" represents good luck to the Chinese because it sounds like "to get rich." So JCPenney helped to announce its 98th anniversary with an ad that used noodles, a Chinese symbol of long life, to spell out the number of years. The longevity of the company and the presence of the lucky number "8" were worth celebrating. The ad promoted a "buy one and get one for 98¢" sale.

Northwest Airlines promoted a new route to China by offering 8,888 additional miles, based on that so-lucky number. InterTrend depicted it with knot tying, a traditional art that symbolizes good luck and continuation. Wasn't it a problem that the offer contains *four* "8"s? The good fortune of the "8" would be seen as stronger than the "4" taboo, said Halladay. The headline reads "Fa-Fa-Fa," which translates to "Prosper, Prosper, Prosper."

Japanese also like the number "8," which they consider a "power" number because the words sound similar. Some people emphasize that number on their family crests, said Ishimoto.

After "8," Chinese prefer "3" because it's pronounced like the word for life. Koreans also like "3," as well as "7." For Vietnamese, as we mentioned, "9" is best.

ere's the difference between Chinese and Japanese tastes in visual messages, says Wilky Lau. Perhaps due to the Zen influence, the Japanese tend to have more tolerance for what he calls the ethereal approach, indirect messages. Chinese, on the other hand, respond to more direct, clear and factual cues. For example, to Japanese, Lau might show a rock to evoke a mood. But if he were to put the same rock in an ad for the more down-to-earth Chinese, he'd probably hear: "'Why the hell are you showing me a rock?'"

Koreans also tend to look for clear meaning in their messages. A GTE ad used "bongs," rice boxes used in native-Korean food markets, to remind immigrants of home, and more (next page, top). It doesn't take words for the boxes to "say" that the company will do more for their loyal customers than the competition will. In Korea, merchants use the wooden dowel to scrape off rice that exceeds the height of the boxes they sell to some customers. But they forget about the dowel for customers they know.

스몰 비지니스 사장님께 –
단골 손님을 제대로 모실 줄 아는
장거리전화 회사가 인사 드립니다

단골 손님께 답을 후하게 베풀수록 더 자주 찾아 온다는 사실은 비지니스의 기초 상식. 그런데 대부분의 장거리전화 회사들은 이러한 기초 상식을 잊고 있는 것 같습니다. 사장님께서 사업 상 장거리 전화를 남보다 많이 사용하셔도 남다른 혜택은 커녕 남들과 똑같은 분당 요금을 지불해야 하고, 일편단심 한 회사만을 이용해도 특별한 대우는 커녕 남보다 불리한 조건으로 사용하신 경우도 허다하지요?

이제, GTE의 단골 손님 대접을 받아 보십시오. GTE의 플래티늄 밸류 플랜 (GTE Platinum Value Plan™)은 장거리 전화를 많이 사용하는 사업체에게는 분당 요금을 남보다 더 싸게, 그리고 3년동안 해마다 분당요금이 점점 낮아지는 획기적인 서비스입니다.

매 월 청 구 액	$0.00 - $24.99	$25.00 - $99.99	$100.00+
1년 째	17¢	14¢	12¢
2년 째	16¢	13¢	11¢
3년 째	15¢	12¢	10¢

이 것 뿐만이 아닙니다. 이 플랜에 가입하시면 월회비 사용액이나 필 사용료도 없으며, 한국으로 거는 국제 장거리 전화도 받기 어려울만큼 저렴한 요금으로 이용하실 수 있습니다. 어떻습니까? 더 이상 망설일 이유가 있으십니까? 지금 당장, 무료전화 1-888-822-4989로 GTE 플래티늄 밸류 플랜에 가입하여 단골 손님 대접을 제대로 받아 보십시오. GTE는 미국 내 최대 규모의 통신회사 중의 하나로 저희 고객들에 비지니스의 기본인 친절과 신용 그리고 후한 인심을 베풀기 위해 항상 노력하고 있습니다.

GTE

1-888-822-4989
사업용 한인 고객 상담 전화

GTE 플래티늄 밸류 플랜은 경쟁 3년 계약이며 도중에 해지될 경우 수수료가 부과됩니다. GTE Platinum Value Plan is a service mark of GTE Corporation.

It may look like only rice, but these boxes also hold nostalgia for Korean immigrants. Vendors in their native land would use the dowel to measure off a precise box-worth of rice. But for favored customers, they would not use the dowel.

AGENCY InterTrend Communications
CLIENT GTE, courtesy of Verizon

米国　　　　日本　　　　欧州

アメリカでのびのび。　日本でのんびり。　ヨーロッパでゆっくり。

選んでうれしい3つの旅。

今、日本またはアジアへ一往復されると、いずれかへの無料航空券を贈呈いたします。

ノースウエスト航空は、お陰様で日本就航50周年を迎えました。今、皆様へ感謝の気持ちを込めて、豪華な特典をご用意いたしました。今、日本またはアジアへファーストクラス、ワールドビジネスクラス、または正規普通運賃によるエコノミークラスのいずれかで一往復されると、5つの無料航空券からお好きなものをひとつお選べます。

・アメリカ本土48州国内線又はカナダへの無料往復航空券2枚（エコノミークラス）
・アメリカ本土48州又はカナダ・日本間の無料往復航空券1枚（エコノミークラス・呼び寄せも可能）
・アメリカ本土48州又はカナダからヨーロッパへの無料往復航空券1枚（エコノミークラス）

ますますワールドワイドになった、ノースウエスト航空での空の旅。次のバケーションや旅行の楽しみさらに広がります。このプロモーションにご参加になるには、パシフィックアワーズプログラムにご登録ください。お電話でのご登録はノースウエスト航空1-800-355-1479（日本語デスク）までどうぞ。

50 YEARS

BRIDGING the PACIFIC
日本就航50周年

NORTHWEST AIRLINES

ここに、翼をもった人たちがいる。
1-800-355-1479 / www.nwa.com

Another relevant cultural note to Japanese with a positive association: The gift envelope traditionally is given on special occasions. It contains money and is elaborately tied, often with a "bow" in the shape of an animal.

AGENCY InterTrend Communications
CLIENT Northwest Airlines, Inc.

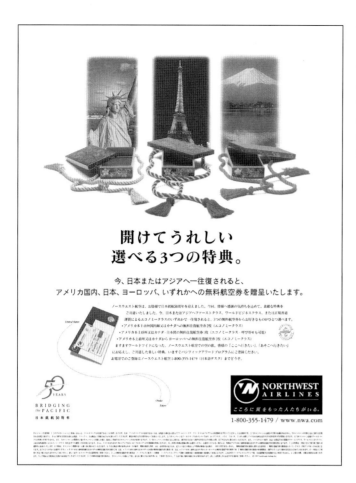

Three open boxes, Tamate Bako, represent gifts to a Japanese audience, based on a folk tale. Icons represent each of the three "gift" countries: the Statue of Liberty, the Eiffel Tower, and Mt. Fuji.

AGENCY InterTrend Communications
CLIENT Northwest Airlines, Inc.

In an ad for Northwest Airlines, three open boxes represent gifts in the form of mileage awards to Japan, the U.S. and France. Each country is represented by its most iconic symbol. The boxes, called Tamate Bako, are tied to a story. One version has a sea captain saving a sea turtle from mean kids, and being rewarded with a trip underwater and a box but warned not to open it. After he returned home, he couldn't resist opening it. When he did, he became an old man, because although he thought he had been away for just three days, it had been many years. He had received the gift of eternal youth.

A Pan-Asian ad for Southwestern Bell featured icons found in the musical notes that hover over an Asian harp. In the ad, for an Asian Heritage Month celebration, each icon symbolizes a different ethnic group. Only the

language—Chinese, Vietnamese, Korean, Filipino, Japanese and Indian (English)—changed from ad to ad.

The symbols that were used:
» for Chinese: goldfish
» for Vietnamese: ox
» for Japanese: crane
» for Koreans: yin and yang symbol
» for Indians: elephant
» for Filipinos: lantern

Some expressions and their visual representations don't translate, so a new symbol must be found. Young & Rubicam (Kang & Lee's parent company), developed the creative guidelines for the Lucky Dog Phone Co. Kang & Lee altered the concept and the logo for the Asian

market. The general-market version had a dog's face in the logo to symbolize luck, but no counterpart to the lucky dog exists in Asian culture so for the Chinese, Japanese and Korean markets, Lucky Guy was born.

Many Chinese appreciate dragons as a symbol of authority, said Zan Ng of Admerasia. But you must be careful how you present it. Young Kim of Kang & Lee said the image can be shared by Chinese and Korean audiences as long as you vary it. Korean dragons can be friendly looking. Both cultures see dragons as symbolizing superiority and protection, Kim said. But it's probably used more in Chinese-targeted designs.

In using dragons and other cues, show you're culturally sensitive without overdoing it, said Angi Ma Wong, intercultural consultant and author. Avoid stereotypes "like the silly idea that anything Chinese must be red and have dragons." If ads are targeting younger, second-generation Chinese, she said, the cultural sensitivity is more catered to lifestyle. "If you use a dragon for this audience, you'll become a laughing stock. Even though we're all Chinese, it's a different culture."

The preview issue of *Element*, a style magazine, shows agreement. Although the publication targets Asian women, publisher Angelo Ragaza "didn't want to push the Asian thing." To him, that meant "no brush calligraphy." Within a strong vision that the style not be too literally Asian, it also couldn't be too red. "I love red," he said, but "in this context, red is way too Chinese." The magazine is designed to appeal to all six major Asian-American groups.

Young Kim uses a food analogy to describe his philosophy. He started his agency, PanCom International, based on Asian tradition. But, he said, now he feels that tradition's less important in advertising than an appropriate and impactful message. "Sometimes don't you want a different cut of meat or a different sauce? But clients always want teriyaki sauce on every food."

The sauce depends on the message and the audience. For example, Wong said, immigrants from Taiwan or Hong Kong aren't westernized and are very interested in their country of origin, so they respond to more traditional symbols. For them, the agency chooses ad images that touch their heartstrings.

130

Kim agrees with the need to avoid meaningless cues: "Never use traditional graphic elements for the sake of recognition or client entertainment. Some clients want to see traditional stuff in an ad even where it's irrelevant to the message."

Meaningful cues can include even real animals. Nature's harmony symbols were shown in a Schwab booklet whose cover featured a fish, which represents abundance and prosperity, said Kerstin Goetz of Jungle Communications. The characters on the fish (from a stone seal that's several thousand years old) literally read "May your table never be empty." Although the language isn't contemporary, the line still can be understood by contemporary Chinese speakers.

Other icons for the Schwab booklet also were chosen for their meanings as well as for their looks:

- » CRANE longevity and wisdom
- » OX fertility
- » BAMBOO LEAVES life (given that the bamboo tree is used as a source of food, building material and firewood)
- » BIRD evokes folktales about men who can understand the birds and use what they learned to get out of danger or amass great fortune
- » THE COLOR YELLOW abundance and prosperity (like gold)

"Non-Asians who look at this piece often say 'Huh? What does a fish have to do with financial planning?'" said Goetz. But Chinese Americans understand instantly. That's the idea behind cultural adaptation, she said. It's showing the willingness to go the extra mile to achieve relevancy and understanding. It's demonstrating your respect for the audience and its preferences. There can be almost an emotional response.

Like Chinese, Japanese follow the custom of giving money in red envelopes for happy occasions, and in white ones for funerals. The red envelopes, called mizuhiki, are often wrapped in gold or silver cord that's tied into shapes like butterflies, turtles and cranes, the symbols of long life. In fact, it's traditional to celebrate important birthdays and anniversaries with decorations of a thousand handmade paper cranes. And if you want to show good luck, show a tea leaf floating vertically in the cup.

Religious symbols for a Japanese audience may be more acceptable than for other Asian or non-Asian audiences. Religion and spirituality are as much a part of daily life as eating, said Noriko Hoge. Spiritual images like a Torii Gate or the entrance to a Shinto shrine can be appealing. In fact, a religious image was used in a

Northwest Airlines TV spot. In Japan, it's part of the culture that most families go to both Shinto shrines and Buddhist temples. It's typical, for example, to go to a Shinto shrine to commemorate births and to a Buddhist temple for funerals.

Also, for Japanese, "cute" sells. In Japan, often you see "little cartoon animals and pastel colors that you wouldn't expect to see for adults, promoting everything from gas stations to food products," said Laurel Lukaszewski of Japanese American Society of Washington. In the States, such animals would be limited to packaging for children's cereal. In Japan, street signs include "cute little characters, such as a frog with a seat belt to encourage buckling up." And you see women carrying Hello Kitty accessories. In fact, she said, she received a Hello Kitty purse as a gift.

But apparently there's nothing cute about winking to the Japanese, so avoid the facial expression in your designs. Where a general-market ad might have a model winking to show cleverness or an inside joke, it's meaningless or rude to this audience. "We don't wink," Hoge said.

An extension of the "cute" idea is a love of things small. While Goetz worked on a package design for a computer part for the Japanese market, every Japanese person who saw it thought it was much too big. That's a practical as well as personal preference, she said. Because merchandise is displayed in small areas in Japan, it's considered inappropriate to have a huge package for a small product and there's a preference for small, even cute items. When Goetz's team made the package as small as it could be, she was asked "Can you make it smaller?" That input came in equal measure from Japanese in Japan, from Japanese Americans and from Japanese immigrants to the U.S.

Although a dragon is seen by some as an Asian design cliché, in this case the image couldn't be more appropriate. It's an ad for a New Year—of the Dragon—sale. Here's the Vietnamese version.

CLIENT JCPenney

Con Rồng
năm Canh Thìn múa lượn
đem vào một
thiên niên kỷ mới.
JCPenney
Xin Kính Chúc
Qui Vị Vạn Sự Như Ý.

Tặng Bích Chương Hình Con Rồng*:
Để đánh dấu năm Canh Thìn, JCPenney tặng một tấm bích chương hình con Rồng tuyệt đẹp cho tất cả mọi khách hàng. Hãy ghé đến studio chụp ảnh của JCPenney để nhận tấm bích chương ấn bản đặc biệt này miễn phí. Với tấm bích chương đầy màu sắc trên tường, cả gia đình bạn sẽ cảm thấy vui vẻ và may mắn suốt năm.

Baby Sale**:
Trong dịp Tết năm nay, JCPenney có đợt Baby Sale thật đặc biệt. Bớt 25% cho hiệu Carters, 25% cho hiệu Heirloom Collection và bớt 30% cho hiệu Osh Kosh. Chăn mền, quần yếm, và rất nhiều các món hàng khác cho em bé cũng đang được giảm giá. Hãy ghé đến để mua sắm quần áo mới cho các em trong dịp Tết.

Nụ Cười Của Thiên Niên Kỷ Mới***:
Xin chúc mừng nếu bạn có em bé tuổi Rồng trong thiên niên kỷ mới. Con của bạn có thể được tặng một bộ ảnh chân dung miễn phí hàng năm trong ba năm liên tiếp tại Photography by JCPenney. Chỉ cần gởi bản sao giấy khai sinh của em bé cùng với tên và địa chỉ của bạn về: 2000 Reasons to Smile Contest. P.O. Box 39899, Minneapolis, MN 55439.

JCPenney®
www.jcpenney.com

Hãy ghé đến. Hãy gọi vào. Hãy log on.

*Bích chương chỉ được tặng trong khi còn hàng. **Số % được bớt trên giá nguyên thủy. Một vài giới hạn được áp dụng. Đợt Baby Sale chấm dứt ngày 21 tháng 2 năm 2000. ***Một kỳ chụp ảnh mỗi năm. Chi tiết và phiếu chụp ảnh miễn phí sẽ được gởi bằng đường bưu điện đến địa chỉ đã được cung cấp. Giới hạn cho 2000 em bé đầu tiên. Những chi tiết trong giấy khai sinh chỉ được dùng bởi LifeTouch và sẽ được giữ kín.

133

a logo makeover

The Asia Society has had its current symbol—a "leogryph," a mythical animal that combines a lion and a griffon—for more than thirty years. The secular creature guards the gates to Buddhist temples and is a symbol of protection against evil. When the Society went to Pentagram's Paula Scher for an identity makeover, she advised keeping the symbol because it's one of the few that works across Asian cultures. The image also means good fortune to all Asian groups. That makes sense for an organization whose goal is to unite the East and the West.

But the logo needed a facelift ... onto a body, for starters. Before the redo, it was a complicated, disembodied head sitting on top of type. The designer simplified it and enclosed it in a circle, to signify unity and harmony. The circle also made the logo look like an Asian stamp, or "chop," which an Asian artist uses to sign artwork. And the circle permits flexibility in coloration and placement. Encircled, the logo can be used as a kind of punctuation. The circle also fulfilled another goal: to create a spare design that can appear horizontally or vertically.

Type changed too. In the old logo, the word "society" is as big as the word "Asia." Scher thinks of the word "Society" as conveying something secret or Machiavellian, so she played it down while pumping up the word "Asia." (No thought of changing the name? Nah. Scher quoted George Carlin who said, "'You be my name and I'll be me. If George is a dorky name, I'm not a dorky guy.'" What's more, the organization has years of equity in the name.)

A leogryph—a lion and a griffon—is a
Pan-Asian symbol, so it was kept and
updated in an identity makeover. Encircled,
the symbol can work in different color
combinations to represent the various areas
of the organization.

CLIENT Asia Society

STUDIO Pentagram

CREATIVE DIRECTOR Paula Scher

PHOTOGRAPHER (BANNERS) James
Shanks (www.jamesshanks.com)

how to design with holiday themes

In any culture, holidays are important themes and that seems to go double for the Asians. So you'll see these themes in plenty of targeted designs to promote sales or just to send holiday greetings. InterTrend's website includes a calendar of the current year's Asian holidays. Most Asian cultures follow the lunar, not the western Roman, calendar, and they share some holidays. So it would be easy to assume Asian segments attach the same meanings or celebrations to similarly named holidays. Don't.

For example, some of the traditions, including icons and other visual representations, change even for the New Year, the biggest and most universal holiday. But not all observances differ among cultures. For example, China, Korea, Vietnam and Japan share the Chinese zodiac, with just minor variations. This zodiac consists of twelve animals, one for each year, in a rotating twelve-year cycle. Starting with 2002, the Year of the Horse, the Chinese zodiac years and their symbols continue like this:

2003: Sheep

2004: Monkey

2005: Rooster

2006: Dog

2007: Pig

2008: Rat

2009: Ox

2010: Tiger

2011: Rabbit (Cat for Vietnam)

2012: Dragon

2013: Snake

holiday symbols

136

LUNAR NEW YEAR

- **China** Zodiac, red and gold, diamond shapes, gift-giving, loud firecrackers, tangerines (sounds like the word for "lucky"), red envelopes containing new money in even numbers. Don't show anyone washing hair or sweeping on New Year's Day (not that it would be a common theme) because it's like throwing or washing away luck.

- **Vietnam** Zodiac, gifts of money in red envelopes. Avoid showing anyone sweeping the floor; traditional Vietnamese equate the act with throwing away luck. Tet, the Vietnam New Year, is considered everyone's birthday.

- **Korea** Zodiac.

NEW YEAR

- **Japan** Zodiac; plum blossoms, pine branches and bamboo; kites; black beans, chestnut and kelp stand for happiness, success and joy; bells ring, arrows are shot in the air.

MOON FESTIVAL

- **China** Moon cakes, lanterns, star fruit, rabbit, goldfish, fairy lady.

- **Vietnam** Lanterns, fairy lady.

- **Korea** Lanterns.

- **Japan** Round rice cakes, rabbit in the moon, pampas grass.

Two golden dragons form the Hennessy cognac bottle in a lucky-red ad that wishes customers a Happy Year of the Dragon (2000).

AGENCY Admerasia

CLIENT Schieffelin & Somerset Co., New York, NY

Give a gift from the heart to a Vietnamese at Tet, but not the heart itself. During some research on organ donations among Chinese and Vietnamese immigrants, Norman Ishimoto of Kiyomura-Ishimoto Associates heard that a Vietnamese woman actually turned down a long-awaited liver transplant because acceptance would mean she'd be in the hospital on New Year's Day! Vietnamese clear out of hospitals during the three days of the New Year celebration because any association with a hospital then is thought to be bad luck. (A nonbeliever would consider losing out on a liver to be worse luck still, so the story certainly speaks to the power of the belief.)

In general, some Asians feel that their bodies must be whole to get to heaven or nirvana so they're against organ donations. Transplant agencies are having initial success, with the church's blessing, by placing an item symbolic of the donated organ in the corpse.

And each sign rotates among five elements, which include earth, metal, wood, fire and water. The colors associated with them are yellow, white, blue-green, red and black. For example, 2000 was the Year of the Golden (metal) Dragon in the Chinese zodiac and a major year for the Chinese it was, Halladay said. All zodiac signs make popular design themes, but that particular sign is a big deal. Luck is a recurrent theme to the Asians and being born in the Year of the Golden Dragon is considered so lucky that some parents try to time the birth of their children with its arrival … not that it's easy. That animal and element blend comes around only every sixty years.

The New Year also represents a time for Asians to give gifts, possibly cognac, and Asians are the biggest consumers of X/O cognac. The design of Hennessy's holiday poster series seeks to reinforce the brand by focusing on the bottle shape, a la Absolut Vodka, said Jeff Lin of Admerasia. The visuals reinforce the holiday with red and gold. And to evoke the zodiac's Year of the Dragon, the bottle shape is implied by two dragons following each other in a circle to show eternity, similar to yin and yang, the symbol of completeness (see pg. 137).

At the New Year, Chinese children also get gifts, mostly money in red envelopes from elders. That makes a red envelope an easily grasped visual symbol. One gift you probably don't want to depict in any design for a Chinese audience if you can help it is a clock or watch, because the word for that in Chinese sounds like the word for "funeral" and, as you've seen, sound-alikes mean a lot to this culture (as discussed in *The Power of Numbers* on page 124). Yet the same image to a Korean is welcome.

But you can depict this: Chinese and Japanese symbolize having more than enough food by leaving some on the plate during their New Year's meals. In fact, for these cultures, a bit of food remaining on the plate is a year-round symbol of satisfaction, while an emptied plate is an insult to the host. And many Koreans dress up in costume for the New Year, said Lun.

The Moon Festival, celebrated by the Chinese, Vietnamese, Koreans and Japanese, also has different cultural meanings. For the Chinese, it's a time to reinforce family unity with a reunion and a dinner, similar to Thanksgiving in the U.S., Lin said. At this time, even if family members aren't together, the family is considered to be

For the Moon Festival, a golden ribbon shapes the bottle. The logo represents a glowing moon against a starry sky.

AGENCY Admerasia
CLIENT Schieffelin & Somerset Co., New York, NY

Above, another ad for the Moon Festival also shows an actual moon against the night sky, which is also illuminated by traditionally shaped lanterns. The ad ran in both Vietnamese and Chinese (shown).

CLIENT Albertson's
AGENCY Dae Advertising
ART DIRECTORS Kendal Yim, Cindy Chan (Dae Advertising)
ILLUSTRATORS Peter Mong, Miranda Poon
PRODUCTION Miranda Poon, San Jue (Dae Advertising)

reunited by looking at the moon, he added. Because the full moon is a circle, it symbolizes completeness, so the tradition includes eating round moon cakes, a confection made with sticky rice. The Hennessy poster designed to mark this occasion depicts a night-sky-blue background with stars and clouds. A ribbon (symbolizing gifts, of course) represents the bottle shape around a logo that shines like the moon in the sky.

The Korean celebration is similar to the Chinese. But for the Vietnamese, the Moon Festival is more like a child's holiday, like Halloween in the U.S., celebrated with candles in lanterns (see pg. 140).

To evoke memories of Moon Festivals in their native lands for Chinese and Vietnamese living in the San Francisco Bay area, Albertson's, a chain of supermarkets, ran ads filled with lanterns, said Vicky Wong.

The lanterns illustrated on the Chinese version come in traditional and meaningful shapes, including a star fruit (a traditional fruit for the festival); a traditional, multisided graphic shape (not signifying anything in particular, said Wong); a rabbit (which turns up in some festival-related fairy tales); and a goldfish (a symbol of good luck and prosperity). Based on the same tales, the "fairy lady," who reigns at the bottom of the ad, is a main symbol of the festival. Everything rests against night-sky blue and shines in the light of the lanterns and, of course, a dominant full moon.

For the Japanese, the Moon Festival isn't as big a holiday as it is for the Chinese, so advertisers don't tend to focus on it as much for this audience. The festival is a celebration of the harvest moon, just one aspect of the culture's general love of the four seasons, said Hoge. Icons are round rice cakes called mochi kamdango, and pampas grass.

seasonal cues make meaningful motifs

Images that evoke the Asian love of nature and the seasons are popular themes. Seasonal themes probably mean the most to Japanese audiences whose typical seasonal motifs include flowers, animals and foods. For example, cherry blossoms and their soft pink color represent spring, and hydrangea with snails and frogs represent June, which is Japan's rainy season, said Noriko Ito of TechArt International. Watermelon and snowcone are the symbolic foods of summer. In fact, for almost every month, Japanese culture includes a traditional event or festival with decorations that are closely related to seasonal motifs. They tend also to be popular themes in commercial art. Ito notes these seasonal holidays and their symbols:

JANUARY » Related to New Year's decoration or food; the zodiac symbol of the year, rice cake (mochi), bamboo, pine tree, tangerine.

FEBRUARY » Plum blossoms. There's a festival called "Setsubun," in which Japanese spread dried soybeans in houses and yards to drive away evil spirits and invite in good spirits. In some regions, people wear costumes of the evil spirits and others throw beans at them, so the items used in the festival (beans, evil masks, etc.) are also symbols of the month. And Valentine's Day also is really big in Japan.

A Vietnamese moon "fairy lady" holding a fish lantern for the Moon Festival is one company's way of conjuring feelings of longing for family and homeland.

AGENCY InterTrend Communications
CLIENT Western Union International, Inc.

MARCH » Peach blossoms, hina (elaborate dolls) for Japanese Girl's Festival. (When a baby girl is born, relatives give her a set of royal family wedding dolls, which include the bride and groom, musicians and wise men. Every year, on March 3rd, Girls' Festival, also known as Dolls' Day, the family displays the set in their home on red-carpeted steps. It's a celebration of the daughters in the family.)

APRIL » Cherry blossom.

MAY » Carp (which symbolizes strength; streamers in the shape of carp are hung from bamboo poles) and samurai armor for Children's Festival, iris.

JUNE » Rain, hydrangea, frogs, snails.

feng shui's place
in graphic design

JULY » Stars and decorated bamboo for "Tanabata" (Star) Festival, which is based on an old Chinese folktale of a young couple separated by the Milky Way. Japanese traditionally decorate bamboo trees with colorful origami paper on which they write their wishes.

AUGUST » Yukata (summer kimono), fireworks, goldfish for Bon Festivals.

SEPTEMBER » Rabbit in the moon, pampas grass, white rice balls for Moon Festival.

OCTOBER » Seasonal fruits and vegetables like persimmon, grapes, mushrooms.

NOVEMBER » Leaves turning colors, chestnuts (similar to the image of American Thanksgiving decorations except for the turkey).

DECEMBER » Traditionally a month to get ready for New Year's, but these days Christmas is the major theme, although most Japanese don't celebrate it as a religious holiday.

feng shui has to do with the land, and harmonious placement of architecture, interior design and objects, said Angi Ma Wong (intercultural consultant and author of 13 books, including *Feng Shui Do's and Taboos*). But you can draw upon feng shui elements to make sure that, say, the identity program you design uses color and shapes that are appropriate for the type of business, and that they are designed in balance. Feng shui is based upon three categories—flow of energy, yin and yang and the five major elements: wood, fire, earth, metal and water. It's no stretch to relate the categories to graphic design.

For example, the flow of energy is easily linked to eye flow through a layout … where the eye comes in and how it travels from one element to the next. The terms yin and yang refer to balance. Yin represents the female, dark, soft, nurturing, right side of the body, and even numbers. Yang stands for male, light, hard, aggressive, left side of the body, and odd numbers. Unlike in architectural or interior design, though, in graphic design, consider the sides in mirror image. The left and right sides are switched because of the viewer's perspective. The viewer is outside of the design, looking at it, as opposed to, say, a person living within the design of a room.

The five elements each have a certain shape associated with them:

> » **WOOD** cylindrical (like a tree trunk)
> » **FIRE** triangles, pyramid (flames come to a point at the top)
> » **EARTH** low and flat (for example, any horizontal rectangle, but stand it on its end to make it vertical, and it becomes associated with wood)
> » **METAL** circular (like coins, or lumps of ore)
> » **WATER** irregular (squiggly or wavy lines)

THE MAGAZINE OF ASIAN STYLE

ELEMENT will be published beginning Spring 2001 by Element Media, L.L.C., 373 Broadway, Suite E2, New York, NY 10013 Tel 212.343.9503, Fax 212.343.8291, www.elementmag.com. Art Director: Daniel Chen.

FROM HONG KONG TO VANCOUVER to New York, young Asian adults understand the power of style. Status-driven and image-conscious, it's no surprise we make up half the global market for fashion and luxury goods. And with our creative energy and rich traditions, we've not only changed the look of American fashion; we've changed the way America eats, drinks, drives, and entertains. It's time for a magazine that celebrates us—our unique beauty, achievements, ideas, and aspirations, not to mention our inimitable sense of style. Starting in Spring 2001, Element will bring the most discerning readers the hottest fashion, beauty, home, food, travel, and arts with an Asian viewpoint. Visit www.elementmag.com to register for a risk-free trial subscription. In the meantime, enjoy this sneak preview of Element— and welcome to the world of Asian style.

ANGELO RAGAZA • *Editor & Publisher*

Element BEAUTY

Day for Night

Makeup that exalts—not faults— the East Asian eye.

"I like to focus color on the upper lid to enhance the tilt," says beauty guru Linsey Li.

Element TASTE

SOME LIKE IT

HAUTE

JAP CHAE— THE COUNTRY GIRL OF KOREAN CUISINE—HAS GOTTEN AN URBAN MAKEOVER

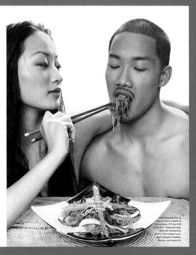

The preview of *Element*, a fashion magazine designed for young Asian women, builds an Asian look with subtlety and balance. The magazine's name crosses the first spread. Everything's positioned precisely—the model, the name, the other type and the colors to balance the spread. "Element" crosses the spread and the type column in a "T" shape, a visual idea that continues throughout the magazine.

MAGAZINE *Element* Magazine
PUBLISHER Angelo Ragaza, Element Media L.L.C.
ART DIRECTOR Daniel Chen
PHOTOGRAPHERS Jenny Risher (top spread), Jill Wachter Photography (middle and bottom)

MIDDLE SPREAD Note the balance again. The same face you see in normal size on the right gets blown up larger than life on the left to form a partial backdrop for the heading. Typography and color reflect the contrast of "day" and "night." The designer pulled the display type's blue out of the touch of shadow on the eye on the right.

BOTTOM SPREAD A scrumptious-looking food spread again draws type colors from the photo, in this case, the veggies.

Colors and shapes relate to compass direction and values. For example:

DIRECTION	COLOR	ELEMENT	VALUES
north	black	water	success, career and communication
northeast	turquoise	knowledge	self-development
east	green	health	harmony, family life
southeast	purple	wealth	material abundance
south	red	fire	longevity, happiness, fame, fortune
west	white	children and their fame	creativity
northwest	gray/silver	fatherhood	international trade, travel
southwest	yellow/gold	relationships	love, marriage

So a graphic designer, being creative, might use a lot of white or white space for her stationery, perhaps adding black for success and communication. Or, for balance, pair the west's white with its opposite direction color: the east's green, symbolizing health, harmony and family life.

Wong's own business card shows the balance between opposites, using red (south, longevity, happiness, fame and fortune) and black (north, success, career and communication). It's a graphic depiction of yin and yang, red being the most yang of all colors, also the color of blood, summer and life; and black being the most yin, representing winter and death. Everything that lives, dies; fire vaporizes water, water puts out fire. The card includes two logos in red, like Chinese "chops," the signature stamps of Chinese artists, that show her initials, one in English, the other in Chinese.

Feng shui is a matter of balance. Based on people's habits, behavior and attitudes, it promotes harmony outside and in, Lun said. It's based on common sense. For example, looking at the rule against putting a mirror facing the bed. It makes sense because people don't look their best in the morning. Feng shui also cautions against

angular shapes in general, and using sharp corners in rooms.

One of a series of TV spots from Bank of America touched on feng shui or harmonious placement of objects to support the flow of life, Yang said. A lot of Chinese people believe in it and a lot of real estate agents, especially in California, have had to study it so they can address these needs. The spot tells the story of a young couple whose new home includes a staircase in the wrong place. They want to move it and the mother-in-law confirms the need to do so. The bank will provide the loan to do it.

But Lun doesn't see too much evidence of the use of feng shui in ads because it's so subtle and "in an ad, sales must come first." Yet, he says, the visuals must be tempting and attractive, so the feng-shui-friendly presence of waterfalls, fountains or other things aquatic could put the audience in a receptive mood.

Although Daniel Chen, art director of *Element*'s preview issue, hasn't studied feng shui, you can see a feng-shui-like design philosophy at work throughout the magazine, and in his design philosophy: "always to create

a sense of balance … a yin and yang contrast." That balance extends to type, which he designs to be part of the image, and to white space, which he uses to balance the image and to bring light into the magazine.

"When you look at a lot of magazines, they're very cluttered," Chen said. Instead, he is inspired by Japanese design, which is simplified, with a kind of architectural treatment of type and images. His use of color is his own. "A basic rule for me is to find the color of display type within the image to balance out the page and integrate it. The color choice may be subtle. For example, the green/blue headline and pull-quote on a cosmetics spread (middle, pg. 142) came from the trace of color shadow on the model's eyelid."

The food spread's type (bottom, pg. 142) mimics the colors in the pictured vegetables and glass noodles. The same color is used for the whole headline: "HAUTE," but, to represent the multiple shades of food more precisely, Chen varied each character in the word by 5 to 10%.

all of *Element* magazine prints in English, because the audience is young and Pan-Asian, and most of it is set in Gill Sans, a favorite of Chen's. It's "my idea of Asian esthetics." If he used only that face, though, it would be boring, he said, so he adds the occasional serif subhead or pull-quote. For example, in "Day for Night," the cosmetic piece, the first word is serif, and white. He agreed with the publisher that brush calligraphy has no place in this publication. That old-fashioned style "only works if it makes sense." (For example, he referred to a Buddhist prayer for protection that's written in brush calligraphy on red paper that his mother gave him to carry.)

Yet calligraphy can evoke memories of home, Lin said. In TV spots for Telecom USA, a master of the art is featured in ads for Mandarin and Cantonese audiences. (For Japanese, the iconography switches to the art of bonsai; for Koreans, the "art" of chess.)

Also in an ad for Volkswagen, the brush lettering is neither accidental nor gratuitous, placed just to say

144

Informal brush lettering on an auto ad conveys the motion of the car.

Agency Loiminchay Advertising, NY
Client Volkswagen

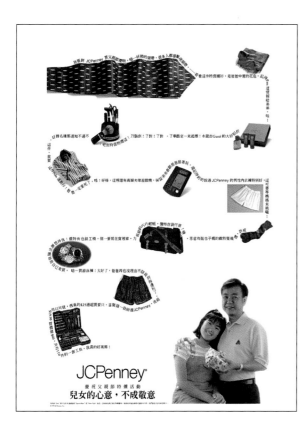

Asian, said Chu. The use of the brush lettering and its free-flowing characters here suggests motion. Calligraphy must be chosen only to be meaningful. Asians look at calligraphy as similar to painting, but he, like the others we talked to, acknowledged it can be overused.

Moving from the hand-drawn to digital, modern Chinese type fonts contain as many as 13,000 Chinese characters, said Richard Weltz of Spectrum Multilanguage Communications. That makes the typefaces much more expensive than English ones, so the average designer won't own many varieties. (About 8,500 characters are needed for common publication needs, such as newspapers and magazines, Weltz added.)

Nor are there nearly as many varieties, probably because the characters—which may contain up to 33 strokes each—are complicated enough without embellishment. A style spin could easily render them unreadable.

The characters are also more flexible than English. Depending on the character, and the context, each may represent a whole word, or even several words. This char-

acteristic means that the language is more compact than English. A sample paragraph set in the book showed it's 61% of the length of a comparable paragraph in English. And, because each character can stand for a word, characters can be written horizontally, left to right (or less commonly, from right to left) or vertically (top to bottom, with lines reading from right to left). In fact, the characters "can be written and read in just about any direction at all—probably even on a diagonal," Weltz said.

Here's a little closer look into the languages that look incomprehensible to the unfamiliar. Through invasions and occupations, Japanese kanji and Chinese have been added to the Korean native language, called hangul. Like Chinese and Japanese, Korean also can be written to read vertically or horizontally. The Korean and Japanese alphabets run about the same length as comparable text in English. "Comparable" is the key word here because "a lot can depend on the style of the translator and the nature of the subject matter," Weltz said.

Japanese's written language includes kanji, which is a Japanese word that means "Chinese character." It's

Veggie as a cosmetic is the idea of the ad that's shot with a facial close-up like a cosmetics ad.

AGENCY Loiminchay Advertising, N.Y.
CLIENT B&W Quality Grown

Watercress leaves, the subject of the ad, complement the shape of the calligraphy. Characters read horizontally and vertically. In any language, the food in the lower right makes it clear that the ad extols the nutritional benefits of the product.

AGENCY Loiminchay Advertising, N.Y.
CLIENT B&W Quality Grown

A nature theme takes advantage of the flexibility of Chinese characters that represent sweet rain falling from the sky, reflecting an Asian proverb.

AGENCY InterTrend Communications
CLIENT GTE Long Distance, courtesy of Verizon

made up of pictographs borrowed from China, but they're not phonetic—you can't look at it and figure out how to pronounce it, Wanla Cheng said. So as time went on, she explained, the Japanese developed their own alphabet, like English italics. The Japanese written language includes two sets of characters called hiragana (mainly used for grammar, such as indications of tense) and katakana (mainly to represent foreign words).

Vietnamese is a written language that uses the same kind of characters as the Western alphabet, plus three or four special characters, and a lot of accents.

In Chinese ads, although the type tends to set shorter, there's always a lot of copy and type in comparison with Western design. Not only does it sometimes take more characters to say the same thing, but often you might have to introduce a sales pitch with pleasantries to soften it, Wilky Lau said.

What type of face do Asian audiences respond to the most? "In general, we choose less glamorous, more wholesome, more real-looking faces" than are usually chosen for the general market, Halladay said. Candid-looking shots work best, added Yang.

Angelo Ragaza believes in representing Asian beauty with a certain amount of diversity. That flies in the face, so to speak, of the American and European fashion industry's traditional definition of beauty. In approving model selection for *Element* magazine, he overlooked the androgynous, cookie-cutter type of models that have been popular in favor of people whom "my Asian friends could identify with and be attracted to."

Of course you need models who look as if they're from the country whose audience you're targeting. That doesn't have to mean they *are* from that country, especially when you're targeting a similar message to different Asian audiences. To work within tight budgets, agencies often cast models with a "Pan-Asian" look, so they don't have to hire different models for each version.

Without the luxury of doing different ads for each market, "we have to use concepts that transcend individual countries," said Yang. Sometimes that means leaning a little closer toward Chinese for images, because "China is the cradle of Asian history." Each nationality has a unique look so it's important to choose Pan-Asian talent that can pass for each country. General-market agencies

watch your language

A lot has been written about the blunders you can make in translation, so I won't choke a sick octopus here (I made up that particular mistranslation, but I wouldn't be surprised if it had appeared somewhere). Just one example, to remind you to put your translations in the hands of a pro: The original "Got a minute" ad for a restaurant chain in a southern California market made no sense at all in Chinese, and translated to a pick-up line in Korean. So it's probably a good thing the agency mistakenly put that type upside down.

Ragaza chooses models that would appeal to his friends, not to the European fashion industry.

PUBLISHER Angelo Ragaza, Element Media, L.L.C.

ART DIRECTOR Daniel Chen

PHOTOGRAPHER Jenny Risher

Element

THE MAGAZINE OF ASIAN STYLE

FREE FALL 2000 PREVIEW

THE EAST
ASIAN **EYE**
BEAUTIFIED

ASIAN ON 7TH
3 HOT YOUNG DESIGNERS

WOMEN
ON THE VERGE
THE KEYS TO THEIR SUCCESS
THE SECRETS TO THEIR STYLE

THE BEST
MOVIES, BOOKS, &
ARTS OF FALL 2000

KOREAN NOODLES GET A LIFT
THE TSAO OF DECORATING

Blond women are popular spokespeople in Japan because they're considered exotic to a dark-haired audience.

People with red hair, though no less exotic, aren't as much in demand, but at least attitudes toward them have changed in four centuries. In 1610, reported Ishimoto, the country was closed for 250 years. To obtain medical technology, though, the Japanese allowed a small trading station only to the Dutch. The Japanese were frightened of the merchants' red hair, "which in their iconography signified demons from hell, but realized the Dutch presented the least military danger of all the Europeans at the time."

Another factor in the red-hair/feng shui thing, said Ishimoto: "Where westerners saw heaven and hell as up and down, respectively, Chinese and Japanese saw them as north and south. So when the westerners sailed up the China Sea from the south—and had red hair—the Asians were all the more convinced that demons from hell were paying them a visit! (Quite a reverse flip from that ancient Aztec prediction that a bearded, white god on a monstrous beast would appear, right about the time when Cortés showed up.)"

often go wrong when they "just throw in an Asian person" without thinking of going for a universal look … or even knowing how to.

Here's how: First trust the sensitive task of identifying a true Pan-Asian look to an Asian, specifically one from each culture you're targeting. For example, three separate crews—Chinese, Korean and Vietnamese—at Kang & Lee screened the Pan-Asian look of the models for Bank of America's campaign. The models are seen by all three teams to make sure there are "no red flags, based on facial structure," said Winifred Lee of Bank of America. But, she said, "it's not an exact science."

The ads targeted the specific segments with different languages, poses and props. The dancer in the Chinese ad posed with a paper parasol, the one in the Korean ad had a white sash, and the Vietnamese, a lotus blossom.

But when the budget allows, there's no question that it's more effective to use a separate model for each version, said Saul Gitlin. The agency produced fourteen versions of the same ad to promote participation in the 2000 Census. The ads used a full-sized close-up of a different model for each version. Besides that, only the language changed.

If price is no object, you can remind recent immigrants of their Japanese home by using western celebrities, including Harrison Ford, and everyone who has ever played James Bond, because they're prevalent there in advertising, said Christine Dicky of Toyota Motor Sales USA.

touching taboos and other body language

Sex sells, goes the saying, but it doesn't necessarily apply to Asians, who don't touch each other in public, let alone kiss, so they shouldn't do so in your ads. Asians won't even touch another on the shoulder. The only exception to the touching ban is for Vietnamese, who show friendship to people of the same sex by holding hands.

Speaking of hands, you know hand signals aren't universal. Here are the ones your models might want to adopt for Asian designs. For Chinese- and Japanese-targeted messages, have models point with the whole hand. Pointing with one finger (any finger) isn't done.

Vietnamese won't point with anything. They prefer to make eye contact. As a last resort, they'll sweep their palm up to their chest. Beckoning is fine for Chinese and Japanese as long as the fingers point downward, as opposed to the western fingers-up style. To get someone's attention, a Korean would extend the arm with the palm down and move fingers up and down.

To show modesty or embarrassment, Japanese, Thai and some Korean women tend to cover their mouths when they laugh. Chinese don't. And Japanese of both sexes may respond in the negative by waving the right hand, with the palm facing left, in front of their face. And when a Japanese person makes a circle of the thumb and forefinger, it means money, not "okay" as it does in the U.S.

Business cards are an important symbol to Asian cultures, including the method of presentation. Make sure that models who present business cards in designs present them with both hands and positioned so they read the right way.

Designs that show the full length of the models need to watch other body parts. To Koreans, foot-shaking connotes driving out bad luck, and crossing legs isn't smiled upon in most Asian cultures. But neither is considered as offensive as this long-standing taboo: showing the soles of the feet or shoes.

south asians

When U.S. advertisers talk to the South Asian market in the U.S., they're usually talking to the Asian-Indian population. That's because it's the largest, most affluent and bilingual group in the category that also includes people from Pakistan, Bangladesh, Sri Lanka and Nepal.

Brian D'Sousa of B.E. International mentions a telecom campaign directed to Indians and Pakistanis. "People's perception is that they're one group, but they're not. They're different," he said. So first "we find out what offends them."

Potential to offend lies in the borders of maps, said Arti Kumar of Western Union. If you're using maps to show Pan-South Asia (and certain other parts of the world of course), be aware of political tensions. If you show India and Pakistan, she said, to which country would you assign Kashmir? People from whichever country you don't choose won't like it.

Another problem is symbols that, although they don't offend, try to include all South Asians in messages directed to them. For example, a tiny dot would have kept an image of a birthday girl blowing out the candles on a cake from speaking to anyone but Indian Hindus, said Neeta Bhasin of ASB Communications. The dot was on a model's forehead, a tradition that doesn't translate to other South Asian cultures, so Bhasin advised her clients to remove it.

Of course it's also useful to find out what touches the audience positively. The birthday party itself is a universal. In particular, a first or second birthday is a common emotional moment, and one that's easily conveyed in print, in which it's more of a challenge to convey emotions than on video. And the cake and candles don't offend these cultures.

south asians: namaste

The word "namaste" is a Hindi greeting, conveyed by pressing the palms of the hands together, elbows at right angles, fingers pointed up. So to design a logo for a website destination with that name, Arati Nath of Admerasia took that basic symbol and combined it with the image of a flame, also a positive symbol, to create an aspirational feeling. One flame's in saffron (an orangey-yellow), the other's red.

Cherishing their Smiles...

...Protecting their Future

NEW YORK LIFE
THE COMPANY YOU KEEP

Toll-Free 1-877-NYL-ASIA

A birthday celebration's a universal for people throughout India (and the world). Add children and the universal formula's complete.

AGENCY ASB Communications/ Bromley Communications

CLIENT New York Life Insurance Company, Asian-Indian Dept.

Another commonality to people from India and Pakistan is the movies, said Peter De Sousa of Admerasia. "Bollywood" is the name of India's movie industry. The name is a morph of Bombay and Hollywood. It's not an actual place. And although the term refers to Indian movies, they're also popular with Pakistanis and Bangladeshis.

So ads for Met Life used three Bollywood songs from specific Hindi films, icons of Indian pop culture. The tie-in was that the company's services set you free to do what you want to in life, including going to the movies (or perhaps even being in them ... Indian movie celebrities are idolized by the culture).

Henna painting (Mehndi) is another example of an Indian cultural cue that has legs (and feet and hands). The Indian custom of decorating brides' hands and feet with elaborate hand-painted patterns has become popu-

lar even outside South Asian groups, and even to those who aren't brides. Even before the practice became trendy, it was a custom in both Hindu and Muslim cultures. According to *Multicultural Manners* by Norine Dresser, the practice was born in the custom of arranged marriages. The hands were decorated because that was all the groom was allowed to see of his intended wife before the vows.

As you've seen throughout this book so far, it's easiest to be inclusive with targeted messages. Nath has done specific print ads for India, Pakistan and Bangladesh to commemorate their respective Independence Days. In each, the cultural cue is the words of that country's national anthem. "When you see your national anthem, it evokes a sense of pride," she said.

153

A celebration of the family and spousal devotion is a common theme in designs for Asian Indians. Here, the husband gives a gift to his wife.

Agency ASB Communications/ Bromley Communications
Client New York Life Insurance Company, Asian-Indian Dept.

Indian-Only Considerations

Even marketing to Indians might be considered Pan-South-Asian, because the country has at least a dozen major and three-hundred minor languages, although English and Hindi are prevalent. Styles and customs vary from state to state, especially from north to south, and people in the north have lighter skin than those in the south.

The two halves of the country vary in more than appearance, Kumar said, and these differences are important to keep in mind if you have the budget to regionalize your designs. Events and scholarships sometimes are directed to one group or the other. The two groups also vary in:

» Cuisine.

» Level of technology. Southern Indians are more Internet-savvy than those from the north.

» Language spoken. Southerners are more likely to speak English; Northerners, Hindi and Punjabi.

» Economic level. Southerners tend to be more affluent. Reach them through the media; reach Northerners more effectively with distributed fliers.

» US areas in which they tend to concentrate. Southerners are in Edison, New Jersey; Northerners, in Jackson Heights, New York and Lexington Avenue in New York City.

Pan-Indian ads tend to be in English, which comes closest to unifying the many Indian states and dialects in the U.S. An exception: For a recruitment banner ad, Nath flashed the word "success" in more than a dozen dialects.

Some Indian Universals Exist

You can take two people from one country and transplant them in the same new country and the way they react to media will be different, said Rupali Steinmeyer of PlanetLeap. So the challenge sometimes, depending on the product and message, she said, is to find a common denominator that appeals to all types of Indians, at both ends of the economic and educational spectrum: from the cab driver and kiosk owner to the doctor and banker.

Here are the common threads:

Love of family, family unity, and respect for elders' values » Indian families are very close knit and in constant touch. In fact, depicting the family is the fastest and most common way to touch the hearts of people in this culture. Extended families live together, parents support children for their whole lives, and children support their parents, said Kumar.

For example, said Srinivas Ranga of New York Life, touching the feet of elder relatives is a sign of respect. In one of their TV spots, an Indian-American family with a U.S.-born son traveled to his grandparents' home in India. As the boy bonds with his grandparents, the custom that was strange to him on arrival, becomes less so. As the family departs, the boy runs out of the car to perform the gesture.

154

Security for Life

Devotion Forever

Of all the things you do for your family, nothing is more important than how you prepare them for when you can't do any more. That's where New York Life can help.

In our full line of life insurance and financial products, you'll find exactly what you need to give your family the gift of a secure future.

Helping others reach their financial goals has been a cornerstone of New York Life's business for over 150 years. Perhaps that's why we are called The Company You Keep®.

THE COMPANY YOU KEEP

New York Life offers a variety of life insurance and financial products.

Toll-Free 1-877-NYL-ASIA

Another emotional spot shows a wedding, joyful at first, then tearful as the girl must leave her parents. And a print ad from Western Union evokes the family with a photo of four generations. In an ad for New York Life, a husband presents a gift to his smiling wife (see pg. 155).

But Bhasin said she saw a retirement commercial that used family images in the worst possible way. A married woman tells her father that he must move out because she needs his room for her new baby. The idea is that you have to plan for retirement because you never know what may come. Although that's true, this situation was all wrong for the market, which responds instead to positive messages of family unity, care and respect.

The culture, like most examined in this book are "we"-oriented, while most western cultures are "I"-oriented. So, said De Sousa, former boxer Muhammad Ali's "I am the greatest" boast would be repugnant in an Asian culture.

EDUCATION » This value is so strong that college is a given in the culture. The bachelor's degree is considered the least you should do. "In our culture, children know they have to go to college … and bachelor degrees don't mean anything … about half of those who go to college have advanced degrees," Bhasin said. There's also a high premium placed on achieving, said De Sousa. It's a hard-working culture and the community has done well for itself. Anyone who's come to the U.S. has an entrepreneurial spirit.

Being highly educated, Indian consumers want information in their ads. They're used to making deci-sions based on it. They're emotional along with being rational, so designs must strike a balance between those concepts, Kumar said. (A demographic note: The company's audience starts at about 20 years old. She has found that older audiences—those 40 to 60—lean more toward the emotional side than the younger segments. For those 20 to 40, communications need to be more tactical, hip and most likely on the Internet.)

For example, a print ad for Western Union shows the hands of a woman rolling out dough to make nan (bread). That's a powerful emotional cue to the immigrant audience, because it's a reminder of their mother or grandmother. It's something they saw every day in their homes growing up. To balance that emotional tie with the audience's need for information and its price consciousness, the ad superimposes the service's price on the bread. Which leads to another commonality …

SAVINGS » Indians believe in saving money, said Bhasin. They don't believe you depend on your weekly paycheck. Everyone—90%—has a bank account in India. The population saves for children's education and future, for relatives back home and for their futures.

The audience also is price-sensitive, said Kumar. She sees the general market as more "focused on service, value and convenience. South Asians aren't there, especially for a money service. When you want to send your hard-earned money to your family, you want the best price."

JEWELRY » Jewelry is considered an asset to Indians for two reasons, said Bhasin: When women get married, jewelry is part of their dowry. Jewelry also is considered an investment and security, so it can always be sold in bad times. And women tend to wear a lot of it, especially gold, so include it in your designs.

CULTURE » Indian culture is extremely rich in visual symbolism. And immigrants often are more involved in it than are Indians living in India. Keeping in touch with the culture is common to Indians, so they'll welcome appropriate cultural symbols in designs.

At the same time as there's a strong feeling about Indian acculturation in the U.S., there's also a sense of clinging to heritage. Not only do Asian Indians stay in touch, they also visit India relatively often, at least annually or every two years.

Indian Icons

As seems to be true of many native cultures of the world, western-style advertising is prevalent in India, said Tina Engineer of Kang & Lee. "When I came here, I realized the role was reversed. Now you have to bring [Asian Indian-immigrants] back home" with designs. Here's what reminds them of home:

MOVIES » Movies are big with Indians, Engineer agreed with De Sousa. They look up to Bollywood movie stars.

INDIAN MUSIC » Classical music is different in the north and the south. Ravi Shankar and Zakur Hussein are popular. (Younger people might listen to London fusion). And songs from India's freedom movement are iconic.

ANIMALS » The sacred cow is not used in advertising, but the tiger, the national animal, is, as is the elephant. A three-headed lion symbol dates from the Golden Ages, when the empire had edicts carved on the three-headed-lion-topped pillars of the palace. But Indians probably won't find dogs to be an appealing image in designs. They tend to consider them unclean.

HISTORIC STATUES, MONUMENTS, AND BUILDINGS » These include the Taj Mahal and the Red Fort in Delhi, which is where the prime minister addresses the nation once a year; the Hawa Mahal in Rajistan, where it's very hot; the name means air and the former palace has one thousand windows. It's an architectural phenomenon because although Rajistan is very hot, the building is always cold inside.

ANY POLITICAL LEADER » Gandhi and Nehru in particular evoke pride in many of their countrymen.

RITUALS AND CUSTOMS » Three common customs, according to Arati Nath of Admerasia, are the aarati, the hanging of floral wreaths after a death, and the "dot" women wear on their foreheads.

> **AARATI** Candles on a plate are waved before visitors, who put their hands on flames before rubbing their hands over their heads. "The ceremony is called the 'aarati.' Traditionally, it is performed towards the end of every ritualistic worship of the Lord or to welcome an honored guest or saint. The plate is called a 'thali' and the candles are called 'diyas.' The flame is interpreted as the light of knowledge and life.

"The honored guest could be a visitor, a relative or even a member of the immediate family being welcomed on a happy or auspicious occasion. Essentially, aarati is a ritual to welcome, for example, a newly wedded couple, into the house.

"In visual communication, the aarati has become a depiction of welcome or a sign of good auspices. Apart from the diyas, the thali usually is also laden with flowers, grains of rice and some sweets.

"Typically at the end of the aarati, we place our hands on the top of the flame and then gently touch from our eyes over the top of our heads. By doing so, we focus our attention on the light that symbolizes knowledge and life, imbibing it through our eyes and making it a part of our being."

> **FLORAL WREATHS** More commonly called garlands in India (or 'mala' in Hindi), floral wreaths adorn the picture of a deceased relative in many Indian homes. This is an offering of respect and love to the departed soul, who is said to have become one with the gods.

> **BINDI, TEEKA, POTTU** "The 'dot' on a woman's forehead is called 'bindi,' 'teeka,' 'pottu' and other names in various parts of India. It's traditionally worn by Hindu women, and is a sign of their being married. Over time, it has evolved into different ways to signify beauty and now is commonly used purely for cosmetic purposes by women of all ages. Younger Indian women today create their own designs with different colors and shapes."

158

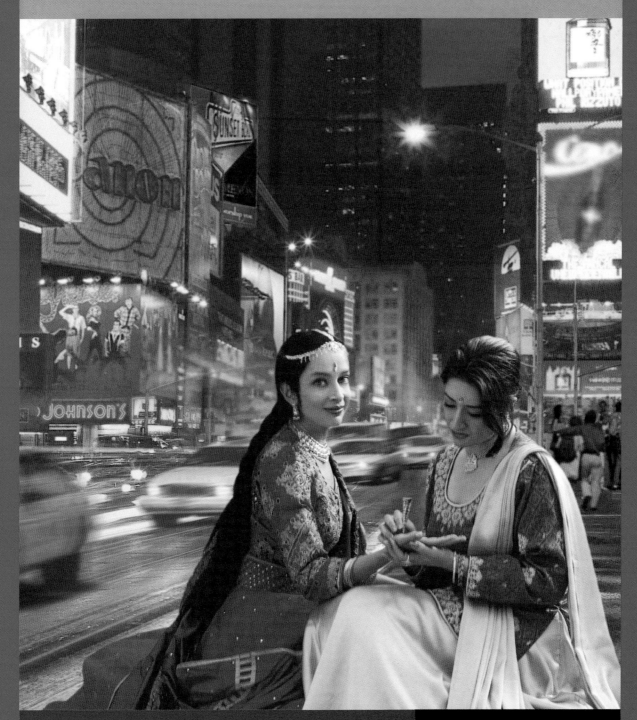

BEAUTY SECRETS OF INDIA @ NAMASTE.COM

From bindis to mehndi, and kangans to jhumkas, all that you need for the classic Indian look is at your fingertips. So no matter where you live everything you love about India, movies, snacks, music, health and beauty products, is just a click away.

GROCERIES • HEALTH & BEAUTY • MUSIC • MOVIES • BOOKS • RECIPES

Tea » Tea-drinking is a common practice, said Kumar, and Indians tend to be very sophisticated (perhaps even opinionated) about recognizing the source and quality of the tea, similar to connoisseurs of wine.

The native flag » The Indian flag contains an iconic wheel with 24 spokes, one for each hour in the day.

Textile patterns » You can see them on the saris worn by many Indian women. Although textiles can have an emotional impact for Asian Indians in the U.S., choose carefully, said Engineer. Any Indian pattern will convey Indianness. But patterns differ from Indian state to state, and Asian Indians typically recognize the differences. To be more inclusive, it might be wise to lean toward patterns from the North, the birthplace of more of the Indian immigrants to the U.S.

You can be more inclusive still with a generic pattern that "says" India, like paisley. The paisley design is so common that "we tend to say it's overused, but it has tremendous staying power," Steinmeyer said. Or work with the lotus (India's national flower) or the peacock (the national bird). Engineer used the lotus to make a pattern on an AT&T calendar she did for the Fiftieth Anniversary of Indian Independence.

Make sure the patterns you choose are merely patterns. If instead the pattern you choose is really one of the country's highly decorative written languages, it will immediately "place" your design.

Clothing Considerations

Especially for any targeted ads for Pakistan and Bangladesh, given their large Muslim compositions, be conservative in photos of women. These cultures especially protect the purity of the women, so never show sexy or intimate photos.

Kumar tends to portray traditional dress because "the minute you see someone in traditional dress, it catches the eye." Lively, happy colors are chosen for clothing. Flag colors—saffron and green—are good, especially during harvest time, in March and April. Advertisers also dress models in a lot of magenta. They stay away from white saris, because in India, that's the dress and the sign of a widow.

The company strives to keep patterns generic so the focus is not on the pattern, but on the face. And she wouldn't show a turban on a man from India for a Pan-Indian ad because turbans are only worn in the Punjab regions.

Color: Warm is Hot

What colors should you choose for an Indian-American audience? The usual caveat applies, as for all design elements: The choice has to be appropriate to each situation. But in general, vibrant or earthy colors are popular, especially saffron yellow, reds and oranges, Steinmeyer said. Engineer said she has been known to take her color inspiration from old murals and textiles. Saffron (an important Hindu color), green (for agriculture) and white (for purity) are the flag and national colors. In fact, the word "India" means "Land of the Pure," De Sousa said.

Color is a big thing in India, Steinmeyer said. Indians tend to make up for material things they don't have by using a richness of colors. They use them on everything from clothes to houses, cars and trucks (called "lorries" in this country that spent so many years under British rule). And they draw some of their most popular colors from native foods, such as mangoes, coconuts, turmeric and oranges. Vermillion, a nonfood-based color also is used a lot.

Most Hindu brides wear red; widows, white. Black and white are associated with death (as are frangipani flowers). Some Muslim brides wear green, considered a holy color.

Indian Holidays

More than 80% of the Indian population is Hindu. If those numbers immigrate with them, that means that a Hindu-oriented design concept has a 20% chance of leaving out someone. Other Indians are Muslim (the second largest group, and one of the world's largest Muslim populations), Christian, Jhan and Zoroastrian. That means that, although you'd wisely avoid religious symbols in designs for most groups, they're probably even less welcome for Asian Indians.

161

One Hindu festival that may be an exception is Diwali (pronounced DiVALi). That's because it's the start of the New Year in some parts of India and the start of the fiscal year for many companies, Nath said. It's celebrated in October or November and it's a huge celebration, said Ranga.

There's no one symbol for the holiday, but everyone wears new clothes and people light oil lamps in their homes. He said that if you see India from an airplane on the night of the festival, it looks like one big red ball. Because celebration of the holiday's so prevalent, it's relevant nationally and it's filled with cultural cues that a non-Hindu Indian is likely to recognize, Nath said.

Diwali is a happy festival of lights that represents good over evil, Nath said. It also represents a new beginning and prosperity, so an ad for Namaste.com worked with the concepts of health, wealth and prosperity. It used a kalsha, a little pot with a coconut on it, which is part of a Hindu ritual, and ethnic patterns and graphics. But the designer avoided patterns that might be identified with any particular state.

"We try to be sensitive and make sure that [the message] has a general blanket," said Nath. "We don't want to isolate anyone." When you communicate to Indians, you always have to communicate to a diverse audience. "We referred to old mythological images for Diwali. We gave it a Tantric feel, not bracketing any one state."

Other special celebrations include:

» Indian Independence Day (August 15)
» New Year's Day (celebrated at different times in the north and in the south)
» Weddings (which tend to be day-long ceremonies, with a lot of color, pomp and gaiety)

Casting Tips

"We tend to use Indian faces. It doesn't make any difference if they're from the north or the south," said Ranga, although generally the audience can tell by a person's skin color and dress where they're from. Bhasin looks for dark skin, round face, big eyes and dark hair. "Beauty is admirable and appreciated in our culture."

In casting for Western Union, Kumar's team looks for warm smiles. They also look for someone who could look like the mother, daughter or wife the customer is likely to be sending money to. The role of mother typically goes to someone aged 35 to 50. She is dressed traditionally, not dressed like a professional. The children cast in the ads are girls or boys from 8 to 10. The idea is to evoke the viewer's child at home, a child "that reminds me of my child."

glossary

AARATI An Indian custom involving a thali (plate) and diyas (candles)

ABC American-born Chinese

BANANA Outside yellow, inside looks white

BINDI, TEEKA, POTTU Names for the dot placed on a Hindu-Indian woman's forehead

GARLANDS Floral wreaths that adorn the picture of a deceased relative in Indian homes

HANGUL Korean native language

MOCHI KAMDANGO Round rice cakes that are an icon of the Japanese Moon Festival

TAGALOG A traditional Filipino language

МЫ р
КОММ
проб

chapter four

european
americans

euro-america:
diversity personified

Talk About Diverse

They may be neighbors in Europe, but don't assume that Eastern and Western Europeans share attitudes, customs or languages. That means you also can't assume they'll respond to the same messages. In fact, among Eastern-European audiences alone, you'll find it easier to find the differences than the commonalities. Even looking at those from just one country of origin, you'll often find different languages, religions and political backgrounds, ages and levels of acculturation or assimilation.

The audiences tend to be concentrated, with Russians in New York, California and Chicago; Poles in New York and Chicago; and Ukrainians in New York, California and Chicago. As of the 1990 Census, there were about nine million Poles residing legally in the U.S., with a possible two million more *illegal*. Another growing group of immigrants is Romanians, in New York and California, especially Los Angeles.

The audiences tend to be well educated, especially Russians. Of all the audiences, the Russian community is more language dependent because the population is older and most will never learn English; many are in Brighton Beach, New York.

InterAccess Inc. does targeted ads for Russian, Ukrainian and Polish audiences. If it's wise to stay away from religion for any group, it's especially advised for the Eastern European. In the Ukrainian group alone, there are at least three religions.

Attitudes Toward the Homelands

The Russian audience in the U.S. is relatively new. What's tricky about it is that marketing to Russians is in reality primarily marketing to Jews, said Alex Nakhapetian of Cybuy.com (formerly of Admerasia). About 80% of the audience is made up of Jewish immigrants, many of whom came in the 1980s when Brezhnev allowed Jews to emigrate. The rest are Armenians (many of whom settled in Los Angeles) and Ukrainians, with their own languages and religions, said Nakhapetian.

What they may have in common is hostility to some Russian imagery. Jews, who suffered persecution for their religion, are the most likely to feel that way. There's a common joke that's based on reality, said Nakhapetian. It goes: "You're only born once, and you're born in Russia. Can you believe it?" meaning that of two hundred countries, Russia's the worst place to be born. Russians consider themselves smart and capable, and believe that the society doesn't support them.

In addition to hostility to Russia, immigrants of the country also share the experience of its school system. Students go to school seven hours a day, six days a week. It's considered very grueling and demanding. As a result, Russians are extremely well educated and they read a lot. That means that good copy is more important than visual imagery for this audience.

Nakhapetian did an MCI direct-mail piece that used an illustration of the clock on the Kremlin. It was a difficult decision, but he decided to use it because it conveyed one of the few positive experiences common to Russians. On New Year's Eve, everyone gathers with their circle of friends and family to await the clock's first chime of the year. Champagne and maybe a little caviar are traditional

regional spotlight:
europeans

Information is sketchy on Western Europeans, but Eastern Europeans reside
primarily in the following U.S. areas:

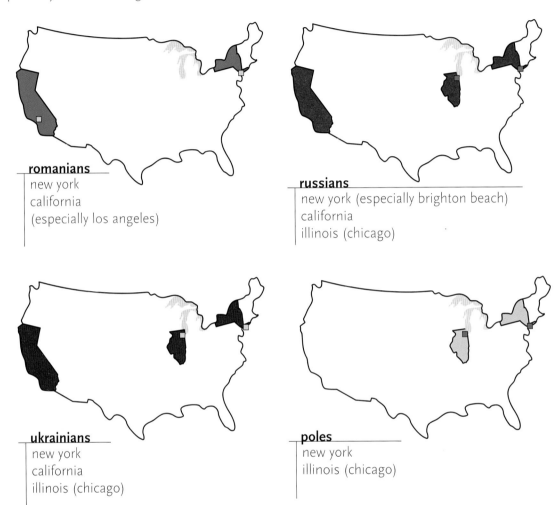

romanians
new york
california
(especially los angeles)

russians
new york (especially brighton beach)
california
illinois (chicago)

ukrainians
new york
california
illinois (chicago)

poles
new york
illinois (chicago)

"Peculiar taste" is the headline, a highly recognizable movie line from a famous actor, and a playful connection to the seafood product.

Agency Global Advertising Strategies
Client B&B International

Visual, playful puns work well for a Russian-American audience, like this Greek statue wrapped in telephone cords instead of snakes.

Agency Global Advertising Strategies
Client Primus Telecommunications, Inc.

for those who can afford it for that special occasion. To show that the company was offering money to anyone who switched long-distance carriers, he also showed a playful image of the check for the offered amount covering a plate of caviar.

The audience is price sensitive. That means if the company you design for has a less expensive product or a special offer, your job will be as simple as focusing on the savings, and keeping the design from getting in the way of the message.

Polish audiences don't attract many targeted messages, Nakhapetian said. Although they still may read Polish-language newspapers, "in my opinion, they assimilate as quickly as they can," he said. They are extremely hostile to the motherland and it's a younger, more professional audience than the Russian one.

There are fewer ad agencies and companies that focus on the Eastern-European audiences for two reasons: Population numbers are smaller and then ebb and flow depending on the waves of immigration. You target an audience and if immigration stops or slows down, you may lose your prominence. As the audience you courted becomes assimilated, general-market companies will be waiting to grab it. And the general-market ones that succeed in grabbing it won't necessarily be the same ones that courted it in-language. There's little brand loyalty, and in fact a company that's new to this audience may be considered more attractive.

For a similar reason, General Motors offers different cars for different age groups, because they want to keep

their audience as it ages. Another, more parallel, example. In 1930, Italian-language newspapers had a bigger circulation than the *New York Times*. Now the market is virtually absorbed in the general market.

But the Asian Americans and U.S. Hispanic markets have a longer "shelf-life" as distinct markets than the European ones. They assimilate more slowly, retain their preference for the language and the culture. That's especially true since elements of those cultures have become embraced by the general market.

olympic clout

Some of Western Union's ads make effective use of celebrities from the target countries, especially those who have immigrated to the U.S. For example, Viktor Petrenko, an Olympic ice-skater and the first Ukrainian Olympic Gold medalist, lives in the U.S. He appeared in Western Union ads to Ukrainian Americans, beginning after the Ukraine's independence in 1991.

In one ad, his smiling face is shown against an elaborately framed photo of his family members back home. (Headline: "My loved ones can rely on me because I rely on Western Union." Subhead: "I know that money I send my loved ones in Ukraine will get there safely and within minutes," says Viktor Petrenko, the Olympic Gold medalist and Western Union customer.)

In a holiday ad that promotes a sweepstakes, he's skating, appropriate for a message that includes traveling. The headline: "Send money with Western Union to Ukraine and win a luxury trip home for two."

A Polish Olympic gold-medalist in sharpshooting (not a U.S. resident) also has appeared in ads, for the Polish-American audiences. So has a Polish jazz singer, who lives in New York.

Funny Images Beat Hard Sell

The use of humor is almost a necessity for this audience, said Nakhapetian, reflecting the words of Russian-American marketing specialists. Russians are cynical and skeptical of promotions, which are new to them. Unlike Americans, who grew up being the targets of ads, Russians grew up with political propaganda. The advertising industry in Russia is only about ten years old. To a Russian American, the attitude is if the company tries to sell so hard, something must be wrong with the products.

So what works best is a soft sell, preferably a humorous one. Present an option and let the consumer choose. "Don't say, 'We're the best.'" For MoneyGram, Nakhapetian used a familiar Russian hat on Ben Franklin in an image of the U.S. $100 bill. The image had more layers of meaning than may be apparent to a non-Russian. For one thing the headline, in Cyrillic, translates to "A New Face in Moscow."

The headline and graphic meant more than the company's entry into the U.S.-to-Russia market. It also meant the U.S. dollar's entry, or more specifically $100. Traditionally, people would send money from the U.S. to Russia in dollars and their relatives would be forced to accept them in rubles. Despite a good exchange rate, people wanted the choice and this company came in offering it. What's more, Ben Franklin is a strong symbol of capitalism.

Love of theater, satire and mocking authority also plays into the concept for an ad for a salted fish product. It includes a photo of Arkadiy Raykim, a famous Russian satiric actor who's known for his monologues, which mock bureaucracy. The headline "peculiar taste" is a famous quote from the movies he's depicted in. A viewer who doesn't speak Russian might be surprised to see the phrase associated with a food product, but it's not a negative association to satire-loving Russians, said Victoria Akhiyezer of Global Advertising Strategies, Inc.

A similar approach is evident in an illustration for a job-exchange section in newspapers. The message translates to: "Human resources decide everything!" This

Images that play with the language are well received. The images are cute and get across the message even to non-Russian speakers to a point. They work better in Russian in which lines that are busy translate more closely to "overloaded."

AGENCY: Global Advertising Strategies
CLIENT: Primus Telecommunications, Inc.

illustration and the slogan again refer to comics popular during the last periods of the Soviet Era. The comics—and this ad's concept—poke fun at the bureaucracy that was thriving in the state.

Zadrzynska often works with famous sayings and rhymes to relate to Eastern-European audiences: For Russian Americans, a print ad features a photo of an elephant, based on a popular Russian nursery rhyme: "My telephone rang. 'Who is it?' 'Elephant.' 'What do you need?' 'Chocolate.'" Instead of that punchline, the ad substituted "The phone number for MCI extras."

From the same company, Polish Americans saw an evocative picture of a chimney sweep in a tall, skinny ad to match his stature. The image is based on a common Polish superstition that if you touch your button when you meet a chimney sweep, you'll attract good fortune. The headline: "Don't grab your button, grab the receiver" (to get a discount on calls made during the holidays, the subhead explains).

Russians respond to U.S.-style testimonial ads, because they see them as propaganda, agreed Akhiyezer. And they love humor and irreverence. They also prefer

indirect messages, like visual metaphors. And it's a good idea to appeal to Russians' love of art, theater and culture. For example, a Primus Telecommunications ad showed a visual pun: an image of Laocoön, a famous statue of a classical Greek god, is wrapped with telephone cords instead of the snakes as in the original (see pg. 167). The image doesn't have to be really relevant for Russians, she says ... it's enough to change it in a clever way.

In another ad, an elephant on a skateboard is more relevant, working with the Russian language because "the lines are busy" in English translates directly to "the lines are overloaded." It illustrates the message that no load is too much for the company's telephone lines. Another version has a family of elephants standing on the telephone cord without causing it to sag.

Don't Go Native … Costume

Although your clients may consider it charming and oh-so-ethnic to dress models in an ethnic folk costume to symbolize Eastern Europeans, advise otherwise. The audience is unlikely to see the charm unless the costume lends itself to the message, such as a folk festival flier. In most cases though, costumes are irrelevant to the daily lives of ethnic audiences in the U.S. And in some cases, they can go beyond irrelevant to offensive.

For example, for a website, Akhiyezer chose images for each culture-specific ad that would be instantly recognizable as "home." Although she advised against it, the client insisted that the Romanian ad include a photo of people in folk costumes. "When I sent it to a Romanian newspaper, they complained," she said. They got offended because the models and costumes were gypsies, not an inclusive image. (In fact, gypsies are discriminated against and few commercial advertisers have the budgets to make political statements in their ads.) Using the costumes was a mistake, she said, and "these mistakes happen because the client has his own idea" of what the cultures look like.

Some clients make the mistake of thinking that Slavic cultures love to see folk costumes … and the more assimilated or westernized the culture, the more mistaken that assumption is. Poles, for example, who have been in the U.S. longer and are more assimilated than, say, Russians, probably would be less likely to relate to native folk costumes. This despite the fact that Poles do read in-language newspapers.

Yet even for Russians, Akhiyezer advised against traditional ethnic clothing for an Internet company. Not only would the image not be appropriate for a high-tech company, but a contemporary, sophisticated Russian audience also wouldn't relate to it in general. And again, reminds Nakhapetian, even for a company that's not high-tech and a consumer that isn't sophisticated, there's that hostility factor.

Native clothing worked better for a tourism ad, but only because budget demanded that one image target Russians and non-Russians alike. A woman in a traditional scarf looks out from the ad for the Russian National Tourist Office. Although the scarf is rarely worn anymore, it's capable of inspiring nostalgia in those Russians who want to return for a visit, and conveying the culture to non-Russians. In the background, Akhiyezer also used a photo of the Volga region's scenery to remind Russians of home. Copy in Russian says, "When was the last time you went to Russia?" In English, the question shifted to "Have you ever been to Russia?"

РОК-МАРАФОН

2000

пЕРВЫЙ
РосСийсКо-
аМериКанский
рОк-фестиваль

A card promoting a Russian rock
concert calls to mind the art of the
Russian avant-garde.

AGENCY Global Advertising Strategies
CLIENT Russian National Group

More Symbolism

For Western Union, a photo of a boy showing his hand
reflects two simple cues for Russians: the school grading
system and calendar. Instead of letter grades A through F,
Russians use a numbering system, from 5 to 1, and the
school year begins on September 1 for everyone. So the
five fingers shown on an ad released on that date convey
the idea of starting the new school year with a 5+. The
tie-in to school suggests the idea of sending money home
to Russia to help family members pay for school supplies
and other needs of school children.

The Russian National Group organized and co-
sponsored a concert in New York of mostly Russian
bands in support of free press. The imagery, colors and
typography on a card promoting the concert reflect a
style of graphic art—Russian avant-garde—that was
popularized near the beginning of the last century. Gen-
erations of Russian artists have mimicked the style on
posters and illustrations, so it's recognizable to Russians.

Rodchenko was a pioneer of the style. The figure
of the rock musician alludes to another recognizable
figure—Miyakovsky, an influential poet of the era—who
was often seen orating with one hand making a fist. In
addition to the avant-garde movement, the red evokes
the Bolshevik period.

To a non-Russian audience, the image
might evoke a Bolshevik Uncle Sam ... or
not. Like the original posters this one
imitates, it calls the masses to arm ... but
only their liquor stocks.

Agency Global Advertising Strategies
Client Marlboro Liquors

What's the man in the hat doing in this
house ad? He's explaining things on fingers,
which means "plainly."

Agency/Client
Global Advertising Strategies

Still another recognizable image appeared on an
ad for a liquor store. Images of a soldier from the "Great
Revolution" were used as recruitment posters with a
headline: "Did you volunteer for the Army?" This ad uses
the image to ask the equivalent of: "Do you know where
to find the best prices?"

A house ad for the agency shows a man gesturing
with his fingers in a way that has no more meaning
for non-Russians than the expression and headline it
illustrates. "We explain everything on fingers," similar
to counting on fingers to simplify concepts, means "in
plain language."

western euro-americans

Go West, Young Designer

Although Western European Americans may retain their own languages and distinct cultures, they are (by definition, not to mention name) highly westernized. That, and the fact that they come in smaller, scattered numbers than other groups and have a high level of English proficiency, makes them reachable by general-market designs.

Fewer companies separately target Western-European audiences in the U.S., said Kerstin Goetz of Jungle Communications, because they kind of blend in more. They're often assumed to be part of the mainstream.

Outside of a few West-Euro-American newspapers, magazines and media programs, there's little targeting. Some companies—most notably, telecommunication, money-transfer and airline industries—have done so.

A few advertisers have targeted directly for the British-American market. Here are four examples: Northwest Orient Airlines takes the heart-tugging approach with "Roots: Trace them to Ireland on Northwest Orient." The photo is the profiles of two girls in blond braids.

AT&T uses humor, with:

» cartoons of animal friends around the world: "Spread the Old Sod a lot further."

» photos of dogs that are bred in England, captioned with "Brit-speak."

» a tweak at Brits' view of the "foreign" language spoken in the U.S. Recognizing that the Queen's English-speakers regularly criticize what passes for the English we speak, the photo shows a phone on two English dictionaries. "Save 25% on English language refresher courses."

Not only don't the numbers of West-Euro immigrants tend to justify the separate targeting, but there are no longer the great differences in culture that once separated the U.S. and Europe. In fact, Oliviero Toscani, creator of controversial Benetton photography until 2000, goes so far as to say "there's a monoculture that's suffocating the world and killing local culture. In Italy, we don't believe in rules as much and we're not yet as well organized as the U.S., where managers are in charge rather than artists, but that's changing. We live under an economic dictatorship and advertising is part of that."

Paula Scher, partner of Pentagram, agrees that the graphic differences are disappearing. "As never before, we are global designers. I just went to South Africa and everyone there knew my work." Yet, she added, some general cultural tendencies remain. Compare, for example, U.K. and U.S. designers. U.K. design tends to be less eclectic than that of the U.S. "If you go to Edinburgh or London, the buildings are like whipped cream. They're filled with decorations, so a designer's natural reaction would be to make things spare. U.S. design, on the other hand, reflects a collision of influences."

Unlike design of the U.K, which tends to contrast with its surroundings, Scandinavian design tends to reflect them—clean, cold and spare. Scher says she finds some of the most futuristic, ground-breaking design in the Netherlands.

She characterizes Italian design as "incredibly elegant," and Italian designers as masters of proportion, architecture … and serif typefaces. One, of course, invented Bodoni, "the world's most beautiful typeface."

Herb Meyers, now retired, was founder and managing partner of Gerstman+Meyers, a brand identity and package design firm that had some European clients. At one time, he said, U.S. designers were considered much more sophisticated and marketing-experienced than European designers. But, he said, European designers got better and European marketers got more sophisticated and caught up with their U.S. counterparts.

U.S. designers (of marketing, corporate identity and packaging) were sought after by European companies, starting with the business resurgence in Europe after WWII. European marketers put U.S. marketers on a pedestal in those days. In the beginning, most marketing-related design in Europe was handled by European ad agencies, many of them branches of U.S. ad agencies. Designers and design groups came into their own only gradually. Meyers estimates that European designers became seriously competitive in the 1980s and the 1990s. Today, many of them are groundbreakers (especially designers in the U.K.) and tend to look down at U.S. designs as being too conservative.

The European Union is further eroding the borders between cultures. It has opened up the markets further to where brands and products are easily cross-fertilized. It is possible, though, that because immigration has become a political issue in many countries, including France, Germany, Austria, England and Italy, some ethnic sensitivities may affect visual images in ads, promotions and packaging.

Some cultural differences still exist: coffee-drinking customs differ between, say, Sweden and Italy, so Nescafé labels portray the coffee experience differently on each country's label.

TV spots vary substantially from European country to country in terms of design style, verbal presentation, humor, human characters, etc. Europeans love logos; people from the U.S. don't as much, relying more on the brand names themselves. The ability to pick up TV stations and the Internet from beyond your borders are probably narrowing those differences too. And there is decreasing emphasis on ethnic issues because of the growing attention of marketers to people who are eighteen to thirty-five, who are more open-minded, less immersed in cultural differences, more westernized, wherever they live.

More Euro-Design

If there are differences in design that appeal to U.S. versus Euro cultures, international media, such as satellite TV and the Internet, are threatening those differences. But some exist. For example, here are some basic design differences between the work of German and U.S. designers, Goetz said, although she was quick to point out they're based on informal observation rather than scientific study.

In Germany, sans serif is preferred and it's unusual to see all-caps type, which is common in the U.S. Also Germans tend to have a preference for justified type, rather than the flush-left, ragged-right alignment that's more common in the U.S. German-born Goetz's awareness of that began in her early days in the U.S. and in a conversation with a U.S. designer. The designer pointed out that justified type looks forced, strict and regulated, whereas the U.S. preference for an irregular right edge links to the societal value of being independent and casual.

German designers also tend to value white space, as opposed to U.S. designers, who tend to pack more elements into the available space. And German designers don't commonly use neon-bright colors.

What's more, West-Euro designers traditionally have tended to be more open about nudity than U.S. designers have. Nudity that doesn't look self-conscious turns up in fashion magazines and less expected places (like ads for orange juice). In fact, well-designed and unself-conscious representations of the body alone can convey a Euro look to the design.

Massimo Vignelli of Vignelli Assoc., an Italian designer in the U.S., said that European designers in general tend to be more disciplined than their U.S. counterparts. And Americans are more susceptible to trends, innovations and novelties than the Europeans, who work more toward refinement.

Vignelli often has found that European clients trust the ideas and advice of designers more than U.S. clients do. That's because art and design is a stronger part of European cultural tradition, and it's why his company does a lot of work for Italian companies. But that trust is vanishing as even European companies begun to immerse in the language of marketing. And marketing, he said, is an expression of the fear of failure. When you're sure of yourself, generally you succeed.

Interestingly, Italian companies like dealing with designers in New York because it gives them a tremendous cache. But they find Italians in New York because they can understand them better.

Speaking of understanding, a newsletter for the Italian Cultural Institute (Istituto Italiano di Cultura) in Washington, D.C., is a fine example of bilingual design (see pg. 177). The six-panel 11" x 6¼" piece unfolds to 38". The newsletter, which mails to Italian Americans and others who are interested in Italian culture, features side-by-side copy blocks of various widths to fit the space and the artwork.

It's a jigsaw puzzle of a layout, but with different typefaces and styles for Italian and English, it's easy for readers to find their preferred language. And the look is stylish. The design, by Fleur Van Kranendonk Duffels, came out of a competition held in Milan at the European Institute of Design.

German versus U.S. design tendencies	
GERMAN	**U.S.**
ulc, not all-caps	more likely to use all-caps
sans serif	serif more popular
justified	flush left
white space valued	space filled

Stereotypes to avoid

The good news is that you probably can reach Western Europeans with general-market designs. For designers who aren't sensitive to offensive stereotypes, that's also the bad news. That means not portraying Irish Americans as drunks, Scots as cheap, French as unfaithful, Italians as belonging to the mafia, or using other national stereotypes.

To begin with, avoid designing in stereotypes because it's the right thing to do. What's more, show stereotypes and those blended-in audiences will come out of hiding to complain, as they should. And some of them are organized. Even an audience that doesn't seem big enough to target can make a big dent in your profit margin if they boycott your expensive ads out of existence.

ITALIAN AMERICANS » And some of those hidden audiences are huge. Take Italian Americans, for example, an audience that is well assimilated in the U.S. "Italian Americans are grappling with the way they're portrayed in the media," said Dona De Sanctis of the National Italian-American Foundation (NIAF). Very often, she said, they're portrayed holding either "a fork or a 45, sometimes both. The mafia has been used to sell everything from milk to video games to chewing gum." She quotes the tag line in a TV spot that has mobsters shouting "die bad breath!" as they rush into an Italian restaurant.

That gum commercial is one of the "Thumbs Down" media examples listed in the NIAF News. Letters to the offending parties from NIAF and its members have convinced some corporations to drop offensive campaigns. The offensive ads are targeted to the general market, but remember that the general market includes Italian Americans. Even if it didn't, depicting stereotypes in the media is a formula for perpetuating them.

The organization also praises media that show positive examples of Italians. They've included a Hallmark spot set in Italy, in which an Italian boy gets a kiss from an American woman to whom he delivered a greeting card. The boy kisses and tells, which draws a crowd of card-carrying boys hoping for the same reward. Another spot considered praiseworthy, for Tylenol, depicts the friendship between two Italian neighbors.

IRISH AMERICANS » Irish-American publications see a rush of ads before St. Patrick's Day, said Anita Daley of Intercultural Niche Strategies. There's more interest in things Irish on the crest of Riverdance. Stereotypes like portraying Irish as drunks are offensive. Lower-budget ads tend to show a lot of leprechauns, shamrocks and dancers as if that's all the culture is about.

McCarthy's Bar, a book by Pete McCarthy, includes a comment about St. Patrick's Day: "There's a sort of reinforcement of cultural stereotypes at these celebrations. It does sadden me sometimes that there are people who delight in taunting the Irish as priest-ridden drunks or what have you."

GERMAN AMERICANS » Germans are shown in Bavarian dress, with the men in shorts, suspenders and knee socks. The image goes with Oktoberfest, beer, beer gardens, but those images apply only to the Bavarian region and even there, not to daily dress. Other stereotypes: "Not until the fat lady sings," with the woman in braids with horns on her helmet. A much less innocent stereotype is the image of someone in a Gestapo uniform.

The bimonthly newsletter of Istituto Italiano di Cultura goes to great length to balance bilinguality with European style. And I do mean great length. Six panels unfold to 38". Cover (panel) art always shows a photo or illustration from an event illustrated inside the newsletter.

CLIENT Istituto Italiano di Cultura, Washington, DC

ORIGINAL DESIGN Fleur Van Kranendonk Duffels

ART DIRECTORS AND DESIGNERS Linda Lee, Vittorio Cammarota

FRENCH AMERICANS » French are often portrayed in advertising as unfaithful, rude, wearing a beret, with the Eiffel Tower in the background. There is nothing offensive in showing the Eiffel Tower, just be aware that it's an image that's more of an icon to tourists than to natives. In fact, people from any country think of themselves as more complex than can be portrayed with any one symbol.

DUTCH AMERICANS » The Dutch are shown as cheap, and often wearing braids, pinafores and wooden shoes.

BRITISH AMERICANS » Stiff upper lip, straitlaced, boring are some stereotypes. Advertising sometimes includes disrespectful images of the royal family. Bobbies and double-decker buses images rarely count as offensive, but they're overused.

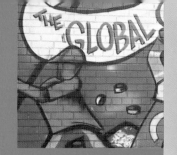

multicultural design

mixing it up in the
multicultural mainstream

"What's black and white and red all over," asks the old riddle that "the newspaper" solves. These days, make it all different colors, and apply it to images even for the general market. Although the practice of ethnic-inclusive casting constitutes a trend, the use of ethnic models is hardly news. For eighteen years until Spring 2000, Oliviero Toscani explored the issue of race in his innovative and often controversial photographs for Benetton that include multiracial themes and models.

Earlier still, Toscani brought that multiracial sensibility to his work for Fiorucci, Esprit, Lee Jeans and *Elle* magazine. What gave him the idea to include black and Asian models? Simply put, "The world is like that," Toscani said. Multicultural images belong to our time. But most advertising, he finds, is far from reality, because advertisers see people as consumers instead of as people.

Toscani takes exception to companies that don't include all races naturally, but do it only to make money. And don't get him started on magazines and ads that target specific ethnicities. "I can understand special magazines for people who like motorbikes or special cooking," he said. But to him, the existence of ethnically targeted magazines shows "a recognition that there is discrimination. What the hell? There is just our race. It's the human race."

Fellow Italian and designer Massimo Vignelli of Vignelli Assoc. agrees: "I don't believe in designing anything for a specific audience. I don't think you do a good service by disguising [something] or putting it in a kind of box. We're all living in the world," he said. Vignelli made the example for this female author that "when people with machismo try to talk to you in a feminist way, it immediately smells wrong." These are "fake, political, phony issues." The major design issue, he said, relates to perception and clarity and that should be universal.

Mark Major of Benetton added that, from its beginnings, Benetton has shown an appreciation for diversity, as opposed to companies that realized it at some point and had to make a change. "We don't market to special groups, we just market."

Another company that just markets is Anheuser-Busch, whose "What's Up" commercial had people from

UNITED COLORS
OF BENETTON.

182

UNITED COLORS
OF BENETTON.

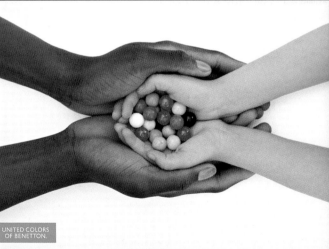

UNITED COLORS
OF BENETTON.

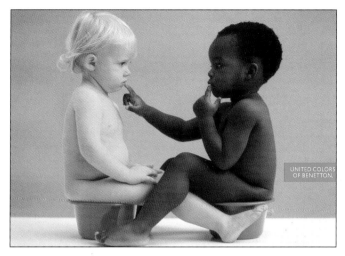

UNITED COLORS OF BENETTON.

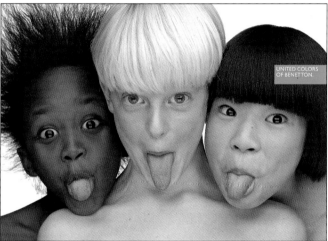

UNITED COLORS OF BENETTON.

The concept of multicultural images in general-marketing isn't brand-new. It only seems that way because they're only recently becoming frequent. That's part of the reason that Oliviero Toscani's work for Benetton in the early 1990s was so controversial. The other part was that he pushed the race issue enough to make the images controversial during any decade. Although ads like the one on the facing page (bottom left) mock media-portrayed stereotypes, even today (based on the author's informal survey), some viewers still see them as perpetuating them. Some question why the black child is portrayed as the stern devil and the white child as the smiling angel. Another view sees this type of advertising as "so powerful, it shakes you out of your stupor," said Steven Thompson of Chelsea Harlem Interactive, Inc., one of the the the survey respondents. "People look at advertising without even questioning; it becomes wallpaper," added his partner Michel Gibbs. The Benetton images, on the other hand, dealing with heated issues like race, "start a dialogue." Here's a sampling of the company's institutional ads.

PHOTOGRAPHER AND CONCEPT
O. Toscani
Courtesy of United Colors
of Benetton

all races chanting the catch phrase. The Coca-Cola Company does targeted as well as multicultural advertising, including a culture-crossing program called Art of Harmony. It's a competition for students that lets them paint murals on the sides of buildings.

Alcatel, a communications company, created controversy with a campaign that used an icon—Martin Luther King, Jr.—in a commercial message. The TV spot begins with the Civil Rights leader delivering his also iconic 1963 "I have a dream" speech in front of the Lincoln Memorial. Then the camera shoots from behind him to show that's he's speaking to no one. Alcatel removed the cheering audience that originally packed the grounds beyond him to convey the message: "Before you can inspire, before you can touch, you must first connect. And the company that connects more of the world is Alcatel, a leader in communication networks."

Reactions were many and mixed, said company spokesperson Brian Murphy. Although Murphy chose not to reveal the number or nature of comments, he said "the problem is, people who have concerns tend to be more vocal." (Seems so. When I called the company to ask for comment and expressed my admiration of the spot's impact, the person who first answered the phone said, "at least it's someone who really likes it.")

Popular as a celebrity if not revered as an icon, comedian Bill Cosby sold Jell-O for years to the general market. Other ethnic spokespeople for other brands—including singers Wyclef Jean and Ricky Martin for Pepsi, comedian Arsenio Hall for 1-800-COLLECT and the "7-Up Yours" guy—followed in Cosby's footsteps or imprinted their own.

Unless you've been media-deprived for years, you also have seen a growing number of noncelebrity, non-Caucasian faces represented in general-market ads. Gap's appealing multicultural general-market campaigns come to mind, and the hip-hop artists—of all races—in Sprite spots. In a Sugar Pops cereal spot taped in a high school,

The Art of Harmony program has transformed some urban walls into murals, like this one on Georgia Avenue in Washington, D.C., and some student street painters into award-winners.

ARTIST Roger Gastman

PROGRAM DEVELOPER/SPONSOR
The Coca Cola Company

PHOTO Ronnie Lipton

most of the cast is black. At the end, one of the black kids eats and laughs with a white kid in the school cafeteria.

If you too want your designs to show that the company behind them embraces diversity, here's some advice: Avoid the design-by-human-resources-department, design-by-the-numbers effect. Make the mix look natural, not contrived. Although it's admirable to create designs that look like America, prepare to turn off plenty of ethnic viewers of general-market media if it seems as if they were cast by quota.

One university admissions official made the even greater mistake of casting by Photoshop, not just by quota, reported an article in the *Washington Post* (9/21/00) by William Claiborne. The photo on the cover of the university's undergraduate application showed a crowd of students who were uniformly cheering . . . but not gleaming. One sharp-eyed sophomore, a reporter at the student newspaper, spotted the gleam on the face of the one black student in the shot. The other students were in the shade. The digital insertion of the man's face was a misguided attempt to show the university as culturally diverse. Whoa.

But even if the African-American man hadn't been artificially inseminated into the photo, even if he had posed for the photo, the result still might've raised some hackles.

"When you have a cast of everybody, it doesn't always go over so well" with ethnic audiences, who are more attuned to cues in ads, said Gary Piñero of Ogilvy & Mather. Making the case for targeted work, he said an ethnic audience can see a multicultural cast as tokenism.

"It's hard for people in a general-marketing agency to have a real appreciation of what it's like to be a minority in this society. If you're in the majority, you're not sensitive to this. It doesn't enter your radar."

Still, any diversity often is preferable to only white faces. Even skeptical ethnic viewers are likely to approve that those getting paid for the work include ethnic

models. But you'd better believe it matters what role they play. If the role is a domestic worker, in general, steer clear of ethnicities. Cast them instead in roles considered more aspirational. Although, obviously, there's no shame in domestic work, black and Latino audiences in particular don't appreciate being stereotyped in such roles by white corporate America.

I'm thinking of a stock photo I've seen that appears to be shot in an office. A few people—white and Asian women and a black man—are standing behind and looking over the shoulder of a white man who's seated. The seated man wears a suit and is directing attention to the work he's showing. He's obviously the boss controlling the meeting. He's the only one sitting, he's at the center of the circle and he's wearing the suit, while the other man, for example, stands, wears a tie but no jacket, and is on the outside looking in. You know what's wrong with this picture. Although to some people, it represents diversity, a black person (or a woman of any race) probably will see the limitations in it.

But if you can show diversity with awareness, here's another likely positive effect: The more white Americans get used to seeing ethnic audiences outside of stereotypes and inside normal life—and the more ethnic Americans see themselves seen that way—the sooner the U.S. will get to a point where multiculturalism is taken for granted. (If all else fails, time will take care of it. Just hang out until the majority becomes the minority in more states than California!)

Your audience will notice and appreciate the unexpected. Why not cast ethnic models as, for example, the majority of partners in a law firm? Why not the ethnic person as boss? Why not (gasp and drumroll . . .) a multiracial family?

A memorable and groundbreaking Tylenol commercial shows a Caucasian man and an Asian boy watching television, having lunch and generally enjoying each other's company (next page). Outside of Big Brother and Big Sister campaigns, it has been so rare to show an intimate moment between two races and generations that you stop what you're doing to wonder about their relationship. The boy lets you in on it at the end, asking (something like): "Can we stay home sick again tomorrow, Dad?"

Now you sense the possibility of an even rarer image in mainstream advertising, although certainly not in life: a couple of multiracial lovers or spouses.

Because of the image's rarity, you pay attention. The specific casting creates a visual puzzle that your mind involuntarily starts to try to work out: Maybe the boy was born to an Asian woman and the Caucasian man. Then you might look hard at the man's eyes and wonder

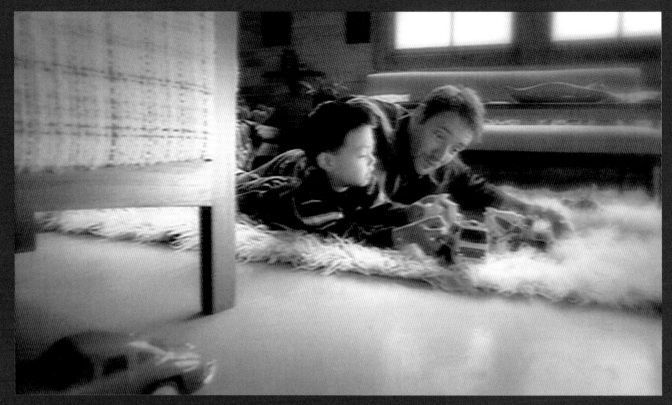

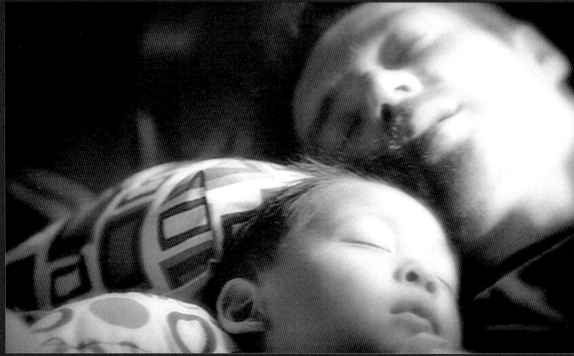

184

In a TV spot, a little boy and his dad enjoy a day home sick together. The twist is that they're different races. It was a groundbreaking concept for the tube when it began airing in early 2000 . . . is it still?

AGENCY Saatchi & Saatchi
CLIENT Tylenol Cold Medications/ McNeil Consumer Healthcare

if he's half-Asian. If he's all Caucasian, are the boy's mother's genes dominant or has the boy been adopted by one or both parents? (In a logic problem, the answer probably would be that the man's name is "Dad.") You might guess at his age—Vietnam War veteran vintage— and imagine him meeting the boy's mother, possibly his wife who's at work, during the war.

But viewers tend to filter messages through their own experiences. People who are in or from biracial marriages, those who've adopted Asian children and those who work for adoption agencies saw no visual puzzles. They saw themselves or their clients in the image. Tylenol's customer-relations center received "a lot of very, very positive" calls and letters, especially from people in those positions, said John Graham, Tylenol's marketing manager.

The ad wasn't built around the two races, Graham said. The agency, Saatchi & Saatchi, presented three dads and three sons, one of them Asian, and "it just happened. The intention wasn't to make a stand," he said. Yet the unusual casting fit within the brand's philosophy of caring that comes in all shapes, sizes, ages and colors. The

question was, "Are people going to get that this is the father?" But there weren't a lot of discussions, he said. The brand's positioned as a family medicine and this is a family, although not a typical one.

The casting "cracks the mold of what traditionally has been the kinds of people who are brought together in an ad or even a situation comedy" in which there seems to be an implied rule about how many of each race can be cast, Graham said.

Not least, while making the thought-provokingly ambiguous meta-statement, the ad also manages to sell the product. And it makes you wonder when the U.S. and its advertisers will be ready for mainstream ads that include multiracial couples . . . and when they're so commonplace in advertising that their very appearance won't surprise viewers. After all, the world is like that.

If you have an ethnic-targeting or multicultural case study or comment, I'd love to hear it. Please contact me at ronlipton@aol.com.

185

resources

Hispanic Chapter Sources

Gonzalo Arjona

Jorge Calvachi, *Kraft*

Diego Cantú, *Lapiz/Leo Burnett*

Hector Cantú, *Baldo*

Angela Carrales, *Grupo Cuatro Publicidad*

Carlos Castellanos, *Baldo*

Marisa Estefan, *Muse Cordero Chen & Partners*

Melanie Feliciano, formerly of *Latino.com*

Aurora Flores, *Aurora Communications*

Ed Flores, *Bromley Communications*

Gabriela Hernandez, *Gabriela Hernandez Design*

Victoria Varela Hudson, *Cartel Creativo, Inc.*

Felipe Korzenny, *Cheskin Research*

Aida Levitan, *Sanchez & Levitan, Inc.*

Irma Maldonado, *HMA Associates, Inc.*

Jose Matos, formerly of *Siboney USA*

Luis Miguel Messianu, *del Rivero Messianu Advertising DDB*

Daniel Nance, *D'Arcy, Masius, Benton & Bowles*

Rochelle Newman-Carrasco, *Enlace Communications*

Esther Novak, *Vanguard Communications*

Ruth Olegnowicz, *Siboney USA*

David Orona, *Cartel Creativo Inc.*

David Perez, *Lumina Americas, Inc.*

Aldo Quevedo, *Dieste & Partners*

Jesus Ramirez, *Cartel Creativo, Inc.*

Irasema Rivera, *Latina magazine*

Orlando Sosa, *Sanchez & Levitan, Inc.*

Andrés Sullivan, *Mendoza Dillon & Asociados, Inc.*

Beatriz de la Torres, formerly of *Latino.com*

Federico Traeger, *The Bravo Group*

Ricardo Trejo, *UniWorld Group, Inc.*

Yury Vargas, *The Bravo Group*

Luis Vasquez-Ajmac, *Maya Advertising*

Ted Xistris, *leapnet*

Armando Zubieta, *Lapiz/Leo Burnett*

African-American Chapter Sources

Lawrence Aarons, *The Chisholm-Mingo Group, Inc.*

Walter Allen, *Anheuser-Busch Companies, Inc.*

Ute Jansen Alonzo, *Ebony magazine*

Deborah Boardley, *Honey magazine*

Michael Brown, *Cultural Circles*

John Church, *UniWorld Group Inc.*

Lamar Clark, formerly *Honey magazine*, now *Savoy magazine*

Ronald Coleman, *The Coca Cola Company*

Alfonso Covarrubias, *Muse Cordero Chen & Partners*

Isaac Dodoo, *Images USA*

J. Van Evers, *photographer*

Ronald Franklin, *Don Coleman Advertising Inc.*

Michael Gibbs, *Chelsea Harlem Interactive, Inc.*

Kevin Hanson, *The Chisholm-Mingo Group, Inc.*

Steve Horn, *Coca Cola Enterprises*

Aubrey Hurse, *Salomon Smith Barney*

Dana Jackson, *Burrell Communications Group*

Wilky Lau, *Muse Cordero Chen & Partners*

Robert McNeil, *Images USA*

Chuck Morrison, *UniWorld Group Inc.*

Kwaku Ofori-Ansa, *Howard University*

Lance Pettiford, formerly of *Savoy magazine*

Ted Pettus, *The Chisholm-Mingo Group, Inc.*

Lorraine McNeil Popper, *UniWorld Group Inc.*

Sara Lomax-Reese, *Levas, Inc.*

Juan Roberts, *Don Coleman Advertising Inc.*

Caralene Robinson, *The Coca Cola Company*

Terence Saulsby, *Black Enterprise magazine*

Alfredia Scott, *Dayn-Mark Advertising*

Munier Sharrieff, *Burrell Communications Group*

Barron Steward, *Burrell Communications Group*

Janine Thomas, *HealthQuest: Total Wellness for Body, Mind & Spirit magazine*

Steven Thompson, *Chelsea Harlem Interactive, Inc.*

Vincent Verdooren, *Burrell Communications Group*

Clive Williamson, *The Chisholm-Mingo Group, Inc.*

David Wiseltier, *The Chisholm-Mingo Group, Inc.*

Asian Chapter Sources

Jason Abbott, *Japanese Trade Information Center*

Austin Babcock, *Urasenke, Washington DC branch*

Neeta Bhasin, *ASB Communications*

Mary Bosrock, *International Education Systems*

Steve Brounstein, *Bank of America*

David Chao, formerly of *InterTrend Communications*

Daniel Chen, *David Chen Design*

Wanla Cheng, *Asia Link Consulting Group*

David Choi, *Imada Wong Communications Group Inc.*

Patrick Chu, *Loiminchay Advertising, Inc.*

Alfonso Covarrubias, *Muse Cordero Chen & Partners*

Myrna DeMauro

Peter De Sousa, *Admerasia, Inc.*

Brian d'Sousa, *B.E. International*

Christina Dickey, *Toyota Motor Sales*

Tina Engineer, *Kang & Lee Advertising*

Kyung Eun An, *InterTrend Communications*

Marisa Estefan, *Muse Cordero Chen & Partners*

Monika Fan, *Kiyomura-Ishimoto Associates*

Mark Finkenstaedt, *photographer*

Saul Gitlin, *Kang & Lee Advertising*

Kerstin Goetz, *Jungle Communications, Inc.*

Wade Guang, *InterTrend Communications*

Bill Halladay, formerly of *InterTrend Communications*

Noriko Hoge, *Nature Pottery by Noriko*

Julia Huang, *InterTrend Communications*

Tomoko Ide, *InterTrend Communications*

Naoto Ishikawa, *PanCom International*

Norman Ishimoto, *Kiyomura-Ishimoto Associates*

Noriko Ito, *TechArt*

Karen Karp, *The Asia Society*

Tariq Khan, *Met Life*

Young Kim, formerly of *Kang & Lee Advertising*

Young Kim, *PanCom International*
Arti Kumar, *Admerasia, Inc.*
Wilky Lau, *Muse Cordero Chen & Partners*
Winifred Lee, *Bank of America*
Jeff Lin, *Admerasia, Inc.*
Laurel Lukaszewski, *Japan-America
 Society of Washington, D.C.*
Andy Lun, *The Toto Group*
Greg Macabenta, *Minority Media
 Services, Inc.*
Arati Nath, *Admerasia, Inc.*
Zan Ng, *Admerasia, Inc.*
Mary Ohno, *Kabuki Academy*
Stephanine Pao, *InterTrend
 Communications*
Supon Phornirunlit, *Supon Design Group*
Manuel de la Puente, *U.S. Census Bureau*
Angelo Ragaza, *Element Media, L.L.C*
Srinivas Ranga, *New York Life Insurance
 Company*
Juan Reyna, *Bank of America*
Jenny Risher, *photographer*
Paula Scher, *Pentagram*
Fanchon Silberstein, *multicultural
 consultant*
Rupali Steinmeyer, *Planet Leap*
Qing Nian Tang, *InterTrend
 Communications*
Jill Wachter, *photographer*
Margaret Walch, *The Color Association
 of the U.S.*
Richard Weltz, *Spectrum Multilanguage
 Communications*
Vicky Wong, *Dae Advertising*
Lee Yang, *Kang & Lee Advertising*
Kendal Yim, *Dae Advertising*

Eastern-European Chapter Sources

Victoria Akhiyezer, *Global Advertising
 Strategies Inc.*
Alex Nakhapetian, *Cybuy.com,* formerly
 of *Admerasia*
Ewa Zadrzynska, *InterAccess Inc.*

Western-European and Multi-cultural Chapter Sources

Mary Bosrock, *International Education
 System*
Kerstin Goetz, *Jungle Communications*

Annamaria Lelli, *Istituto Italiano
 de Cultura*
Herb Meyers
Oliviero Toscani, *Toscani Studios*
Frank Ros, *The Coca Cola Company*
Massimo Vignelli, *Vignelli Associates*

Books and Periodicals

THE COLOR COMPENDIUM by Augustine
 Hope and Margaret Walch, pub. by
 Van Nostrand Reinhold: 1990
DO'S AND TABOOS AROUND THE
 WORLD, edited by Roger Axtell, pub.
 by John Wiley & Sons 1993; orig.
 copyright: The Parker Pen Co.
INTERNATIONAL BUSINESS ETIQUETTE
 by Ann Marie Sabath, pub. by Career
 Press 1999
MARKETING AESTHETICS by Bernd
 Schmitt and Alex Simonson, pub. by
 Free Press 1997 (div. of Simon &
 Schuster)
MULTICULTURAL CELEBRATIONS by
 Norine Dresser, pub. by Three Rivers
 Press 1999 (div. of Crown Pub.)
MULTICULTURAL MANNERS by Norine
 Dresser, pub. by John Wiley & Sons.,
 Inc. 1996
MULTILANGUAGE DESIGN STRATEGIES
 by Ellen Opat Inkeles, pub. by Step-
 By-Step Graphics, March/April 1988
SHOPPING FOR IDENTITY by Marilyn
 Halter, pub. by Schocken Books, 2000
 (div. of Random House, Inc.)
SPECTRUM MULTILANGUAGE COMMUNI-
 CATIONS newsletters
TYPOGRAPHY: POLYGLOT: A COMPARA-
 TIVE STUDY IN MULTILINGUAL TYPE-
 SETTING by George Sadek and
 Maxim Zhukov, pub. by The Center
 for Design & Typography, The
 Cooper Union 1991 (type samples
 by Spectrum Multilanguage
 Communications)

Tipsheets

• Cultural Insights, Kang & Lee
• list of guidelines for flowers, colors
 and food from State Department's
 Ceremonials Desk

• similar sheet from the Dept. of
 Commerce, provided by Spectrum

Art Permissions

P. 12 © 2001 HMA Associates, Inc.
P. 17 © (photo) 2001 Jeffrey Young
 Imaging
P. 21 © 2000 Phillip Esparza
P. 22 © (photo) 2001 Jeffrey Young
 Imaging
P. 25 © del Rivero Messianu DDB
P. 28 © 1995 Florida Lottery
P. 31 © 2000 Valencia, Perez & Echeveste
P. 32–33 © 2000 Gayle Kabaker
P. 34 © Copyright 2001—Home Box
 Office, una división de Time Warner
 Entertainment Company, L.P. HBO®
 y HBO Latino™ son marcas de servi-
 cio de Time Warner Entertainment
 Company; © Copyright 2001—
 Home Box Office, a division of Time
 Warner Entertainment Company,
 L.P. HBO® and HBO Latino™ are
 service marks of Time Warner Enter-
 tainment Company, L.P.
P. 36 © 1999 Pueblo Corporation. All
 rights reserved.
P. 39 © (top left) del Rivero Messianu
 DDB; (top right) 1999 Pueblo
 Corporation. All rights reserved;
 (bottom) © Maya Advertising and
 Communications, Inc.
P. 40 © (left) 2001 Verbitsky.com/Latina
 Media Ventures; (right) Maya Adver-
 tising and Communications, Inc.
P. 41 © 1998 Andrea Arroyo
P. 42 © 1999 Enlace Communications, Inc.
P. 43 © HMA Associates/Edward R. Roy-
 bal Institute for Applied Gerontology,
 California State University
P. 44–45 © Copyright 2001—Home Box
 Office, una división de Time Warner
 Entertainment Company, L.P. HBO®
 y HBO Latino™ son marcas de servi-
 cio de Time Warner Entertainment
 Company; © Copyright 2001—
 Home Box Office, a division of Time
 Warner Entertainment Company,
 L.P. HBO® and HBO Latino™ are
 service marks of Time Warner
 Entertainment Company, L.P.

index

a

b